Art with an Attitude

by

Daniel Wilder

Art with an Attitude

Compiled, Written, Edited, Page Layout and Cover Design

by

Daniel Wilder

Registered with the
Library of Congress
United States Copyright Office
Washington, D.C.
U.S.A.

Copyright © 1997 Daniel Wilder

Revised
Copyright © 2000 Daniel Wilder

Revised
Copyright © 2015 Daniel Wilder

Revised
Copyright © 2017 Daniel Wilder

Revised
Copyright © 2018 Daniel Wilder

All Content
All Rights Reserved

ISBN-13: 978-1502351074

Printed by
Create Space
an
Amazon.com Company

Art with an Attitude
First print 2015

Art with an Attitude
is dedicated to
Ilene,
my one,
my only.

Preface

While we, as a society, live in a state of endurantism, we look back on history to help shape our future.

Wilder

Introduction

Whether you are a patron of the arts, an art student, a novice or experienced painter, or simply a person who is interested in learning about the history of painting, this guidebook introduces the origins and evolution of materials, techniques and terms concerning the discipline of painting.

In addition to this, I found it interesting to unravel the time-lines of several complex art periods from the nineteenth and twentieth centuries, and to show which European or American artists created which concept, style and/or painting technique. It also seemed relevant to examine the relationship between artists and their association, if any, to various art movements.

Knowing there is more to the discipline of painting than meets the eye, it only seemed natural to delve into how current events concerning the visual fine arts community, society, the economy, the environment, religion, and politics including war, may have influenced the artists creating Art with an Attitude.

Wilder

Contents

Dedication	v
Preface	vi
Introduction	vii
Page References and Abbreviations	10

Section I
The Discipline of Painting

Chapters

The Origins of Painting	14
The First Millennium	22
The Second Millennium	26
The Nineteenth Century	34
The Twentieth Century	40
The Mid-Twentieth Century	46
The Second Millennium Ends	52
The Third Millennium	56

Section II
The Avant-garde

Chapters

Revolution and Modern Art	62
Post-Modern Art	66
Neo-Post Modern Art	72
Moda Contemporary Art	78
Modern Millennial Art	82

Section III
Reference Material

Index of Terms	86
Glossary	90
Artists and Personages	174

Section IV
Government and the Free Press

United States Federal Government	194
Federal Government Infrastructure	195
Executive Orders	196
White House Office	197
Alternative Information Outlets	198
The Free Press	199

Section V
External References

Bibliography	cciv
Kindle Books	ccviii
Manifestos	ccix
HTTP Reference Material	ccx
About The Author	ccxii

Page References and Abbreviations

Page References

Index of Terms: A list of terms in *italics*	86
Glossary: Descriptions for terms in *italics*	90
Artists and Personages:	174
The vital statistics for names in **bold** letters	

Abbreviations:

a.k.a.	- also known as
b.	- born
BCE	- Before Common Era
c.	- circa (approximate date)
CE	- Common Era
Dems	- Democrats
EPI	- Electrical Power Infrastructure
EU	- European Union
GOP	- Grand Old Party, a.k.a. the Party of Trump
NEA	- National Endowment for the Arts
NEH	- National Endowment for the Humanities
POTUS	- President of the United States
SRE	- Sustainable and Renewable Energy
[1]	- Endnotes (at the end of the chapter)

Art with an Attitude

Section I
The Discipline of Painting

Chapters

The Origins of Painting
The First Millennium
The Second Millennium
The Nineteenth Century
The Twentieth Century
The Mid-Twentieth Century
The Second Millennium Ends
The Third Millennium

Throughout the course of human history, the *discipline* of *painting* has gone through several remarkable transformations and remains the most diverse and challenging *discipline* within the *Studio Arts*.

The Origins of Painting

Some of the earliest known *mural* paintings date back to the end of the *prehistoric* era in Western Europe (Upper Paleolithic Period, c. 40,000-10,000 BCE). Even though the *self-taught* Neanderthals were not aware of how their actions would affect future civilizations, they introduced the first pictographic historical record of their existence, of their *intuitive*, creative abilities, and gave shape to the first *Art Period*. Therefore, these pictographic records became one of the first cornerstones of civilization.

To create hand impressions on cave walls, male and/or female Neanderthal *artists* may have thrown handfuls of colored earth, used a tube-shaped fist, or a hollow bone to blow colored powder over and around their hands.

Regardless of which scenario occurred, the necessities of the day are unknown. Some believe the cave dwellers created the hand impressions for their amusement, possibly for aesthetic purposes, or even as a learning tool.

Nevertheless, it is easy to imagine the first Neanderthal *art critic* wandering into a cave and begins to stare at the strange images on the cave walls. The critic, with a smug *attitude* scratches his/her skull and proceeds to hit the *artist* over the head with a colossal femur bone. One thump for an excellent critique, two or more whacks for a bad review. This action could also be the first *interactive* art form. Eventually, some Neanderthals evolved into Homo sapiens.

Aside from grunting, Homo sapiens innate desire to communicate continued to evolve. These aspirations become apparent in their renderings of *representational* 2-dimensional scenes on cave walls. Due to the elaborate nature of these images, it is possible the *conceptual* cave paintings were intended to help teach young clan members about the world outside.

To create their paintings, these primitive artists may have used charcoal from the embers from fire pits. They may also have

formulated the first *Watercolor* paints and/or *Pastels* using a fusion of crushed berries or colored earth mixed with water. Also, the artist turned *engineer* may have constructed the first *paintbrush* made from twigs and/or blades of grass.

Irrespective of how these creative events took place, the cave dwelling artist had the aptitude to produce works of art that have kept global society mystified as to their purpose for generations. Consequently, civilizations ancestral cave dwelling painter may be society's first *conceptualist*.

As humanity continued to evolve, so did the skills and tools of the artist. During the Solutrean Period (c. 18,000-15,000 BCE), nomadic tribes began to show evidence of their existence on the North American continent. A few year later, during the Magdalenian Period (c. 15,000-10,000 BCE), Eurasian artists began painting on animal skins, which became the first type of artist canvas.

The tribal a*rtisan* also began to create *relief* engravings in stone, ivory, and animal horns. In addition to craft items, they began creating sculptures in the round, and cave wall reliefs, which on occasion they would paint.

While this theory remains unsubstantiated, it is possible that during the Mesolithic Period (c. 8000-6000 BCE), people on the North American continent began to speak and form their own language. During the same period, indigenous tribes practiced Spiritism/Shamanism, and that they were developing complex social systems involving the family unit and communal groups.

The artists and/or artisans within these groups created various art forms related to their environment, their ideologies, and to their way of life. To paint or carve their images, the artist/artisan used organic materials such as natural watercolor paint, animal skins, animal horn, and small wooden vessels.

Concurrently in the region known as the ancient Near East, Anatolian/Turkish artists were creating paintings believed to have spiritual significance inside rock-shelters. The Anatolians who built these shelters became humanities first known *architect*.

Consequently, Eurasian civilization started to become building dwellers. With this change of environment and habitat came an early form of mural painting, which depicted 2-dimensional cultural scenes.

As new social orders continued to appear over the globe, agriculture and systematized farming methods emerged in Egypt around 5,000 BCE. About one thousand years later artists began creating pictographic *hieroglyphics* on the interior walls of tombs.

During the Predynastic Period (c. 3650-3150 BCE), the first script hieroglyphs appeared, and Egyptian artists developed the *concept* of *Frontality*. Artists used this painting *technique* to depict the images of the royal families, their religious icons, and everyday life of the Egyptian culture. Artisans also used this new approach to creating relief carvings and wall paintings.

Due to the harsh conditions of the terrain, and the marauding tribes from Eurasia and Africa, urbanization of the Egyptian Nile Valley began to flourish throughout the Early Dynastic Period, (c. 3150-2650 BCE).

In 2630, in the early part of the Old Kingdom Period (c. 2650-2150 BCE, Dynasties III-VI) Djoser, of the first pharaoh of the Third Dynasty (c. 2650-2575 BCE) began to build the first step pyramid.

With intricate architectural features, these immense pyramids were built to unprecedented scale. Beginning with Dynasty III, artists began using the *secco* technique to paint their stylized scenes on tomb walls.

At this *time*, Egyptian society, Pharaohs and royal families believed in Animism and Polytheism. The Egyptian monarchy, however, believed they were Gods, and that their Ka (soul) would continue its journey after the death of their host body. To ensure their Ka would continue to live in comfort in the afterlife, the monarchs also entombed their worldly possessions with their mummified bodies.

When considering the attention to detail found in the Egyptian pyramids and Egyptian *contemporary art*, it is interesting to note

that the architectural plans for the great pyramids have not been discovered.

Around 3,000 BCE, pictographic hieroglyphs appeared on the Isle of Crete (SE of Greece). Later, in Mesopotamia c. 1800 BCE, the prophets Abraham, Isaac, and Jacob founded Judaism, a monotheist *religion*. About one hundred years later, pictographic hieroglyphs appeared in Asia Minor (Middle East, Turkey).

Three hundred years later, c. 1580 BCE, Greek artisans began working with a new material called *enamel*. From 1500 BCE to 50 CE *Germanic Religion* (Polytheism) emerged in Germania (Western Europe), and languages using scripted hieroglyphics began to appear in Northeastern Africa, Northwestern Europe, the subcontinent of India, and in North America.

The most significant archaeological find of this period (Northwestern India, c. 1500 BCE) is the Sanskrit Indo-Aryan language discovered in the ancient verses of the Vedas, which gave birth to Hinduism.

During the same era, *war* broke out between the Egyptians and the invading Canaanites. Even though the Egyptians won this battle, Egypt would begin to lose its dominance over the region within the next nine hundred years.

While Eurasian empires began to flourish, artists continued to develop secco painting techniques along with new artisan techniques.

Near the end of the 6th century, the prophet Zarathushtra founded Zoroastrianism in Persia, while Taoism and Confucianism appeared in ancient China. Meanwhile, Siddhartha Gautama became known as Buddha after he founded Buddhism in ancient India.

Buddhist philosophies would have a positive influence on society and the creative expression of Eurasian artists, artisans, and musicians for centuries to come.

Around the midpoint of the Zhou Dynasty (c. 1025-220 BCE), Sun Wu Tzu, a Chinese General wrote about his philosophical views

concerning *the Art of War* (c. 500 BCE). His philosophy has been studied by numerous Heads of State and countries in the East and the West, and have influenced both battle and business stratagems into the twentieth-first century.

During the Zapotec Period (c. 600 BCE-800 CE), the indigenous people of Middle America began to develop social and agricultural systems while artisans created massive sculptural heads in the round.

Their cultural development also included writing, mathematics, astronomy, a polytheist religion, and the now famous Mayan Calendar. Along with this global cultural progression, artistic creativity continued to flourish, and new painting materials would continue to be developed.

During the Roman Republican Period (c. 509-27 BCE), the city of Rome had become the hub of Western culture and home to transient artists and artisans. Concurrently, in 425 BCE, **Herodotus**, produced the History of the Greco-Persian Wars (492-449 BCE), and thus became known as the Father of History.

Less than fifty years later (c. 386 BCE), **Plato** founded the first known educational institution. Referred to as The Academy, the Institute was located in the city of Athens.

After the death of Plato, **Aristotle** broke through cultural *boundaries* and began teaching outside the Athenian gymnasium, called the Lyceum, around 335 BCE. In addition to the birth of the *Arts and Sciences*, Greek artists developed a new concept and *style* of painting called *Illusionism*.

In 334, Alexander III a.k.a. Alexander the Great (356-323 BCE) set out from Macedonia to realize his vision to conquer the world. Civilization's first *museums* were founded in Egypt during the Alexandrian Period (c. 336-323 BCE), and Greek artists developed a new painting technique and a material called *Encaustic Paint*.

Sometime during the middle of the Hellenistic Age (323-30 BCE), Gnosticism, a new religion emerged in Greece, and after the sudden death of Alexander, the Roman Empire began to decline.

Adding to the financial burden of the Empire, the Roman army had to maintain a constant state of readiness to fight off retaliatory attacks from Northern European tribes. However, the deterioration of the Empire was due in part to the high cost of maintaining an active military in its northern regions.

In Asia, during the Han Dynasty (c. 206 BCE-220 CE) *Sumi*, another new painting technique, and style, was developed. Artists of this period used *Sumi-e* to depict the splendor of nature in landscape scenes and communal life, which included character inscriptions in their compositions.

As society continued to evolve so did the literacy skills of the wealthy. Derived from the Roman Senates *Acta*, citizens having excellent literary skills began providing handwritten daily news of current events around 59 BCE.

Just before the Common Era began, Gaius Julius Caesar (100-44 BCE) was named *Dictator* of Rome for life. That same year (45 BCE) Caesar introduced the *Julian Calendar* to the citizens of Rome.

While Caesar was popular with the lower and middle-class citizens of Rome, the Senators grew envious of his rising power. Less than one year later, sixty senators conspired to assassinate Caesar on March 15, known as the Ides of March.

In relationship to the discipline of painting, the First Millennium was seemingly uneventful. However, as humanity continued to evolve, a few events took place that would significantly affect the future of human culture, and the future of the Arts and Sciences.

The First Millennium

Thirty-four years after the death of the Hebrew Rabbi and Prophet called Jesus (b. Joshua, c. 4 BCE-29 CE), Simon-Peter one of thirteen disciples, founded The (Christian) Church in Rome and became the first Pope (c. 63 CE).

Nothing is known of the prophet Jesus between the ages of twelve and thirty. However, it is reasonable to believe that the prophet traveled extensively throughout the region making it plausible to consider that the philosophies of Taoism, Confucianism, Buddhism and Zoroastrianism influenced his teachings.

Before launching the new religion, Simon-Peter had thirty-four years to study doctrines and beliefs involving Judaism, and the teachings of Plato concerning Dualism, Muthos, and Logos. Simon-Peter also had time to study Germanic Religion, along with Greco-Roman mythology, including the stories of Amphitryon and the Hyperboreans.

After the founding of The Church, Nero Claudius Caesar (37-68 CE) the Roman emperor (54-68 CE) blamed the Christians for the burning of Rome and began to persecute the followers of the new cult. These actions only fanned the flames of angry Christians who accused Rome of its part in the death of their prophet.

Prior to the eruption of Mount Vesuvius near Pompeii in the year 79, *contemporary* painters began to make the transition from Illusionism to a style very similar to *Trompe-l'œil*.

In the 2nd century, *Iconoclasm* emerged within the Christian Church, and midway through the third century, Mani (c. 216-276 CE), a visionary prophet of Persia founded the religion of Manichaeism. With its roots in Zoroastrianism, Manichaeism incorporated doctrines from Christianity, Dualism, and Gnosticism. After the martyrdom of Mani, this new religion quickly spread through the Roman Empire and Asia.

Due to the popularity of Manichaeism, Christianity was on the verge of becoming a dead religion. However, in the year 313, Constantine I (285-337 CE) the Emperor of Rome (306-337 CE) converted to Christianity, which helped to unify The Church.

As the Roman Empire continued to collapse, the Byzantine Empire Age (c. 330-1453 CE) merged with the *Medieval Period* (c. 325-1325 CE). In 325 CE, almost 300 years after the martyrdom of Jesus, Constantine I assembled the First Ecumenical Council of Nicaea in Anatolia.

The Council proceeded to establish a type of polytheism found in the Holy Trinity. The Trinity consists of three deities in one God: God the Father, God the Son, and God the Holy Spirit. The council also proclaimed Jesus, a mortal and son of Mary, to be born God the Son.

Favoring *Visionary Art* and *Intuitive Art*, Christian monks rejected the intellectual properties found in Illusionism. This attitude was a setback for the discipline of painting, considering the monks returned to using 2-dimensional techniques found in the *Illuminations*.

The Illuminations, as a style was popular with the monks who transcribed the liturgical books by hand. The *media* of the day was *Egg Tempera*, *Gouache*, and Watercolor Paints. After The Academy founded by Plato had closed in 83 BCE, philosophers continued to teach any student with a desire to learn. Independent philosophers sustained this practice until the year 410 when The Academy re-opened.

In 475, a Buddhist monk by the name of Bodhidharma left India and founded Zen Buddhism in China. In 610, the prophet Muhammad began to teach the monotheistic religion of Islam.

In 529, Justinian I (b. 482-565 CE) the last Roman Emperor (527-65 CE) aimed to eradicate followers of the Greco-Roman religion and also hunted down members of new Christian cults that were competing with The Church. In the process, Justinian I, a.k.a. Saint Justinian closed Plato's Academy permanently.

Meanwhile, Middle Eastern and Muslim cultures (c. 410-1000 CE) continued to influence architecture, *mosaics*, mural painting, and sculpture. However, concerning new media, styles, and techniques, the discipline of painting would not progress for the next seven hundred years.

As methods of transportation began to improve on land and sea, so did the mobility of empires and society. Consequently, this contributed to the complexities of civilizations evolution, and the progression of the discipline of painting.

The Second Millennium

During the first five hundred years of the Second Millennium, The Church undertook two major campaigns. The first crusade began with the Holy Wars, and the second stratagem began with the *construction* of elaborate Cathedrals that would rival the Great Pyramids of Egypt. Although somewhat dormant until the second half of the millennium, the discipline of painting would continue to evolve.

During the Romanesque Period (c. 1000-1150 CE), *Casein Paint* was developed in Germany. This new *medium* was used in *fresco* and mural paintings inside grandiose cathedrals. One of these structures was Saint Michael's Cathedral in Hildesheim, Germany. Also during this period, Norse Vikings established settlements in lands on the other side of the Atlantic Ocean, now known as the North American Continent.

In 1021, **al-Haytham** gave a description and analysis of the camera obscura in The Book of Optics. Late in the 11th century, the Holy War commenced with the Christian Crusades (1095-1396 CE).

Throughout the Gothic Period (c. 1100-1500 CE), the papacy's zeal for new architecture eclipsed the need for new painting styles. More importantly, the pontiffs continued to ignore the needs of the increasing number of poor. As the deprived masses perished from starvation, the papacy spared no expense on the extravagant cathedrals constructed throughout Western Europe and the Mediterranean region.

During this period, the Christian Crusades marched into the 13th century, led by the Papal Inquisition (1233-1542 CE). Over the next 780 years, the Christian Cross would remain one of the most revered and loathed symbols throughout Eurasia.

In 1202 CE, **Fibonacci** wrote the book titled Liber Abaci concerning mathematics. Along with mathematical theory, he also discusses what is presently known as the *Fibonacci Sequence*.

Also in the early part of the 12th century, Sufism, an Islamic philosophical and literary movement emerged in Persia. Sufism derived its ideologies from Neo-Platonism, Buddhism and the teachings of Jesus. The movement was led by **al-Ghazālī**, an

influential Sunni philosopher. Meanwhile, the Cambridge and Oxford Universities were established in Great Britain.

In the 14th century, Humanism, a philosophical and literary movement rejected medieval religious authority, focused on human values and capabilities, and encouraged studies in the Arts and Sciences. Two leading Humanists of this period were **Boccaccio** (poet and storyteller) and **Petrarca** (poet and scholar).

A short time later, in 1415, **Brunelleschi**, an Italian architect, engineer and Godfather of the Renaissance rediscovered the use of *linear perspective*. With the Renaissance Period (c. 1430-1600 CE) about to begin, the discipline of painting and the concept of *Realism* would go through several evolutionary phases.

Meanwhile, in Germany, **Gutenberg** became the first known artisan to print with a movable type printing press (c. 1436 CE). He was also the first known person to print pages from the handwritten Christian Bible.

During the same period, artists such as **Bellini**, **Botticelli**, **Michelangelo**, **da Vinci**, **Ghirlandaio**, **Mantegna**, **Perugino**, and **Raphael** used Christian themes for their frescos, murals, and paintings. As artists started using *gesso* in their frescos, the *genre* of portrait painting began to gain widespread popularity, and da Vinci, one of the most influential artists of the era often employed the *Golden Ratio* when composing his paintings.

In 1478, the Spanish Inquisition (1478-1834 CE) was initiated by Ferdinand the Catholic (King Ferdinand V, 1452-1516 CE), and Isabella the Catholic (Queen Isabella I, 1451-1504 CE). In 1492, Queen Isabella I financed the explorations of the Italian explorer, Christopher Columbus, who was attributed with the re-discovery of the Americas.

It is important to note that up until the middle of the 20th century, the discipline of painting was considered a male profession. Even though both genders encouraged this belief, not all male artists agreed with it. Neither did some female artists, who would go on to become accomplished painters.

During the Italian High Renaissance (c. 1490-1520 CE), da Vinci and **Sir More** continued to help bring about an intellectual rebirth to the Arts and Sciences. Exploring the illusion of reality in 1503, da Vinci created the painting with the *title* of Mona Lisa.

In 1516, Sir More wrote the book titled Utopia, depicting the fictionalized account of Hythloday and the state of reason. Renaissance artists also developed a formula for *Oil Paint* and would become the most popular medium used by artists for the next five hundred years.

During the Late Renaissance (c. 1520-1600 CE) Mannerism, a new style of painting emerged in Italy. An example of this style is found in the painting titled The Deposition from the Cross (c. 1528) by **Pontormo**.

Nevertheless, as the papacy continued to lose its influence over the Arts and Sciences, Mannerists such as **Fiorentino, La. Fontana**, and **van Hemessen** a Flemish artist began to break away from Christian themes.

In Germany, painting styles had begun to change dramatically. After completing his studies of the artwork and theories by Italian masters, **Dürer**, gradually started to break away from religious themes.

At the time, this was considered a dangerous move, one that might jeopardize his standing with art patrons, and in the art community. However, his shift in style and art theory would influence the course of future German art.

During this period, the king of England, Henry VIII (1491-1547 CE) issued the Act of Supremacy. An advocate of religious reformation, he rejected papal control over Christian Religion and established the Protestant Church of England (c. 1534 CE).

Pope Paul III (1534-1549 CE) was the first pope of the counter-reformation and a patron of the arts. In 1536, Portugal established its own Inquisition (1536-1750 CE), and in 1582, Pope Gregory XIII sponsored a correction of the Julian Calendar, now known as the Gregorian Calendar.

Despite the commoners changing their attitude towards Christianity, religious themes continued to dominate the Western European art communities. However, **Poussin** and other leading painters of the Baroque Period (c. 1556-1792 CE) worked with both Christian and Secular themes.

Evan though paintings of the Baroque style were somewhat dark in relationship to the color palette they began to show unprecedented animation and individual characterizations.

Some of the more notable painters of the Baroque period were **Caravaggio**, **Rembrandt**, **Rubens**, Poussin, **Valázquez**, **Van Dyck** and **Vermeer** who is known for his use of the *glazing* process. During this time, the Trompe-l'œil style of painting re-emerged in the *Art World*, which both The Church and the aristocracy embraced.

Three Italian *artistes* of the Baroque period were **Gabrieli**, **Corsi**, and **Peri**. In 1597 Gabrieli, a Venetian composer wrote the world's first symphony while Florentine composers, Corsi, and Peri penned the first Opera.

At the beginning of the seventeenth century, several Christian sects seeking religious freedom fled from England. Landing in the region known as Plymouth, New England they began the colonization of the new world. As irony would have it, the new Christian community started its' own Inquisition, which, in the literal *sense* became a Witch Hunt.

Back in the Old World, those with an inquisitive mind, such as painters, chemists, scientists, physicists, and teachers began to develop an interest in the perception of color theory. One of the earliest theories came from **Newton**.

In 1687, Newton published his Philosophiæ Naturalis Principia Mathematica (The Principia ~ Mathematical Principles of Natural Philosophy). Seventeen years later, he published Opticks: or, a Treatise of the Reflexions, Refractions, Inflexions and Colours of *Light*.

Based on his observations, Newton determined that a glass prism separates sunlight or white light into a visible spectrum of color (*White Light Spectrum*).

Also during this period, Flemish art was beginning to flourish with artists such as **van Honthorst**, who was well known for his Night paintings. At this time, European artists were just beginning to use *impasto* and *painting knife* techniques, while **Carriera** gained recognition in Paris for her unique Pastel paintings.

Early in the 18th century, **Schulze,** a German professor developed the principles of photography (c. 1727 CE). This new medium would eventually have an effect on the discipline of painting in the 19th and 20th centuries.

A few years later, the Industrial Revolution (c. 1750-1850 CE) emerged and gave birth to new technology.

As this era began in the New World, twelve Delegates from the *original* thirteen colonies met in Philadelphia, Pennsylvania, and formed the First Continental Congress (1774 CE). The Second Continental Congress continued to meet from 1775 through 1781. The United States of America emerged as a new nation in the city of Philadelphia, where fifty-six Delegates signed the Declaration of Independence, on July 4, 1776.

The Articles of Confederation and Perpetual Union served as the first Constitution of the United States, which Congress formally ratified in 1781. Under the Articles of Confederation, Congress elected **Hanson,** a Delegate from Maryland, to a one-year *term* as the first President of the Congress of the Confederation. On September 17, 1787, Representatives from twelve of the original Thirteen States signed the United States Constitution as the Supreme Law of the land.

In 1789, under the U.S. Constitution, **Washington** was elected the nation's first President by the Electoral College, and in 1790, The *United States Congress* enacted the first Federal *copyright* law. On the 15th of December 1791, Congress ratified the First Ten Amendments to the United States Constitution, known as The Bill of Rights.

Two weeks later John Barry registered the first copyright in the U.S. District Court of Pennsylvania, for The Philadelphia Spelling Book, and *American Folk Art* had emerged in the new world. In 1793, construction began for the *United States Capitol,* and became the permanent residence for the U.S. Congress.

Shortly after the American colonists won the war against Great Britain (American Revolution, 1775-1783 CE), the French Revolution (1789-1799 CE) broke out. This Revolution of Enlightenment had far-reaching political ramifications that affected American relations with France and Great Britain. Nonetheless, the revolution primarily affected the future of the French nationals seeking equality as citizens and in government.

Along different economic lines, the Industrial Revolution continued as watercolors became a manufactured product in Great Britain. By the end of the 18th century, watercolorists began to use the *Wet-in-Wet* painting technique.

With the Industrial Revolution coming to a close, the Avant-garde finds its voice, and a new Revolution is afoot.

The Nineteenth Century

The nineteenth century ushered in new technologies and philosophies, which contributed to the shaping of new attitudes affecting not only the evolution of society, but the Arts and Sciences as well, especially the discipline of painting.

Progress stops for no one, and in 1802, **Wedgwood** and **Davy** produced the world's first photogram in England. The image, however, disappeared after a short time. Nevertheless, the discipline of painting started to come into its own as the European art community entered the Period of Romanticism (c. 1800-1850 CE).

In Germany (1810 CE), **von Goethe** published Zur Farbenlehre (Theory of Colours), where he discusses the human physiology and the individual's perception of color. The German Art and Science community received his theories with little enthusiasm. After the second publication in 1840, Von Goethe's theory received the same reaction from England's Arts and Science community. In the present day, his theories are highly regarded.

As the Industrial Revolution continued, *mass production* of interchangeable parts emerged, while America and Great Britain went to war, once again (War of 1812 CE). A short time later in France, **Niépce** created the first paper negative (1816 CE). Three years later in the United States, Washington, D.C. became the home for the nation's *Capital*.

Across the ocean in 1826, Niépce produced the first known photograph on a pewter plate. Twelve years later (c. 1838 CE) in England, **Talbot** invented the prototype for the photographic process called Talbotype or Calotype.

In 1833, **Chevreul**, a chemist and color theorist finished writing his chromatic theory titled Les Principes d'Harmonie et le Constraste de Couleurs, et Leurs Applications aux Arts (The Principles of Harmony and Contrast of Colours, and Their Applications to the Arts).In this book, Chevreul discusses his observations of white light and physiology in detail in three parts.

Meanwhile, the United States government and pioneers who wanted to move westward, and those with California Gold Rush Fever, began systematically to kill Native American Indians, who

would do anything to protect their sacred homelands. Having seized almost all of the Native American Indians land, the United States Government and settlers almost succeeded in extinguishing an entire culture.

In 1850, **Courbet,** who opposed the prevailing attitude towards Romanticism, led the rebellion of the Realist Movement, while the Women's Suffrage Movement began to gain strength. As the Industrial Revolution ended, humanity entered the *Modern* world bringing about *Modern Art* (c. 1851- 1900 CE) CE).

With the emergence of this new era came progressive thought. In 1859, **Darwin** published, On the Origins of Species by Means of Natural Selection. Darwin's theories not only shocked the world of Natural Science; his concepts shook the very core of Christian theology.

In 1861, the sciences continued to evolve as **Maxwell** created the first color photograph and formulated his *Electromagnetic Theory* involving the wavelengths of the White Light Spectrum. From this, Maxwell established that White and Black do have wavelengths, and, therefore, are not colors.

In America, the War Between the States (1861-1865 CE) had begun, while two separate events were taking place in Western Europe that would greatly alter the course of painting in the 20th century. First, artists began painting with oils using the *alla prima* technique. Second, due to unfair selection practices at *L'Academie des Beaux-Arts*, an *Art Revolution* broke out in the Parisian art community in 1863.

The Parisian art revolution and the opening of the first *Alternative Art Space* known as *Le Salon des Refusés* established three landmarks in art history.

First, it established the city of Paris as the hub for Western culture. Second, it paved the way for future artists to break away from conventional *barriers* and protest against *academia's* unwavering teachings of Realism and outdated methods related to *Formalism*. Third, it laid the foundation for future members of the *Avant-garde* to stand up to the elite who dictated what they thought art should be, and who was selected for the exhibitions at the museums and academies.

In 1865, **Bahá'u'lláh** founded the Bahá'í Faith in Iran while French Realists such as **Moreau** began to work with Christian Symbolism. Back in the United States, the assassination of President **Lincoln** (1861-1865 CE) took place only five days after the Civil War ended.

In 1866, all of Europe was in a state of chaos as Austria, France, Italy, Prussia and the Kingdom of Hanover entered the 7 Week War. After the fall of the French Second Empire in 1870, the French Third Republic took over as the new Republican Government, and France and Germany entered yet another war (Franco-Prussian War, 1870-1871 CE).

Despite the chaos between the two warring countries, artists such as **Harnett** were using the Trompe-l'œil technique while other artists began working with the concepts known as *French Impressionism*, and *Naturalism*, while **Whistler** brought *Aestheticism* to the Parisian *Salon*.

Also in 1870, the United States Congress ratified the Fifteenth Amendment granting African-Americans the right to vote. However, this would not become a reality for years to come, and women were still denied the right to vote.

As America entered the Gilded Age (c. 1865-1898 CE), corrupt legislators at state and federal levels helped unregulated free enterprise make the rich extremely wealthy off the backs of the working class. In 1872, **Nietzsche** published The Birth of Tragedy: Out of the Spirit of Music. This work along with other titles would soon have an influence on European art and philosophy. In 1875, the Social Democratic Party of Germany (SDP) was established and was the first political party directly influenced by Marxism.

The socio-economic/political views of the SDP along with Nietzscheeesque philosophy influenced German society, the *Performing Arts*, and the *Visual Fine Arts Community*.

In 1876, the United States Centennial celebration was held during the World's Fair in Philadelphia, and the **Stanley** twins patented the plans for the *Atomizer*, a prototype of the *airbrush*. In the meantime, **Edison**, an American inventor, and **Swan**, a British physicist were both in the throes of developing the incandescent light bulb.

A few years later, the world witnessed the emergence of *Expressionism*, and Post-Impressionist Movements such as *American Impressionism*. In 1881, only six months into his *term*, President **Garfield** was assassinated.

Meanwhile across the pond, **Seurat** began to work with *Divisionism*. Interested in the division of color, Seurat's new concept, style, and painting technique changed the way the audience looked at paintings. Seurat is the first of only a few known artists to complete the *Trilogy of Painting*. Five years later, sheets of aluminum rolled out of Switzerland.

In 1888, **Riep**, a Dutch chemist developed *Enamel Paint* suitable for the construction trade just before *Art Nouveau* went to the forefront of the European Art World.

In 1890, America witnessed the birth of the Progressive Era, which brought about political reform, and in 1891, the Belgian *Société Des Vingt* came to life. A few years later *Jazz* was born in the American city of New Orleans, Louisiana, bringing a new vibrancy to music.

Three years after the birth of Jazz, the Spanish-American War would last only two and a half months (April, 25, 1898-August 12, 1898 CE). Resulting from that war President **McKinley** (1897-1901 CE) and Congress made a joint resolution to make Hawaii an official United States territory.

In 1900, the Eastman Kodak Company introduced the Brownie Camera along with 120 *monochromatic* or *grayscale* film.

Society and the Avant-garde prepare to enter the twentieth century; neither suspecting a narcissistic psychopath would soon become the legal Dictator over Germany.

The Twentieth Century

As the twentieth century began, the Progressive Era (c. 1890-1920 CE), continued with extensive political reform, active Socialism, women's suffrage and child labor laws. Unfortunately, President McKinley was assassinated only six months into his second term.

The new era also saw the birth of the *G.I. Generation*, *Post-Modern Art*, and a new age of intellectualism. This new wave of creative thought gave rise to a fresh-faced Avant-garde who presented *Austrian Expressionism*, *French Expressionism*, and *German Expressionism* along with **Freud's** research on Psychoanalysis (1902 CE), and **Einstein's** Special Theory of Relativity (1905 CE).

In 1907, *Grassroots Artists* such as **Braque** and **Picasso** introduced *Cubism* to the world, while **Minkowski** published his concept of *space-time*. That same year, **Munsell** developed the *Munsell Color System* and published his book titled *A Color Notation*. Like Chevreul and Seurat, Munsell was interested in the perception of color relationships and their differences.

In 1909 new concepts and movements related to Cubist sculpture, *Futurism*, and *Luchism* emerged in Europe. In 1910, *Non-Objective art* emerged in Germany, and in December 1911, **Kandinsky** and **Marc** established the *First Exhibition of the Editors of The Blue Rider*.

This exhibition was a group showcase of artists working with different concepts in painting. The artists were **Arp**, **Bloch**, Braque, Derain, Kandinsky, **Kirchner**, **Klee**, **Macke**, Marc, **Nolde**, and Picasso. In that same year, Picasso introduced the *Collage*.

Over the next three years, this exhibition traveled throughout Europe. In 1913, **Malevich** wrote his Manifesto titled *Suprematism* involving Non-Objective Art. The attitude behind the formulation of the Non-Objective works by Kandinsky and Malevich became synonymous with the terms *Abstract* and *Abstract Art* and subsequent movements in Eurasia and North and South America.

Also in that year, works from Kandinsky's Blue Rider exhibition were included in the New York Armory Show. For many Americans, the Armory Show was the first opportunity to view the

content of Cubist paintings by Picasso and **Duchamp** (antedating *Orphic Cubism*), and **Sheeler** (industrial photographer and painter). A few of the artists included the show were **Cézanne, Gauguin**, Kandinsky, **Matisse, van Gogh** and **Hopper.**

The Armory Show traveled to Boston and Chicago where it was on display at The Art Institute of Chicago. Despite the new *Art Movements* taking place in Europe and America, Impressionist and Realist paintings continued to dominate American Art. Popular themes and techniques included Americana, Regionalism, Scenic Painting, Social Realism and by artists such as **Brownscombe**, Hopper, and **Rockwell**.

The year following the Armory Show, World War I (1914-1918 CE) began. During the first year of the war, Macke one of The Blue Rider group died in battle. In that year **van Doesburg** and **Mondrian**, a close friend of Macke, initiated the *de Stijl* movement in search of the pure art form.

As the war raged on members of the European, aristocratic Art World often praised battle themed paintings, such as those by **Lady Butler**, while privileged society lauded **Sargent's** portrait paintings of society's elite. Two years after Marc died in the trenches, the *Dada* movement was born in Switzerland. In 1917, the United States entered World War I, and *Metaphysical Art* by **de Chirico** suddenly appeared from the fourth dimension.

In 1918, the year World War I ended, a group of German artists established the *November Group*. In 1919, **Gropius** founded the Staatliches *Bauhaus* in Weimar, Germany. On the downside of that year, German politicians established the National Sozialist Deutsche Arbeiter-Partei (National Socialist German Workers' Party (NSDAP), later known as the Nazi Party, or simply the Nazis. One year later, Adolf Hitler (1889-1945 CE) a Nationalist, took control of the Nazi Party.

On a more positive note, the United States Congress ratified the Nineteenth Amendment, which prohibits any State to deny any individual the right to vote because of gender. Meaning, women finally received the right to vote. Also in that year **Huelsenbeck**, published the Dada Almanac.

In 1923, the Weimar Republic dissolved the Nazi Party, and the Dada movement had come to a halt. In 1924, all the official Dada centers closed in Europe and America. As the *Silent Generation*

began to emerge in 1925, *Surrealism* and the *Art Deco* movement streamlined the Arts.

One year later, having played to the emotions and fears of low income and the middle class, the German Nazi Party was reinstated. Soon after, Hitler's Brown Shirts began to brutalize any man or woman who showed any signs of opposition towards the Nazi Party. Slowly German citizens began to turn on each other, including family members and began to betray their Jewish friends and neighbors they had known all their life.

However, another event would take place that would alter the future of the entire world. In 1927, **Baird** transmitted the first live television signal between London and Scotland.

One year after that, Baird sent the first transatlantic television signal between London and New York, while *Alkyd Paint* was being developed. The next year the stock market crashed on the day remembered as Black Tuesday.

As a direct result of the Crash, the Great Depression (1929-1939 CE) occurred, affecting global socioeconomics, which contributed to Hitler's rise to power in Germany. Two years later Swing music swung into dance halls and soda shops across America and Europe.

In response to the Depression, which ultimately affected the proletariat class, President **Roosevelt** (FDR, 1933-1945 CE) created a series of economic programs called the New Deal (1933 CE). Also in 1933, **Röhm** develops and trademarks Plexiglass for international trade.

In January of 1933, Germany's exiting President **von Hindenburg** reluctantly named Hitler the Chancellor of Germany. Two months later, on March 23rd, Germany's newly elected Reichstag (similar to the U.S. Congress) voted in favor of the Enabling Act, making Hitler the legal *Dictator* over Germany.

Also in that year, the Nazi Party forced the Bauhaus to close its doors, and after stripping German citizens of their right to freedom of speech, Hitler and Goebbels (Minister of *Propaganda*) seized control of the news media, and kept the populace from the truth.

In 1935, Senator **Long** of Louisiana was assassinated. Famous for his Every Man a King radio speech, Long also put his Share the Wealth program on Congressional Record. In that same year, the Nazi Party officially adopted hieroglyphs for their insignias from Germanic Religion and the ancient *futhark*.

Also in 1935, under the New Deal, FDR launched Federal Project Number One, a subdivision of the Works Progress Administration. Number One became the umbrella for five artistic programs. These programs were the Federal Art Project, the Federal Music Project, the Federal Theatre Project, the Federal Writers Project, and the Historical Records Survey.

During this period, the *Abstract Art Movement* had begun to take hold in America with painters such as **Albers**, **Avery**, and the *American Abstract Artists*. However, Avery's later paintings considered too representational lost their abstract status.

In 1937, during the Spanish Civil War (1936-1939 CE) Picasso completed the painting titled *Guernica*. In that same year, the Nazis held the *Degenerate Art* Exhibition. In 1939, Germany invaded Poland where the systematic genocide of the Jewish people (Holocaust) and the Second World War began (1939-1945 CE). Also in 1939, the Radio Corporation of America (RCA) televised the opening of the New York World's Fair, and a speech given by President Roosevelt.

In 1941, the Japanese military attacked Pearl Harbor in Hawaii, forcing the United States to enter World War II (1939-1945 CE). For the next four years, American and Allied troops fought against The Axis Powers in the Pacific, East Asia and in Europe.

The year the WWII ended, the artist **Dubuffet** started to collect *l'Art Brut*: One year after that, *Abstract Expressionism* began to emerge in America, and **Pollock** began using a style of painting, later termed *Action Painting*.

From 1946-49, **S. Golden** worked on developing a new acrylic paint for studios artists called *Magna Paint*, and the Abstract Expressionist Movement would soon bring international acclaim to American art for the first time.

During this period, the *Baby Boomer Generation* was born, and in May of 1948, Prime Minister David Ben-Gurion declared the

establishment of a Jewish state known as the State of Israel, and scientists begin to warn world leaders of *global warming* effects.

The social order and the Avant-garde not only challenge authoritarian rule of any kind, but they also begin to protest against all forms of social injustice.

The Mid-Twentieth Century

As the new decade began, America sent troops to fight in the Korean War (1950-1953 CE). Aside from yet another war and the fear driven *McCarthyism*, the 1950's were productive years. In 1950, Duchamp coined the phrase, *Retinal Art*, as *The Beat* descended upon American culture, and the creation of a computer named Simon helped in the advancement of computer science (c. 1950 CE, Berkeley, California).

This new technology would eventually affect global society and the *Commercial Arts*. Meanwhile, elitists in the Visual Fine Arts Community snubbed their noses at *Paint by Numbers*.

In 1951, Congress ratified the Twenty-Second Amendment, stating that no President shall hold no more than two terms in office. A year later, **Paolozzi** and *Pop Art* (Neo-Dada) emerged in the United Kingdom.

In 1953, **Hefner** published a new men's magazine called Playboy, which provided a fresh, new perspective on American culture and society. However, focusing on one aspect of the publication, Christian groups censured the magazine stating it was pornography, and it did not fall under the protection of the First Amendment.

By the middle of the decade, *Conceptual Art* and artists from the *New York School* were gaining notoriety, as *Beatniks* and the *Beat Generation* snapped their way into coffeehouses from coast to coast. Meanwhile, teenyboppers and pioneers such as **Berry**, **J. Brown**, **J. Lewis**, and **Presley** Rock-n-Rolled into *mainstream* culture, and artists **Rauschenberg** and **Johns** Popped into New York City culture.

In 1958, Maharishi **Mahesh** Yogi founded the Transcendental Meditation (TM) movement, in Burma. By the end of the decade, **F. Stella** completed his Black Paintings, and Contemporary Realism emerged with artists such as **Danby**, while **Bocour**, Utrecht and Liquitex, pioneers in paint manufacturing were developing *Acrylic Polymer Paint* and *Mediums*.

As the *Art Revolution* continued in the last year of the decade, the *San Francisco Mime Troupe* hit the west coast in northern California, while The Second City Theater in Chicago opened its

doors to Avant-garde artistes, and Hawaii became the fiftieth of the United States.

During the 1960's, America entered another ongoing Conflict in Vietnam (1954-1975 CE). In the meantime, the Beatles and the Rolling Stones re-invented Rock-n-Roll and ascended into mainstream culture, while the *Fluxus* Movement flowed into the world and the San Francisco Mime Troupe staged political protests in the city on the bay.

As *Op Art, Post-Painterly Abstractions* and *Digital Computer Art* emerged in the World of Visual Art, **Dylan** wrote the song titled Blowin In The Wind (1962), which helped define the decade of discontent.

In June of 1963, **Evers** a leading civil rights *activist* was assassinated. Two months later, on August 3^{rd}, **Dr. King Jr.** gave his speech "I have a dream", in Washington, D.C. On November 22^{nd}, of the same year, President **J. Kennedy** (1961-1963 CE) was assassinated in Dallas, Texas.

Some Americans believed (too many still do) they had the right to take away or to block the rights of other groups of people whose physical hue is different from their own. One way to prohibit African Americans from voting in southern states was to impose a Poll Tax.

In 1964, Congress enacted the Twenty-Fourth Amendment forbidding states from collecting Poll Taxes in Federal elections; **Rosenquist** began work on his painting titled *F-111*, and **Frankenthaler** brought the technique she dubbed *Soak Stain* painting to realization. In the meantime, Beatniks evolved into Hippies, Heads, and Flower Children who grooved into American Pop Culture. These free spirits and non-violent people of all races and religions were known as the Love Generation, who consequently gave birth to *Generation X*.

In 1965, the artist/pioneer by the name of **Castellon** began to work with airbrush painting techniques. In February of that year, followers of the Nation of Islam assassinated Malcolm X, a Muslim minister and Human Rights Activist. Aside from this, some far right Caucasian Americans were still having problems accepting the Twenty-Fourth Amendment, and it took the Voting Rights Act of 1965 to enforce this amendment.

In 1967, the Counter-Culture emerged in New York City as the Youth International Party. The members of this Freedom of Speech group were better known as Yippies. Meanwhile, Flower Children, who embraced the ideals of Peace and Love, wanted to change not only corporate America but the worldview as well. Their far-out philosophy traveled quickly through the streets, coffee shops, high school, and college campuses. The laid back; groovy attitude of the Flower Children also affected the Performing Arts, Studio Arts, the *Literary Arts*, and global society.

Unfortunately, not everyone received the Flower Children's message of Peace and Love. In 1968, the assassinations of both Civil Rights leader Dr. King Jr. and Senator **R. Kennedy** stunned the world. In response to King's Death, The Last Poets emerged in Harlem on the anniversary of Malcolm X's birthday and revolutionized music with a voice an integrated *public* was not prepared to understand.

After Duchamp's death in 1968, his followers known as *Duchampians* deemed the discipline of painting to be dead. Coincidentally the art of painting began to take a backseat to Conceptual Art, *Installations*, Sculpture, and new printing techniques.

In the same year, **Max,** a commercial artist was creating prints with bold psychedelic colors, while **Leary** and members of the counter-culture dropped tabs of Orange Sunshine and Purple Haze (LSD, a psychedelic drug). While on LSD, they would. "turn on, tune in, and drop out ", a phrase coined by **McLuhan**, a Canadian philosopher.

Conversely, members of left-wing extremist groups such as the Students for a Democratic Society (SDS) took their angst out on the servicemen returning home from Vietnam. These anxiety-ridden individuals would throw anything they could (rocks, broken glass, and bricks) at uniformed soldiers walking along the street and at young veterans as they stepped off the plane onto American soil. *Mass Media* did not help soothe the tension as it began live coverage of soldiers in battle in Vietnam.

In April of 1969, Apollo 11 launched into *space*, and the first humans landed on the moon. On June 28th, the Stonewall Riots erupted in New York City's Gay neighborhood due to unjust police harassment. The Stonewall Monument in the West Village is symbolic of the nation's first protest for Homosexual Civil Rights.

In that same year, **Lack**, one of Americas leading Realist painters founded Atelier Lack, A Studio School where he taught nineteenth-century French Formalism and Bostonian Impressionism.

At the same time, Flower Children threw flowers at servicemen and continued to hold peaceful sit-ins to protest the conflict in Vietnam. In August of that year, peace loving Hippies, Heads, and Flower Children attended the Woodstock Music and Arts Festival at Max Yasgur's farm approximately 100 miles due North of New York City.

Nonetheless, as the tension continued to grow at the dawn of a new decade, the Ohio State National Guard shocked the nation and fired into a crowd of disorderly student demonstrators at Kent State University. After the gunfire had stopped, four students lay dead, and a dark cloud loomed over the country.

Later that year, *African American Art* emerged in New York. In 1971, **Lennon** released the song titled Imagine, and a year later *Graffiti Art* hit the Bronx, a borough of New York City. As Flower Power grew, American Pop dominated the New York art scene while computer technology advanced at a rapid rate. After United States involvement in Vietnam ended in 1973, our war-weary troops started to come home to an unwelcoming America.

Even though President **Nixon** (1969-1974 CE) was a brilliant foreign diplomat, he resigned from office in 1974 to avoid an impending impeachment for his alleged involvement in the Watergate scandal. One year later, the fall of Saigon brought the Vietnam Conflict to a close.

Also In 1975. **Gates** and **Allen** converted computer programing language for use in personal computers (PC). Soon after, Microsoft was born. A year later **Wozniak** and **Jobs** gave birth to a PC environment called Apple.

Between Microsoft and Apple, the new computer environments would change the way Homo sapiens do business and how people would interact with each other. By the middle of the decade, the Post-Modern Art period came to an end.

Unregulated financial institutions send the nation into a Legendary Recession, subsequently the Federal Government places the brunt of the country's financial burden on the Middle Class. In the meantime, painters of the Avant-garde stop seeking truth in art.

The Second Millennium Ends

1976 saw the emergence of the *Moda Contemporary Art* period, while the United States began to celebrate its' bicentennial birthday in Washington, D.C. The festivities began at the Smithsonian Institution which opened an exhibition that replicated the World's Fair held in Philadelphia, one hundred years earlier.

Meanwhile, movements such as New Wave Art, Post-Abstract Expressionism, Punk Art and Feminist Installations descended upon the Art World. Consequently, members of the *Religious Right* began criticizing the *Visual Fine Arts Community*, complaining that *Performance Art* and the Studio Arts were immoral.

As the 1970's progressed, Hippies, Heads and Flower Children began to fade into the shadows. Some members of the Peace Genteration practiced Transcendental Meditation and began to levitate, transcending their resentment towards corporate America. Those who were more grounded found their mantra in the Om, and in *New Age Spiritualism*.

On November 28, 1978, San Francisco Mayor **Moscone**, and **Milk**, a Board Supervisor and Gay rights activist were assassinated. As the decade ended scientists continued to warn world leaders about the effects of global warming.

The 1980's began on a sad note when Lennon was murdered outside his apartment building in New York City. Along with this tragedy, HIV (Human Immune Deficiency Virus) and AIDS (Acquired Immune Deficiency Syndrome) surfaced in California and New York city. Alarmists within the Religious Right blamed the *LGB* community for causing the pandemic.

In the meantime, the new *Millennial Generation* entered infancy as politicians started to dumb down the Studio Arts by defunding art programs in public schools. During the same period, the *Outsider Art Movement* started to receive recognition from the mainstream art world and *Art Competitions* began to replace the intellectual pursuit for new concepts, styles or painting techniques.

In 1982 Lack coined the phrase Classical Realism, and assisted in founding the American Society of Classical Realism, while **Lin**, an Asian-American sculptor created the *design* for the Vietnam

Veterans Memorial in Washington, D.C., and **Haring** became a Neo-Pop icon.

In 1987, President **Reagan** (1981-1989 CE) authorized United States involvement in the Iran-Iraq War (1980-1988 CE) and without warning, the Dow Jones Industrial Average plummeted 508 points on October 19.

The economic conditions from 1987 through 1989 sent America into its worst recession since the Great Depression and would last through the next decade. To make matters worse, the Post-Industrial Age started to swing into full gear, as American production-based businesses continued to outsource jobs to third world countries.

By the end of the Reagan administration, the Cold War came to an end, and global society watched as the news media televised the Berlin Wall tumble down. In the last decade of the last century, a few events took place, which helped to set the stage for the arrival of the Third Millennium.

During the administration under President **Bush** (1989-1993 CE), America entered the Persian Gulf War (1990-1991 CE). However, in 1991, the Union of Soviet Socialist Republics collapsed, and the United Nations and President Bush assisted with the transition of the new Commonwealth of Independent States of Russia.

Meanwhile, corporate America began to downsize the workforce, making middle and lower management the scapegoats for losses incurred during the last decade. As a direct result of these actions, low-income and middle-income families suffered most during the recession.

In 1993, **Clinton** was elected the 42nd President of the United States (1993-2001 CE) and by the end of his second term; he had brought the country out of its recession. Except for a few minor conflicts in the Middle East, President Clinton kept America at peace, and had the longest era of economic expansion in United States history. These are just a few of the accomplishments by the Clinton/**Gore** administration.

Despite warnings by Vice President Gore, by scientists and other members of society, United States Senators and Congressmen continued to ignore the damage our planet, our home has sustained due to global warming. Global warming is the result of the

greenhouse gasses generated by an industrialized and fossil fuel driven culture. However, on the other side of the Atlantic Ocean European countries, such as Germany, were already utilizing alternative fuel sources.

Also during the 1990's, developers of innovative software technology created new programs for personal computers (PC and Mac) that made it possible for graphic designers to use *color models* to create *CyberArt*, Virtual Realism, and *Massurrealism*.

In 1999, Russian President Boris Yeltsin (b. 1931 CE) discharged Prime Minister Sergei Stepashin (b. 1952 CE), and promoted former KGB [1] officer Vladimir Putin (b. 1952 CE) to Prime Minister.

With the exception of a few painters such as Lack, Haring, **Chidish** and **Thomson**, the Studio Arts continued to stagnate as they had for the last quarter century.

As the last century of the second Millennium came to a close, people who believed in the Dooms Day theory predicted that all computers and financial institutions would crash at midnight on year 2,000.(Y2K)

On New Year's Day, Y2K came and went and no computer systems crashed, nor did the world economy. However, Putin was elected the President of Russia [2] in the same year.

[1] KGB - Komitet Gosudarstvennoy Bezopasnosti (The Committee of State Security), the world's most thorough information gathering agency until its demise in 1991 CE.

[2] Refer to authoritarian rule, page cxcii.

Society and the Avant-garde prepare to enter a new millennium, neither suspecting that a former host of a Television Reality Game Show would soon become President of the United States.

The Third Millennium

As civilization entered the third millennium, some members of the visual fine arts community continued to belittle the discipline of painting by escalating efforts to increase the number of Art Competitions that have no intellectual merit.

In January 2001, **Bush** was elected the 43rd President (2001-2009 CE). On September 11, 2001, al-Qaeda, a well-known terrorist group led by Osama bin Laden (1957-2011 CE) waged four separate attacks on the United States, murdering 2,996 people in New York City. Since then, the United States has been fighting terrorists in several Middle Eastern countries.

Even though President Bush had one of the lowest approval ratings of any exiting President, he did sign into law the No Child Left Behind Act, Medicare prescription drug benefits for seniors, and funding for AIDS relief.

In 2009, **Obama** was elected the 44th and the first African American President (2009-2017 CE) of the United States. On the day of his inauguration, Obama had one of the highest inaugural attendance records of any president with over 1.3 million attendees. As Commander-in-Chief, Obama brought bin Laden to justice in 2011, after a group of Navy Seals captured and killed the head of al Qaeda.

During their two terms in office, the Obama/**Biden** administration created the Climate Action Plan, and signed in several other reforms such as the long awaited Patient Protection and Affordable Care Act (Obamacare); and urged the Supreme Court to strike down bans on same-sex marriage as unconstitutional.

Despite societal advances, racism is very much alive in America. In 2012, George Zimmerman a White Hispanic shot and killed Treyvan Martin (1995-2012 CE), an unarmed African American youth. One year after the shooting, three activists, Alicia Garza (b. 1981), Patrisse Cullors (b. 1984), and Opal Tometi founded the Black Lives Mater Movement.

On May 26, 2016 Donald Trump (b. 1946 CE), a former host of the Celebrity Apprentice, whose tagline of You're Fired, became the GOP candidate for President of the United States. During his

campaign, Trump began to attack The Free Press[1] and Free Speech.

On September 1, 2016, Colin Kaepernick (biracial), a quarterback for the San Francisco 49ers, knelt on one knee during the National Anthem in protest of the social injustices against African Americans and other minorities. For the remainder of the NFL season many African American football players took a knee during the National Anthem. Trump said they should be fired (Nov. 2016).

Unfortunately, an uneducated or ill-informed public is a public easily controlled and manipulated. Consequently, to help secure votes Trump pandered to the wealthy, took advantage of naïve middle class Americans, promised he would create ten million jobs, and played to the emotions and fears of non-degreed, blue collar and low-income Caucasian Americans.

In the Presidential election held on November 8, 2016, Trump beat the Democratic candidate **Clinton**, **H**, former United States Secretary of State. On Friday, January 20, 2017, Trump was sworn in as the 45th POTUS. On the day of his inauguration, Trump had the lowest public approval rating of any incoming American President, and possibly one of the lowest inaugural attendance records of any president since President Nixon in 1973.

That same day, Trump signed Executive Order 1[2]. Minimizing the Economic Burden of the Patient Protection and Affordable Care Act (pending repeal). He signed this order without having a replacement health care program in place, which potentially could leave 20 million Americans without health insurance.

Trump's inauguration was a wakeup call for global society and the Modern Millennial Avant-garde. On that day, politically and socially aware personages and artists began to emerge worldwide in defense of Free Speech, in defense of women's and human rights, and against hate, racism and social injustice.

On January 21, the day after the inauguration, the million women march staged Anti-Trump protests around the world in over fifty different countries on all seven continents. In the United States alone, over three million women and men in all 50 states marched in protest against Trump's policies on abortion and women's innate human rights (with the support of millions behind them).

After one considers Trump's background as an executive of The Trump Organization, and a former game show host with no military, government or political experience, it is imperative that all Americans hold him accountable to uphold the solemn and sacred oath of the President, as stated in the United States Constitution, Article II, Section I [3].

Americans must also be vigilant and impress upon Trump that it is his sacred duty to uphold and defend the First Ten Amendments to the Constitution, known as the Bill of Rights, and particularly the First Amendment. Without the First Amendment, citizens would not have freedom of speech, which grants citizens the right to defend the 2^{nd} - 10^{th} Amendments, and Amendments 11 - 27.

On March 16, with the entire world watching, Trump presented Congress with a preliminary proposal for the White House Budget for 2018. The purpose of this budget; escalate military spending and build The Wall, while sacrificing America's infrastructure [4].

Trump also proposed to eliminate the NEA, and the NEH. The purging of both agencies is tantamount to dumbing down the Humanities, censoring the Arts, and eliminating jobs filled by the working middle class. During his campaign, Trump promised never to let the middle-class down.

In regards to the Arts at state and local levels, politicians and school boards continue to dismantle and/or shut down Performing and Studio Arts programs in public education systems. This places the financial burden of purchasing art materials on underpaid teachers, and cash-strapped low-income and middle-class families.

Believing Global Warming to be a myth, Trump has set out to dismantle everything put into place to protect the environment by early twentieth century progressives on both sides of the aisle.

Trump unfortunately, has chosen to put the future of humanity in jeopardy by ignoring the capabilities of EPI and SRE. In addition to this Trump has dismissed the fact that SRE sources already employ over two million people worldwide, and that SRE has the potential to create millions of jobs in the United States.

Despite this, on March 28, Trump signed an Executive Order to rescind Obama's Climate Action Plan. Following this, Trump withdrew The United States from the Paris Climate Accord.

Unable to grasp the Big Picture of an evolving global community, and incapable of comprehending the significance of the Black Lives Matter Movement, Trump exacerbated the racial divide in the United States. On May 24, 2018, Trump censured African American citizens without any concern for their the First Amendment rights. "You have to stand proudly for the National Anthem or you shouldn't be playing (football). You shouldn't be there. Maybe you shouldn't be in the country."

As he struggles to shield Putin and Russia from the Democratic process, Trump uses daily tweets and live video to alienate longtime Mexican, Canadian and EU Allies, to disparage The Free Press, to antagonize U.S. voters and to drive a wedge between U.S. bi-partisan assemblies. These actions are reprehensible, and his communiqués exemplify a lack of desire to be a POTUS for all Americans.

Similarly, religious and government leaders around the globe have yet to conceive a viable strategy that promotes peace and helps diverse cultures to coexist without the need for violence or *war*.

Nevertheless, 2018 is a pivotal election year for both the GOP and the Democratic Party; however, it also marks the one hundred and fifty fifth anniversary of the *Art Revolution*.

While devotees of the Moda Contemporary and Modern Millennial Avant-garde create *Blue Art,* they continue to grapple with the restraints of finding venues to reach the general populace. Contrary to this, members of the visual fine arts community continue to eliminate objective art exhibitions, and replace them with *Retinal Art* competitions.

As history repeats itself on many levels, the social order and members of the visual fine arts community need to be reminded that a painting like society, should not be judged by its visual appearance alone.

Having descended from ancestral cave-dwelling artists, painters (visual historians) continue to stand watch, ready to capture the essence of humanity.

[1] The Free Press, page cxci

[2] Executive Orders, page clxxxviii

[3] United States Constitution, page clxxxvi

[4] Federal Government Infrastructure, page clxxxvii

Art with an Attitude

Section II
The Avant-garde

Chapters

Revolution and Modern Art
Post Modern Art
Neo-Post Modern Art
Moda Contemporary Art
Modern Millennial Art

Having found their voice, artists of the Avant-garde realize their *raison d'être* is to capture the essence of humanity.

Revolution and Modern Art

1863 The *Art Revolution* begins in Paris and *Le Salon des Refusés* opens its doors to the public.

1870 c. *Modernism*: A philosophical movement affecting the Arts and Sciences emerges in the Europe.

1870 c. *Modern Art* emerges in the European art community.

1872 *Aestheticism*: A concept and style of painting developed by Whistler.

1872 *French Impressionism*: A concept, style of painting and movement developed by **Monet**, **Renoir**, **Sisley**, and **Pissarro**.

1876 *Atomizer* (a.k.a. the first airbrush): Patented by the Stanley twins.

1877 *Naturalism*: A style of painting conceived by Cézanne.

1880 *American Impressionism*: A Post-Impressionist movement involving prominent painters such as **Butler**, **Twachtman**, and **Weir**.

1880 *German Impressionism*: A Post-Impressionist movement involving prominent painters such **Corinth**, **von Hofmann**, **Liebermann**, and later joined by **Slevogt**.

1880 *Expressionism*: A style of painting developed by van Gogh (painter), the Father of Expressionism (German Expressionism and French Expressionism).

1884 *Divisionism*: A concept, painting technique, and style of painting conceived by Seurat (painter and theorist).

1885 Paint manufacturers begin to offer professional artists a new product, pre-mixed Oil Paint in metal tubes.

1888 Synthetism: A bold style of painting influenced by Expressionism and Polynesian Primitivism, conceived by Gauguin (painter), also used by **Bernard** (painter).

1890 *Art Nouveau*: An international movement that embraced both the Arts and Crafts. Three of the movements' forerunners were ***Toulouse-Lautrec*** (Illustrator, painter, and lithographer), **Gallé** (glass designer) and **van de Velde** (architect and designer).

1890 c. *Deutsch Jugendstil*, German Art Nouveau had two phases. The first phase had a soft floral style to it, the second having a hard streamlined edge.

1890 Modern Symbolism: A painting style developed by **Munch** (painter) and **Denis** (painter and theorist).

1890 *Les Nabis*: A movement in France involving painters such as **Bonnard**, Denis, and **Vuillard**.

1891 *Pointillism*: A short-lived Post Divisionist movement, technique and style of painting.

1891 Naive Primitivism: A bold, colorful painting style developed by **Rousseau**, known by his contemporaries as Le Douanier (the customs officer).

1891 *Société Des Vingt*: An ad hoc group of Belgian artists founded by **Ensor** (painter and lithographer) and Munch (painter).

1893 Naturalism in Architecture: An American movement conceived by **Wright**, (architect).

1898 *French Expressionism*: A Parisian movement, better known as Fauvism, and led by Matisse.

1898 *Austrian Expressionism*, Vienna Secession: A movement founded by **Klimt** (painter and printmaker), involving both Arts and Crafts.

Note Two late entries to the Modernist Movement came from **Chagall** and the Grupo dos Cinco.

1913 c. Near the end of the *Modern* Era, Chagall created a Modernist Judaica style of painting that he would use throughout his career in mosaics, stained glass and for book illustrations.

1922 Brazilian Modernism: A movement involving artists who broke away from traditional Brazilian principles, and promoted Neo-Brazilian idealism that was relevant and indigenous to a Modern Brazil,.and which affected the visual fine arts, performing arts, architecture, and the literary arts.

Key members of the movement were known as the Grupo dos Cinco (Group of Five), **Amaral**, **Malfatti**, **Picchia**, **M. Andrade**, and **J. Andrade**.

In a sometimes harsh and imperfect world, the Avant-garde seeks balance, revealing their truth to humanity.

Post-Modern Art

1905 *German Expressionism*, the first faction: A short-lived movement and style of painting that started in Dresden.

1907 *Cubism*: Even though Braque and Picasso never discussed the *framework* behind Cubism, the Parisian Cubist movement embraced all disciplines in the Studio and Literary Arts.

1907 *Munsell Color System* emerges in the US.

1909 Cubist Sculpture: A style conceived by Picasso and utilized by **Duchamp-Villon** early in his career.

1909 *German Expressionism*, the second faction: A movement and style of painting started in Munich. Some of Munich's Avant-garde included Kandinsky, Macke, Marc, **Münter, von Jawlensky**, and von Werekin.

1909 *Futurism*: Conceived by **Marinetti** and influenced by Cubism, this painting style and movement involving the Arts and Literature emerged in Italy.

1909 *Luchism*: A concept and painting style that was influenced by Futurism and Cubism, and was conceived by **Larionov**, and his wife, **Goncharova**.

1910 Non-Objectivity, *Non-Objective Art*: A concept and painting style conceived by Kandinsky.

1911 The *First Exhibition of the Editors of The Blue Rider* was a group exhibition comprised of works by Arp, Bloch, Braque, **Deráin**, Kandinsky, Kirchner, Klee, Macke, Marc, Nolde, and Picasso.

1911-12 *Collage*, of Cubism: An art form developed by Picasso.

1911-13 *Synchromism*: An American movement, concept, and style of painting conceived by **Macdonald-Wright** and **Russell**.

1912 *Papier Collé*, of Cubism: An art form developed by Braque.

1912 *Imagism*: A British Literary movement: Involving poetry and founded by **Pound** (critic, poet, and writer).

1912 *Section d'Or*: Golden Section: A Parisian group of artists working with Cubism. Refer to Golden Ratio.

1913 *Construction*: Of Cubism, an art form conceived by Picasso.

1913 *Constructivism* (Konstrucktivizm): A Russian movement, concept, style of painting and style of architecture designed by **Tatlin** (Painter, sculptor, architect, and art-engineer).

1913 *Ready Made*: conceived by Duchamp (painter and sculptor).

1913 *Orphic Cubism*: A Parisian movement and style of painting influenced by Cubism and developed by **Apollinaire** (art critic, poet, and writer).

1913 *Metaphysical Art*: A concept and painting style developed by de Chirico (painter and sculptor). Four years later de Chirico and **Carrà** (painter) founded Metaphysical Art, which became the forerunner of Surrealism.

1913 Simultaneous Representation: During this period, Picasso began to in incorporate continuous line drawings into his paintings. A style also used by Braque, **Gleizes** (painter and author), **Gris** (painter), **Le Fauconnier** (painter), **Metzinger**, **Villon** (painter and lithographer).

1913 Simultaneity: A style of painting similar to Simultaneous Representation and used by **Delaunay**, Duchamp, **Kupka**, **Léger**, **Lhote**, **Marcoussis**, and **Picabia**.

1913 *Suprematism*: Conceived by Malevich.

1913 c. Gleizes and Metzinger pen their treatise titled Cubism.

1914 *de Stijl*: Meaning "The Style," known as Neo-Plasticism: A Dutch movement, concept, and style influenced by Non-Objective art, and founded by Mondrian, van Doesburg, and **Vantongerloo**.

1914 Vorticism: A concept and style of painting and sculpture influenced by Imagism, Cubism, and linked to Futurism. The intent behind Vorticism was to render and emulate the ideals of Industrialism. **Gaudier-Brzeska** (sculptor), **P. Lewis** (painter and writer), and Pound all developed the idea.

1915 *Photomontage*: A German movement and technique: Conceived by **Heartfield** (photographer and publisher) and, **Grosz** (painter, lithographer, and writer).

1916 *Dada*: **Ball** and **Hennings** introduced this *multi-media* anti-war/anti-art movement, which erupted in Switzerland and, a new kind of war spread across Europe.

1918 New Objectivity (Neue Sachlichkeit): Influenced by society's cynical attitude following World War I, this German movement, concept, and style of painting focused on hard line portraiture and objective corporeality. Members of the movement included **Beckmann, Dix,** and Grosz.

1918 *November Group*: Founded by **Pechstein** and **C. Klein**.

1918 Purism: A style of painting that renders linear perspective hard-edged contour lines of architectural and design objects using pure Black and White, greyscale and monochromatic colors. Founded by Ozenfant (painter/writer) and Le Corbusier architect/painter

1919 *Bauhaus*: founded by Gropius (architect).

1920 Realistic Manifesto: Brothers **Gabo** and **Pevsner** present their concept concerning Constructivism and break away from Tatlin's group.

1920 Found Objects: of Construction: Conceived by **Schwitters,** painter, writer sculptor publisher, and photomontagist. The idea was to take everyday objects believed to have an *intrinsic value* or an artistic aesthetic and turn them into an art form.

1920 Harlem Renaissance: An African American movement involving the Studio and Performing Arts and Literary

Arts: A major figure in this Renaissance was **Douglas** (painter).

1920 Société Anonyme, Inc.: A group founded by **Dreier, Man Ray,** and Duchamp. The intent being to promote the Studio Arts and Literature with a focus on social reform.

1920 c. Precisionism a.k.a. Cubic Realism: Influenced by Cubism and Futurism, this American movement involved the industrialized hard edge style of painting. A few Precisionists were Sheeler, **Demuth,** and **Berresford**.

1922 With its roots, stemming from Picassos Construction **Barnes** creates his first installation.

1924 **O'Keeffe** creates a new style uniquely her own, with her first large-scale painting of a flower titled *Petunia, No. 2*.

1924 c. *Automatism*: A drawing technique developed by **Masson**.

1925 *Surrealism*: A Studio Arts and Literary movement founded by Benton (art critic, poet, and theorist).

1925 *Art Deco*: An international movement which had a widespread influence on the visual fine arts, the commercial and design arts, and film.

1929 *Alkyd Paint*: A new type of paint developed in Germany.

1930 *Concrete Art*: A term coined by van Doesburg and defined in the Manifesto of Concrete Art.

1930 Mobiles and their counterpart, Stabiles: A new sculptural style conceived by **Calder** (ceramist, painter, sculptor, toy maker, illustrator).

1933 Body Painting: As an art of spiritual expression, body painting began thousands of years ago with Tribal Cultures from around the globe. However, **Factor Sr.** founder of Max Factor and Company stunned the audience at the Chicago World's Fair when he painted the nude body of his model Sally Rand (1904-1979 CE).

1934 Free Forms: A new sculptural style conceived by Arp.

1936 American Abstract Artists: A few of the founding members of this organization were **Bolotowsky**, **Diller**, **Lassaw**, **Shaw**, and **Opper** (painter).

1936 Biomorphic Form: A new painting style developed by Arp and **Miró**. Barr, Jr., an art historian, provided the neologism of Biomorphic Form.

1937 Picasso completes the painting titled *Guernica*.

1937 *Degenerate Art* Exhibition opens in Germany.

1937 Painting children and angels at the age of ten, **Keane** creates her own style, later known as Big Eyed Waifs.

1938 c. *Op Art* (Optical Art) conceived by **Vasarely**.

1942 **Herbin** develops L'alphabet plastique, a new pictorial language coordinating numbers, geometric and free-form shapes, and color.

1945 c. Lettrism (France): Influenced by Dada, **Isou** created this movement involving the Literary Arts.

1946-49 *Magna Paint* (NY, NY): Developed by S. Golden while working at his uncle's company, Bocour Artist Colors.

1946 The Manifesto Blanco: **Fontana, Lucio** an Argentinean sculptor and painter pens his Manifesto giving rise to the Italian *Spatialism* Movement.

1946 *Action Painting*: A concept, technique, and style of painting associated with Pollock (painter).

1947 c. *Tachisme*: A concept, technique, and style of painting very similar to Action Painting.

1947 c. *Abstract Expressionism*: An American Post Expressionist movement.

1947 *Spatialism* (Spazialismo): An Italian movement founded by Lucio Fontana and **Joppolo**.

The next generation of the Avant-garde continues to challenge society and social norms.

Neo-Post Modern Art

1950-59 c. Bocour, Utrecht and Liquitex, pioneers in paint manufacturing develop *Acrylic Polymer Paint* and *Mediums*.

1950 *Paint by numbers*: **M. S. Klein**, an engineer and owner of Palmer Paint Company and **Robbins** an artist invented the first painting by numbers kit.

1950 **Kerouac** publishes his first novel titled The Town and The City.

1952 *Pop Art* often referred as Neo-DaDa: The British movement was conceived by **Blake** (painter), and Paolozzi, the Patriarch of Pop (painter and sculptor).

1953 **Hefner**, publisher/political activist launches the controversial men's magazine called Playboy.

1954 Lyrical Abstraction: A style of painting derived from Abstract Expressionism.

1954 New Brutalism: A British architectural movement: Conceived by **Smithson** (architect) and **Smithson-Gill** (architect).

1954 Neo-Illustrationism: **Neiman**, a commercial artist collaborating with Playboy magazine takes Illustrationism to a new level with a bold, and colorful style some call Neo-Expressionism.

1955 Hefner publishes the controversial short story by **Beaumont** titled The Crooked Man.

1955 **Ginsberg** publishes the controversial poem titled Howl.

1955 *Pop Art*: East Coast Neo-Dada emerges from two of New York's Avant-garde, Johns, and Rauschenberg.

1955 Johns completes a series of Flag paintings,

1955 Rauschenberg develops the *Combines*.

1955 c. Conceptual Art or *Conceptualism* emerges in the art world as a new art form.

1957 *Pop Art*: The West Coast movement emerges with **Bengston** leading the way upon a giant wave.

1957 c. Situationists: A French political movement whose members were critical of the Arts and Capitalist society. Two of the more prominent members were **Debord** (Marxist poet) and **Jorn** (painter, ceramicist).

1957 Happening, the: **Kaprow** deconstructs the physical nature of Art believing it to be more than just an objet d'art to be hung on a wall. It is something ephemeral, something that Hippies later adopted as an impromptu get together, party or Happening.

1958 Packages and Wrapped Objects: Any object, ranging from personal items to buildings, which are wrapped using a variety of materials. **Christo** (installationist) and his wife **Jeanne-Claude** (installationist) conceived the concept.

1958 **Holtom**, a British artist, creates the International Peace symbol by placing two flag semaphore letters N and D, inside a circle.

1959 The Second City opens in Chicago, IL: Founded by **Sills**, **Alk**, and **Sahlins**. This small cabaret becomes the most prolific and influential comedy theatre in the universe, well, at least for another 15 years.

1959 **R.G. Davis** establishes the *San Francisco Mime Troupe*.

1959 *Minimalism*: A movement begins further affecting the style of painting, sculpture, and music.

1960 c. *Fluxus*: A Neo-Dada international multi-media movement founded by **Maciunas**.

1960 c. Video Art: *Performance Art* on video emerges in New York. **Paik**, the Father of Video Art, coined the phrase "Electronic Super Highway" in 1974.

1960 *Nouveau Réalisme*: A response to American Pop Art by French and Italian artists.

1960 c. *Post-Painterly Abstractions*: A genre used as an umbrella to describe several distinct concepts and/or styles of painting.

1960 c. *Décollage*: A technique developed by the Nouveau Réalistes and considered the opposite of creating a collage.

1960 The Beatles emerge in London and begin to re-shape the sounds of music. Dubbed the Fab Four, the band members were **Harrison**, Lennon, **McCartney** and **Starr**.

1961 With the installation titled Roxy's, **Kienholz** (installationist and sculptor) takes this genre to a new level of shock art.

1961 c. Pop Art begins to take a different course of action with artists such as **Lichtenstein**, **Warhol**, and **Segal**.

1961 *Comic Strip Art*: **Lichtenstein** takes a different approach to Neo-Pop Art and painting.

1962 **Dylan** writes a song about the changing social norms, titled Blowin In The Wind.

1962 The British invasion continues with the Rolling Stones, the Bad Boys of Rock-n-Roll. The original members of the band were **Jones**, **Stewart**, **Jagger**, **Richards**, **Wyman**, and **Watts**.

1962 *Digital Computer Art* emerges, Conceived by **Noll**, a pioneer in Art Engineering.

1963 Dylan releases the song titled Blowin in the wind.

1963 *HyperRealist-Printmaking*: Warhol a Neo-Pop graphic artist, photographer, and filmmaker opens The Factory in New York City.

1963 Soft Sculpture: American Pop: A form of sculpture conceived by **Oldenburg** (sculptor).

1963 c. Funk Art: A concept and movement that emerged in California involving ceramics and *Mixed Media* works that

attempted to bring about social accountability by using humor and bawdiness.

1963 c. **Close** develops a large-scale grid painting process called *Photo-Realism*.

1964 Cut Pieces: A Performance Art piece by **Ono** debuts in Japan, and focuses on non-violence against women.

1964 Cubist Folk Sculpture: Pop Art: A form of sculpture conceived by **Marisol** (sculptor).

1964 *Soak Stain* Painting: A concept, technique, and style of painting conceived and dubbed by Frankenthaler (painter).

1964-65 Supersized Art: Rosenquist (painter, graphic artist) starts work on the anti-war painting titled F-111 (10' X 86').

1965 c. *Airbrush* painting emerges in the Studio Arts with artists such as Castellon.

1965 Davis (SFMT) pens the Guerilla Theater Manifesto.

1965 c. M. S. Klein develops a textured surface with painting knife and brush strokes already in the canvas.

1966 c. Segal creates a new sculptural casting technique he called Plaster Bandages.

1966 Experiments in Art and Technology: Established to bring art and engineering together, and founded by **Kluver**, Rauschenberg, **Whitman,** and **Waldhauer.**

1966 *Tactile Art*: Art for the blind emerges.

1967 The Youth International Party, better known as Yippies, emerges in New York City. Founded by Abbie and Anita **Hoffman**, **Kurshan**, **Krassner**, and **Rubin**.They were the counter-culture, to the counter-culture. The Yippies were a non-violent, anti-war, politically minded, street theater group known for their satirical pranks at political functions.

1968 c. After Duchamp's death, his disciples a.k.a. *Duchampians*, declare the discipline of painting to be dead.

1968 c. Max transforms Illustrationism with his use of bold Psychedelic colors.

1968 The Harlem invasion erupts with The Last Poets, a group of political/civil rights activists. Founding members and the Grandfathers of Hip Hop and Rap are **Kain**, **Luciano**, **Nelson**, **Nuriddin** and **Oyewole**.

1968 **Zagar** and his wife Julia open the Eyes *Gallery* on South Street in Philadelphia, PA. That same year, Zagar completes his first Folk Art mosaic.

1970 *African American Art* emerges in America.

1970-78 **Skiles** starts WAR, an acronym for Women Artists in Revolution. A feminist movement created to counter a male dominated art scene.

1971 Lennon releases the song titled Imagine, as a single.

1971 *Tactile* Dome: A sensory installation involving the Arts and Science opens in San Francisco, California.

1972 c. *Graffiti Art*: Presently known as Street Art, a style of exterior wall painting and movement that originated in the Bronx, N.Y.

1974 The Dinner Party (1974-79 CE): An installation depicting the social history of women in Western civilization, created by **Chicago** (installationist and sculptor), with the aid of volunteers.

1975 Saturday Night Live: **Michaels** creates a Hip new program televised throughout the galaxy. Well, maybe not the whole galaxy.

1975 *Contemporary American Folk Art* emerges.

1975 *Ruralism*: An ideology developed by a group of seven artists who moved from an urban life in London to rural life. The artists were Blake, **Haworth**, **A. Arnold**, **G. Arnold**, **A. Ovenden**, **G. Ovenden**, and **Inshaw**.

Painters from the *Moda* Contemporary Avant-garde and society are lulled into quiet slumber.

Moda Contemporary Art

1976 c. *Mobile Electronic Art* emerges in San Francisco.

1976 New Wave: A movement involving music and art emerges in England, but does not become popular until the 1980's. A style of painting that became the forerunner to *Massurrealism*.

1976 Punk: A Neo-Angst movement involving music and art emerge in England.

1978 Fashion Moda: Founded by **Eins** in Bronx, N.Y.: An art education center and incubator for Graffitist and Neo-Pop artists.

1979 Poetry Slam: A Post-Beat movement involving Performance Art emerges in New York.

1980 c. **Hockney** (painter/photographer) produces a Polaroid photomontage he dubs Joiners.

1982 **Lin**, an Asian-American sculptor designs the Vietnam Veterans Memorial in Washington, D.C.

1982 Haring, a leading advocate for safe sex, a graphic artist, and neo-pictographic painter becomes a Neo-Pop icon.

1986 Opray **Winfrey** becomes the first African American female to host a syndicated daytime talk show on a network television station.

1987 Dimensionalism: An Italian Movement founded by **Pierelli** (sculptor). For the most part, this sculptural movement involved the exploration beyond hyperspace and addressed the *barriers* and boundaries believed to be present in three-dimensional space.

1989 *November Events* or the Velvet Revolution emerges in Czechoslovakia.

1992 *CyberArt*: A Post-Neo-Pop art form emerges in America.

1992 *Giclée*: (1992 CE): A high-resolution, *fine art* printing and reproduction process emerges.

1992 *Interactive Art*: A Post-Neo-Pop art form emerges in America.

1992 *Massurrealism*: A computerized painting program that sends images through *Cyber-Space* emerges.

1993 Politically Incorrect with Bill **Maher** makes its debut on Comedy Central television network and revolutionizes the talk show format.

1995 *Rapid Prototyping*: A new technique developed in America for creating three-dimensional sculptures.

1995 Artists Against Racism: A movement born in Canada of **Cherniak** and **Mendelson Joe**

1998 The Sonny Bono Copyright Term Extension Act is an extension for most original works. The term of copyright protection extends to the life of the author, plus seventy years after the author's death.

1999 Chidish and Thomson pen the Stuckist Manifesto and start the Stuckist anti-anti-art movement.

Trump awakens the Modern Millennial Avant-garde.

Modern Millennial Art

2001 Water miscible and solvent free oil paints have been around for generations. However, the binding mediums were inadequate for studio use. With the development of reliable solvent free binders, there has been a renewed interest in water miscible oil paints.

2002 Movement for Classical Renewal Manifesto: An anti-abstract, anti-conceptualist movement conceived by **Fiddes**, a British painter.

2003 The Ellen **DeGeneres** Show airs on television. DeGeneres is the first female Comedic Commentator, in a field dominated by males, to secure a daily syndicated broadcast.

2015 Stephen **Colbert**, a comedian and political satirist takes over as host of the Late Show on CBS.

2015 Full Frontal with Samantha **Bee** airs on cable television. In a field dominated by male comedic political commentators, Bee is the first female Comedic Activist to secure a weekly broadcast dedicated to political satire.

2017 The United States is a Great Nation, but the Red and Blue need to work together to make America smart again.

Shaken and confused by the reality of a Game Show Host being elected President of the United States, the Avant-garde recovers and confronts The Party of Trump with movements such as Artists Against Trump Now, Artists Against Hate, Artists Against Racism, and Artists Against Social Injustice.

If the younger generations want the Silent Generation and Baby Boomers to retire from politics, they need to start grooming members of their own generation to take their place.

and The Beat goes on

Art with an Attitude

Section III
Reference Material

Index of Terms
Glossary
Artists and Personages

Index of Terms

A

Abstract	40, 90
Abstract Art	40, 90
Abstract Art Movement	43, 91
Abstract Expressionism	43, 91
Academia	35, 92
Acrylic Polymer Paint	46, 92
Acta	19, 93
Action Painting	43, 93
Activist	47, 93
Aestheticism	36, 93
African American Art	49, 93
Airbrush	36, 94
Alkyd Paint	42, 94
Alla Prima	35, 94
Alternative Art Space	35, 95
American Abstract Artists	43, 95
American Folk Art	30, 95
American Impressionism	36, 96
Architect	15, 96
Artisan	15, 96
Artist	14, 96
Artiste	29, 96
Art Competition	56, 96
Art Critic	14, 98
Art Deco	42, 98
Art Movement	41, 98
Art Nouveau	37, 98
Art Period	14, 98
Art Revolution	35, 99
Art World	29, 99
Arts and Sciences	18, 99
Assemblage	101
Atomizer	35, 101
Attitude	14, 101
Austrian Expressionism	40, 101
Automatism	69, 101
Avant-garde	35, 101

B

Baby Boomer Generation	43, 102
Barriers	35, 102
Bauhaus	41, 102
Beat, The	46, 103
Beatniks	46, 103
Beat Generation	46, 103
Blue Art	59, 103
Boundaries	18, 104
Braque	40, 104

C

Capital	34, 104
Casein Paint	26, 105
Collage	40, 105
Color Models	54, 105
Color Wheel System	105
Combines	72, 106
Comic Strip Art	74, 106
Commercial Arts	46, 106
Concept	16, 106
Conceptual	14, 106
Conceptualist	15, 107
Conceptual Art	46, 107
Concrete Art	69, 107
Construction	26, 107
Constructivism	67, 107
Contemporary	16, 108
Contemporary American Folk Art	76, 108
Contemporary Art	16, 108
Content	41, 108
Copyright	30, 108
Crushed Relief	108
Cubism	40, 108
CyberArt	54, 109
Cyber-Space	79, 110

D

Dada	41, 110
Décollage	74, 111
Degenerate Art	47, 111
Design	52, 112
De Stijl	41, 113
Deutsch Jugendstil	63, 113
Dictator	19, 113
Digital Computer Art	47, 113
Discipline	13, 113
Divisionism	37, 113
Duchamp	41, 114
Duchampians	46, 114

E

Egg Tempera	23, 114
Electromagnetic Theory	35, 115
Enamel	17, 115
Enamel Paint	37, 115
Encaustic Paint	18, 115
Engineer	15, 116
Expressionism	34, 116

F

F-111	47, 117
Fibonacci Sequence	26, 117
First Exhibition of the Editors of the Blue Rider	40, 118
Fluxus	47, 118
Formalism	35, 118
Framework	66, 119
French Expressionism	40, 119
French Impressionism	36, 119
Fresco	26, 121
Frontality	16, 121
futhark	43, 121
Futurism	40, 122

G

Gallery	76, 123
Generation X	47, 123
Genre	27, 123
German Expressionism	40, 123
German Impressionism	62, 124
Germanic Religion	17, 124
Gesso	27, 125
Giclée	79, 125
G.I. Generation	40, 125
Glazing	29, 126
Glassine	126
Global Warming	44, 126
Golden Ratio	27, 126
Gouache	23, 127
Graffiti Art	49, 127
Grayscale	37, 128
Grassroots Artist	40, 128
Guernica	43, 128

H

Hieroglyphics	16, 130
High Arts	102, 130
High Relief	130
HyperRealist-Printmaking	74, 130

I

Iconoclasm	22, 131
Illuminations	23, 131
Illusionism	18, 131
Imagism	67, 132
Impasto	29, 132
Installation	48, 132
Interactive	14, 132
Interactive Art	79, 132
Intrinsic Value	68, 133
Intuitive	14, 133
Intuitive Art	23, 133

J-L

Jazz	37, 133
Julian Calendar	19, 134
L'Academie des Beaux-Arts	35, 134

L'Art Brut	43, 134
Les Nabis	63, 134
Le Salon des Refusés	35, 135
LGB	52, 135
Light, Dimension of	29, 135
Linear Perspective	27, 137
Literary Arts	48, 137
Low Arts	102, 138
Low Relief	130, 138
Luchism	40, 138

M

Magna Paint	43, 138
Mainstream	46, 138
Manet	120, 138
Mass Media	48, 139
Mass Production	34, 139
Massurrealism	54, 139
McCarthyism	46, 140
Media	23, 140
Medieval Period	23, 140
Medium	26, 140
Metaphysical Art	41, 140
Middle Relief	130, 141
Millennial Generation	52, 141
Mind's Eye	109, 141
Minimalism	73, 141
Mixed Media	74, 141
Mixed Media Relief	142
Mobile Electronic Art	78, 142
Moda	77, 142
Moda Contemporary Art	52, 142
Modern	35, 142
Modernism	62, 142
Modern Art	35, 142
Monochromatic	37, 142
Mosaic	23, 142
Multi-Media	68, 143
Munsell Color System	40, 143
Museums	18, 143

N

Naturalism	36, 145

New Age Spiritualism	52, 145
New York School	46, 145
Non-Objective Art	40, 146
Nouveau Réalisme	73, 146
November Events	78, 146
November Group	41, 147

O

Oil Paint	28, 147
Op Art	47, 147
Opposition Party	58, 148
Original	30, 148
Orphic Cubism	41, 148
Outsider Art	52, 148
Outsider Art Movement	52, 149

P-Q

Paint by Numbers	46, 149
Paintbrush	15, 149
Painting, Discipline of	13, 149
Painting Knife	29, 152
Papier Collé	66, 153
Pastels	14, 153
Performance Art	52, 153
Performing Arts	36, 153
Photomontage	68, 154
Photo-Realism	75, 154
Picasso	40, 154
Pissarro	62, 155
Pointillism	63, 156
Pop Art	46, 156
Post-Modern Art	40, 156
Post-Painterly Abstractions	47, 157
Prehistoric	14, 157
Primary Light Colors	106, 157
Propaganda	42, 157
Public	48, 158
Pure Alla Prima	94, 158

R

Rapid Prototyping	79, 158

Raison D'être	61, 158
Ready Made	67, 158
Realism	27, 158
Relief	15, 158
Relief-In-Reverse	159
Religion	17, 159
Religious Right	52, 159
Representational	14, 159
Retinal Art	46, 160
Ruralism	76, 160

S

Salon	36, 160
San Francisco Mime Troupe	46, 160
Secco	16, 161
Section d'Or	67, 161
Self-Taught	14, 161
Sense	29, 161
Silent Generation	42, 162
Soak Stain	47, 162
Société Des Vingt	37, 162
Space	48, 162
Space-Time	40, 163
Spatialism	70, 163
Studio Arts	13, 163
Style, Dimension of	18, 163
Sumi	19, 165
Sumi-e	19, 165
Suprematism	38, 165
Surrealism	42, 165
Synchromism	66, 165

T

Tachisme	70, 165
Tactile Art	75, 166
Tactile Dome	76, 166
Technique	16, 167
Term	30, 167
Textural	126, 167
Three-Dimensional Quality	108, 167
Time	16, 167
Title	27, 168

Toulouse-Lautrec	63, 168
Trilogy of Painting	37, 169
Trompe-l'œil	22, 169

U-V

Under-Drawing	94, 169
Under-Painting/Over-Painting	92, 169
United States Capitol	30, 170
United States Congress	30, 170
Utilitarian	96, 170
Visionary Art	23, 170
Visual Art	102, 170
Visual Communication	92, 170
Visual Fine Arts Community	36, 171

W-Z

War	17, 171
Watercolor	14, 172
Wet-In-Wet	30, 172
White Light Spectrum	29, 172

Glossary

A

Abstract (c. 1994) A detachment from a single occurrence of something specific. In the United States alone, the term Abstract has several meanings, of which have been amended several times since 1910. This is also the circumstance for most written languages.

Depending on the school of thought, the following interpretations of this term are in relationship to the Studio Arts, the discipline of painting in particular.

1: Abstract A style of painting in which the *content* is not hindered by the perceived barriers or boundaries of a 3-dimensional universe.

2: Abstract: A term that serves as an umbrella [a] for all styles of Abstract painting.

[2a]: The following are examples of various styles: Abstract Expressionism, Action Painting, Color Field Painting, Geometric Abstractions, Hard-Edge Painting, Lyrical Abstractions, Non-Objective, Post-Painterly Abstractions, Stain Painting, Suprematism, and Tachisme.

With the exception of Non-Objective, Hard-Edge Painting and Suprematism, the remaining styles have been condensed into a single genre known as Abstract Expressionism.

3: Abstract: The deliberate or unconscious act involving the partial or complete fragmentation [a] of a corporeal or imaginary subject.

[3a]: This may include the creation of completely obscure, unidentifiable content.

Abstract Art: (Post-Modern Art): Between 1910 and 1913, two different theories relating to Non-Objective Art emerged in the art community. Kandinsky approached the process of painting as a visceral action/reaction, a philosophy that appeared in his treatise conceived in 1910.

The other hypothesis, regarding the visceral action/reaction to socio/religious events, surfaced in Malevich's manifesto on Suprematism in 1913. As a point of interest, the complex theories by both artists seldom refer to the term Abstract.

At this time, American and European artists were developing their own concepts and styles of painting. Nevertheless, the attitude behind the formulation of all new art forms soon became synonymous with the term Abstract Art.

During World War I, DaDa was born, and artists began to declare war on war itself, they declared war on wealthy society, they declared war on art, and they declared war on other artists and their concepts. After the death of Dada, the term abstract art became an umbrella for any art form that was non-representational.

Abstract Art Movement (Munich, 1913 CE): Artists such as Larionov, Kupka, Malevich, Kandinsky, Mondrian, and van Doesburg began working with Abstract concepts at about the same time. However, many consider both Kandinsky and Malevich as the Fathers of Abstract Art.

Abstract Expressionism (c. 1947 CE) is a neologism that would become the umbrella term for several painting styles. Shortly after World War II, New York Abstract Expressionists brought international acclaim to the American art scene for the first time in art history. Various philosophies, ranging from German Expressionism to Zen Buddhism influenced members of the Avant-garde from the New York School.

The commonality among the Abstract Expressionists concerned the development of ideas relating to individualistic attitudes regarding art, life, spontaneity, and most importantly, non-representational form. Due to the wide range of philosophical approaches to painting, no particular style dominated this movement.

The New York School of Abstract Expressionists consisted of painters such as **Bacon, de Kooning-Fried, de Kooning, Frankenthaler, Gorky, Gottlieb, Guston, Kline, Krasner, Motherwell** (painter and writer), **Opper, Pereira, Pollock, Rothko, Twombly,** and **Tworkov**.

Academia: (c. 386 BCE): Of or relating to a community of colleges, universities, and art schools/academies involved with education, teaching, and research. Plato founded The Academy, one of the first academic institutions known to man. The core values of academia have not changed in over 2400 years.

Depending upon the institution, academicians, following Aristisle's lead have divided formal education into the Arts and Sciences. The Arts refer to 1: *Visual Fine Art*, 2: *Visual Communication*, 3: *Studio Arts*, 4: *Performing Arts*, 5: *Literary Arts*.

The Sciences have been divided into 1: Astronomy, 2: Biology, 3: Botany, 4: Cosmology, 5: Mathematics, 6: Medicine, 7: Physics, 8: Psychology, and Philosophy which incorporates Metaphysics, Governmental Theory, Logic, Ethics, Rhetoric, Theology, Political History/Theory.

Refer to Arts and Sciences,

Acrylic Polymer Paint (c 1959 CE): In 1855, acrylic acid was developed. In 1936 acrylic resin was developed, followed by Magna Paint in 1947, and from this, Acrylic Polymer Paint and Mediums were created in the mid to late 1950's.

As a type of paint, acrylics consist of a dry powder color pigment mixed with water based clear synthetic polymer binders. Blended these materials make a soft, butter-like consistency. Although water will thin out acrylic paint and mediums when they dry, they become a hard plastic that is impervious to water. Some Acrylic Polymer Paints are unaffected by ultraviolet light and have a high tolerance to arid or humid environments.

More than a few surfaces are suitable for an acrylic painting. A few examples are; glass, metal, Plexiglas, textiles and wood. Anything with an oily surface is undesirable for acrylic painting. Acrylics, painted over oil-based *under-paintings* may appear to adhere to each other.

However, an adverse chemical reaction will eventually occur and will cause permanent damage to the painting. Except for water miscible oil paint, blending acrylic and conventional oil paints together is not a good idea.

To clean a soiled or dusty Acrylic Painting use only a soft damp sponge or lint free cloth. Also, it may be possible to repair a painting with a scratch (not gouged). In either case, consult with a professional conservator experienced with Acrylic Polymer Paints.

Acta Even though examples of the Acta do not exist prior to 59 BCE, it is believed that when the Senate was in session, someone would write down matters of importance, similar to the minutes of a business meeting.

Action Painting (1946 CE): A concept, technique, and style of painting created by Pollock. Even though Pollock did not name or have a concept in mind at the beginning, this painting technique driven by a visceral attitude involved the use of dripping, pouring, spots, blotches or splashes of colored paint on large un-stretched canvases laying on the ground or a table. Six years after Pollock developed his abstract painting method, **Rosenberg**, an art critic dubbed the technique Action Painting. Refer to Abstract Expressionism.

Activist: Of or relating to a person who speaks up for, or supports a cause, whether it be political or social.

Aestheticism (c. 1872 CE): A concept known as l'art pours l'art (Art for Art's Sake). As one of the Parisian Avant-garde, Whistler had a very different attitude towards art and aesthetic values. Whistler's later paintings, regarded as representational, render a preview of forms brought about in works by German Expressionists.

An example of Whistler's expressionism lies in the body of works from his Nocturne period (1870-1880 CE). These works are mostly night scenes, which Whistler painted from memory.

Along with his artistic achievements, Whistler was recognized for transforming the decor and ambiance of prominent Parisian and London Salons. Refer to alternative art space, German Expressionism, Expressionism, French Impressionism, Naturalism, *Salon*, and Pissarro

African American Art (c. 1970 CE): After the assassination of civil rights leader, Dr. King, Jr. African Americans launched a concerted campaign to develop a feeling of pride and to raise the consciousness of the African American community.

This movement involving ceramics, dance, graphic arts, literature, music, painting, sculpture, and theater, demonstrates a positive influence African Americans have had on American culture over the last 225 years.

A few members of the African American Avant-garde and forerunners of the movement were **Artis**, **Burke**, **Catlett**, Douglas, **Du Bois**, **McCann**, and **Porter**.

Airbrush (c. 1876 CE): Initially, the airbrush was developed from the Stanley brother's atomizer. As airbrush technology advanced in the 1930's-50's this device was becoming popular with commercial artists. However, the airbrush was unreliable and would not be suitable for commercial and studio artists until the 1960's. Castellon, a studio artist was an early pioneer of the airbrush.

The new airbrush is a small tool that looks something like a pen and operates by using compressed air. The typical airbrush was manufactured with stainless steel components to prevent rusting. It has an atomizer at the tip, which sprays various media such as ink, dye, and paint from a small container/jar attached to the body of the tool. Refer to Atomizer.

Alkyd Paint (Germany, c. 1929 CE): A material originally developed for house painting. For easel painting purposes, it is a mixture of oil modified synthetic resins containing oil based binding and drying mediums. Alkyds can be thinned using oil based mediums or a solvent such as turpentine.

Alkyd paints have an unfavorable tendency to discolor (yellow) with age. It is recommended alkyd paintings not be touched as the oil and grime from the human hand can cause further discoloration or permanent damage to the work.

Alla Prima: Of or relating to an oil painting technique that was popular in Europe during the 19th century. Alla Prima is a term used to distinguish an oil painting from a watercolor painting.

An alla prima painting will have a slight *under-drawing* or *under-painting*, whereas, the *Pure alla prima* painting will have no under-drawing or under-painting, The focal point of this technique is the final affects and effects which are achieved in the initial and only application of paint.

As is the case with many techniques, a few modifications have developed over the years. These new techniques are:

1: alla prima mixed media, 2: impasto alla prima, 3: impasto alla prima mixed media, .4: Pure alla prima, 5: Pure alla prima mixed media, 6: Pure impasto alla prima, 7: Pure impasto alla prima mixed media,

With the arrival of Acrylic Polymer Paints in 1959, the alla prima technique regained popularity with experienced artists. Considering both acrylic and oil paints have their advantages and disadvantages, the use of either medium depends upon the demands of each artist. Refer to Watercolor and Wet-in-Wet.

Alternative Art Space (Paris, 1863 CE): Le Salon des Refusés was the first alternative art space established for emerging and little known artists. In recent years, however, art galleries, established artists, and art organizations have begun to occupy popular alternative art spaces, thereby limiting the venues for emerging and little-known artists.

Despite this, it is quite common for the public to become acquainted with little known/emerging artists and neoteric artworks before mainstream culture. A few contemporary alternative art spaces are:

1: artists studios, 2: commercial buildings, 3: cafes, 4: coffee houses, 5: cultural centers, 6: fringe launderettes, 7: government buildings, 8: performing arts theaters, 9: pop-up galleries, 10: public libraries, 11: recreation centers.

Refer to Le Salon des Refusés.

American Abstract Artists (New York, 1936 CE): This is one of, if not the first group in America that focused on the creation of Abstract Art. A few of the founding members were Shaw, Diller, Bolotowsky, and Lassaw.

Other members included Albers, **Browne, Browne-Bengelsdorf, Cavallon, McNeil, Moholy-Nagy, Morris, Louis**.

American Folk Art, Folk Art (c. 1776-1876 CE): 1: Craft items made by hand, such as pottery, dolls, knitted items and cloth made on a loom, and quilts. Struck by the originality and artisanship of the crafts made by native Africans, American

artisans began to fashion some of their craft works after Primitive African Art. Refer to Contemporary American Folk Art.

American Impressionism (c. 1880 CE): American artists to follow the lead of French Impressionism, and began working with the effects of natural light or personal impressions were Butler, Twachtman, and Weir.

Architect (Mesolithic Period (c. 8000-6000 BCE): Constructing rock shelters, Anatolian/Turkish artisans become humanities first architects. An architect is an individual who designs, plans, constructs or oversees the construction of a structural dwelling or commercial space.

Artisan: A title reserved for an individual who creates works of fine crafts having both *utilitarian* and intrinsic values. Such works include furniture and ceramics. Some works may have only an aesthetic purpose. Refer to Title.

Artist (c. 40,000-10,000 BCE): A descendant of the cave dwelling artist. The title of Artist is reserved for the individual working in the *Studio Arts*, and who creates a work with an aesthetic and/or intellectual purpose. Refer to Title.

Artiste: A descendant of the artist and artisan. A title reserved for an individual who performs, creates or composes works in the *Performing Arts*. Refer to Title.

Art Competition (origin unknown): With a few minor changes, the twenty first century art competition is almost identical in structure to that of the selection process of l'Academie des Beaux-Arts, in Paris, France leading up to 1863.

Once a year l'Academie sponsored an Official Salon, of which artists were permitted to submit work for exhibition. Controlled by wealthy collectors and privileged socialites, an indiscreet and subjective selection committee chose the artwork. Paintings showing non-conformity, new styles and/or techniques were always rejected.

Weary of this blatant elitism, Parisian artists who recognized the injustice of this process, made a request of Napoleon III (1808-1873 CE) to sponsor and to establish a new alternative exhibition space known as Le Salon des Refusés. These events

paved the way for future artists to present new concepts, styles, and painting techniques.

During the latter part of the nineteenth to mid twentieth centuries, many artists fought against conventionalism, many of whom were adamantly opposed to the art competition construct. These artists however, did challenge their own creativity, and often competed against each other on an intellectual level by developing new concepts, new styles and/or new painting techniques.

Despite this, some members of the Moda Contemporary Visual Fine Arts Community decided to dumb down the Studio Arts. The neo-art competition has once again become a regulatory and subjective selection process, which serves to promote intellectual stagnation, and the dehumanization of both the artwork and the artist.

Forgetting about the sacrifices made by Modern Arts Forefathers, or simply not caring, some painters seek to gain recognition, not for creating new concepts or new styles, but for winning awards similar to those given in 4-H or canine competitions.

Similar to 4-H and canine competitions, art competitions give out awards at the discretion of a judge or selection committee. These awards are; the prize for Honorable Mention, a 3rd place ribbon, a 2nd place ribbon, and one prized Blue Ribbon for 1st place. The only medal missing from the art competition is the Holy Grail of all awards, the Purple and Gold ribbon for Best in Breed.

Another difference between the 4H/canine competitions and the art competition is the artist who wins the coveted Golden Ribbon for Best in Show, does not prance around with his/her painting in front of the audience, although some have been known to strut. While this entire process may sound like material for a satire/comedy skit, the Blue Ribbon seeking painter takes the subjective art competition very seriously.

Aside from this, some competitions require the artist to pay an entry fee (ranging from a few dollars per painting to thousands of dollars). Lastly, some competitions require the artists to sign a release in which they forfeit all rights to their own work (including copyrights), and without compensation.

Ironically, the Neanderthal cave dwelling artist had a higher purpose behind the creation of his/her wall paintings than the ribbon seeking painter.

Art Critic (c. 40,000 BCE): A person who lends their opinion, analysis, or interpretation of a work created by an artist, artisan, artiste or by an author. The third-millennium art critic no longer hits people over the head with a club to give their critique. To provide their reviews, the professional art critic now uses hard print and on-line news media, hard print art publications, and/or blogs sent by Hyper Text Transfer Protocol (HTTP).

Art Deco (c. 1925-1939 CE): An international movement intended to reflect contemporary thought, attitude and design which affected film, architecture and industrial design, interior and fashion design, and the decorative arts involving painting and graphic arts. Art Deco paintings are defined by their hard edge compositions.

Art Movement: An art movement is a mysterious entity. A movement can be a spontaneous effort lead by a single individual or by a group. It can also be an organized endeavor started by one person or a group that has developed, believes in or advocates for a particular concept, theory, philosophy, style or technique that pertains to the creation and communiqué of art.

An Art Movement can be an organized effort in which performing and studio artists use their particular art form to lobby against or show favor for a particular cause.

Art Nouveau, New Art (c. 1890-1920 CE) often called the Decorative Arts. A widespread movement in Europe, which rejected current trends of mass production, and which sparked new creativity in architecture, craft design, furniture design, painting, printmaking, sculpture, and textile art.

A painting in the Art Nouveau style is defined by its soft, floral, curvilinear and flowing compositions. Some of Art Nouveau's forerunners were Galle, **Guimard**, Klimt, **Majorelle** van de Velde), and **Abbott**. Refer to Mass Production.

Art Period: The names and timelines of an era, age or period may change based upon the author, historian or academic institution. For example, at the time of their creation, French Impressionist paintings were referred to as both modern and contemporary. In

the 20th century, Cubism was simultaneously referred to as Modern, Post-Modern, and Neo-Post Modern.

Keep in mind, trying to group together all the names of artists, materials, techniques and terms into a single period is similar to attempting to define a single generation with one or two words.

For the express purpose of this text, the timelines from 1850 to present have been broken down into five periods.

1: Modern Art: 1850-1900 CE

2: Post-Modern Art: 1901-1949 CE

3: Neo-Post Modern Art: 1950-1975 CE

4: Moda Contemporary Art: 1976 to 2000 CE

5: Modern Millennial Art: 2001-Present

Art Revolution (Paris, 1863 CE): A non-violent, artistic counter-offensive aimed at individuals, groups, institutions, theories and/or philosophies which attempt to bully, censor, oppress or regulate the public voice, or the creation, communiqué and/or exhibition of a discipline or genre within the Studio Arts, paintings in particular.

Note: Because no individual actually stood up and declared, "Let the Art Revolution begin," some members of the visual fine arts community contend that this rebellion is a myth.

Refer to Le Salon des Refusés, DaDa, Guernica, F-111 and War.

Art World: 1: Also known as the World of Art, 2: Of or relating to the culture involved with the visual fine arts community.

Arts and Sciences: In 386 BCE, Plato, Mathematician, and Philosopher founded The Academy in Athens, Greece. Here, Plato and Aristotle, Scientist and Philosopher held discussions on subjects concerning epistemology (the theory of knowledge), and various philosophies concerning ethical, political, and metaphysical issues.

After Plato's death, Aristotle left Athens, only to return twelve years later. Meeting at the Lyceum, Aristotle and his students

(both wealthy and poor) continued their exploration into subjects regarding:

1: The Arts (music, painting, poetry and sculpture).

2: The Sciences (astronomy, biology, botany, cosmology, mathematics, medicine, physics and psychology).

3: Philosophy (metaphysics, governmental theory, logic, ethics, rhetoric, theology, political history and theory).

In the year 83 BCE, the Academy founded by Plato closed its doors due to the death of Philo (153-83 BCE), who was the head of the Academy. For the next 327 years, philosophers no longer affiliated with any academic institution, continued to teach any student with a desire to learn. In 410 CE, The Academy re-opened.

In 529, Justinian I (b. 482-565 CE) the last Roman Emperor (527-65 CE) aimed to eradicate Greco-Roman education or any academy that competed with The Church and closed Plato's Academy permanently.

The Church having control over education allowed only the wealthy to receive instruction in the Arts, Sciences, and Philosophy. During this era, Christian monks rejected the conceptualism found in Illusionism believing only in spiritual expression or intuitive art, and the symbolism found in the Illuminations.

During the Age of Enlightenment (1194-1600 CE), a rejuvenation of the Arts transpired with the emergence of Humanism and the establishment of England's Oxford and Cambridge Universities. All through this period, society's elite continued to establish museums, art academies, and universities in France, Great Britain, and Italy.

However, believing they were intellectually superior to an indigent and desolate public, academicians, aristocrats, and museum curators presumed that only they could fully appreciate the aesthetic values of the Arts.

In France, during the 18th century, the Arts were re-termed Les Beaux-Arts (The Beautiful Arts) by French philosopher **Batteaux**. In a rudimentary form, Les Beaux-Arts referred to the

aesthetic appreciation of music, painting, poetry, and sculpture. Also, see Academia.

Assemblage: This term refers to interchangeable genres such as Collage, Construction and/or Installation.

Atomizer (1876 CE): the Stanley twins patented the first airbrush. However, it would take another 30 years for engineers to perfect the new airbrush so it would be somewhat useful as a painting tool. See Airbrush.

Attitude: A term used to describe the stance/posture of a male/female figure that is depicted in a statue, sculpture or painting.

An attitude is neither positive nor negative, neither good nor bad. A person's attitude is merely the reflection of that individual's thoughts or emotions, which are expressed through various physical/verbal means and/or use of media. At present, the word attitude has a negative connotation.

Austrian Expressionism, Austrian Expressionismus (c. 1897 CE): Also known as the Vienna Secession. Founded by Klimt, the goal of the Secessionists was to approach and explore art from outside academic boundaries.

Automatism (c. 1924 CE): A drawing technique developed by Masson in which the subconscious creates the content of a work. After Masson became associated with the Surrealist Movement, so did this technique.

Contemporary Surrealists continue to use Automatism as a means of communication. While Surrealists do not like to admit it, this style of drawing closely, resembles Simultaneous Representation created by Picasso.

Avant-garde (c. 1450 CE): This term refers to an individual or to a group of intellectuals who stand up to authoritarian rule, who create authentic/original works, develop groundbreaking and/or experimental concepts within the Literary Arts, Performing Arts, Studio Arts, and the Sciences. Contrary to popular belief, when it come to the Avant-garde, educational background is irrelevant.

B

Baby Boomer Generation (c. 1945-1965): It is impossible to generalize an entire generation. Therefore, the description for each generation within the glossary regards mainstream cultures.

The Baby Boomer Generation is a complex group that is constantly redefining itself. It is a living organism comprised of approximately 76 million human beings. Many Boomers were part of the Hippie and activist cultures of the 1960's and 70's, and helped pave the way for future generations to make their voice heard, Even though Boomers have a very strong loyalty to country, they know they need to watch, and stay on top of government issues.

Refer to The Beat, The Beat Generation, Generation X, Millennial Generation and Silent Generation.

Barriers: 1: Often thought of as something, such as three-dimensional structures/objects, that impedes one's physical movement or journey. 2: Imaginary/mental blocks or actions taken, that restrict physical movement, or prevent an activity to take place or impedes the thought process.

Bauhaus (Weimar, Germany, c. 1919-1933 CE): After the establishment of the Weimar Republic in 1918, Gropius became the director of the Weimar School of Art. In 1919, he restructured the school, which became an experimental school of art and architecture called the Staatliches Bauhaus.

Like the Cubists and Futurists, Gropius wished to raise the public's perception of art by not making any distinction between the *High Arts* and *Low Arts*. He later added classes in furniture design, weaving, and typography to the school's curriculum.

Due to rising political pressure In Weimar, Gropius moved the Bauhaus to Dessau in 1925. In 1930, Gropius appointed **van der Rohe** (architect and furniture designer) as the new Director of the school, who in turn moved the Bauhaus to Berlin. In 1933, the Nazi Party forced van der Rohe to close the Bauhaus doors.

A few instructors dismissed from their posts were: Albers, **Bayer**, Beckmann, **Breurer**, **Feininger**, Gropius, **Itten**, Kandinsky, Klee, **Marcks-Stiftung**, **Meyer**, Moholy-Nagy, **Muche**, **Schlemmer** and van der Rohe.

After the Bauhaus had closed, Albers headed to America where he continued to teach Bauhaus concepts at Black Mountain College in North Carolina. Later in 1950, he became the Chairman of the Department of Design at Yale University in New Haven, Connecticut.

In 1937, Gropius left Germany and founded the New Bauhaus School of Design in Chicago, Illinois. Having appointed Moholy-Nagy as the Director, Gropius went on to Harvard University in Cambridge, Massachusetts where he taught until 1957.

Resulting from a lack of financial support, Chicago's New Bauhaus School of Design went bankrupt. In 1939, Moholy-Nagy opened the School of Design, later becoming the Institute of Design, which became an affiliate of the Illinois Institute of Technology. Moholy-Nagy remained the Institute's Director until his death in 1946.

Beat, The (c. 1950-1959 CE): A term used by Kerouac to describe the experimental Bohemian lifestyle, and the intellectual and philosophical journeys concerning his group of friends. Having an affinity for hanging out in New York City's Greenwich Village, the original core group of The Beat consisted of Kerouac **Burroughs, Cassady, Corso, Huncke, Orlovsky, Holmes,** and Ginsberg. Members of the Avant-garde were born in during the G.I. Generation (c. 1901-24 CE) or the Silent Generation.

Beatniks (c. mid 1950's - early 1960's): Beatniks, Kool Katz, and Hipsters, were young adults (18-25) that were poets, writers, artists and musicians who were influenced by The Beat and lived a Bohemian and intellectual lifestyle. They are often stereotyped or portrayed as comical characters.

Beat Generation, The (c. 1950-1964 CE): The Beat Generation refers to tweens, teenagers and young adults who still lived at home but were influenced by The Beat or were creative-minded individuals with a penchant for the literary, performing and/or studio arts.

Blue Art (2017 CE): A work or works of art created to stimulate the mind. The word blue invokes many thoughts that engage the mind, and sentiments associated with emotion. Nevertheless, the word blue is internationally and culturally diverse in meaning.

In addition to this, the word blue is often associated with art or music. For these reasons, the idiom Blue Art was chosen.

Boundaries: Often thought of as defining the fixed borders of a geographical area or the limitations of something either tangible or imaginary.

1: Boundary: A conceptual boundary can be defined by a single 1-dimensional line having two finite ends, or as one infinite line such as a circle. A circular line may be viewed as the contour line of a 2-dimensional shape, which may be the silhouette of a 3-dimensional sphere.

Braque, Georges (13 May 1882-31 August 1963 CE): As a young teenager, Braque attended L'Ecole des Beaux-Arts in Le Havre, France. Moving to Paris when he turned eighteen, Braque enrolled and studied at L' Academie Humbert. Soon after this, he started painting in the French Impressionist style.

After meeting Matisse, Braque began working with Fauvism and joined the Fauvist movement. However, he was not completely satisfied with Fauvist ideas and began to break away from the group. However, Braque was impressed by the concepts involving Naturalism and Divisionism.

In 1907, Braque began working with a new concept soon to be known as Cubism. That same year Apollinaire introduced Braque to Picasso, and the two began working together immediately. However, neither artist approached their work from an abstract perspective. Braque and Picasso continued with their collaboration until the war broke out in 1914.

Even though Braque had enlisted, he understood Picasso's position as a pacifist. After the war, Braque and Picasso remained good friends, and over the course of both artists lifetime, their work continued to evolve. Refer to Cubism, Divisionism, French Expressionism, French Impressionism, Naturalism, and Picasso.

C

Capital: 1 Of or relating to financial assets, an upper case letter in an alphabet. 2 The city or town, which houses the Capitol Building that holds the official legislative seat of government.

Nine cities have held the esteemed title Capital of the United States of America. The first city being Philadelphia, PA, 2: Baltimore, MD, 3: Lancaster PA, 4: York, PA, 5: Princeton, NJ, 6: Annapolis, MD, 7: Trenton, NJ, 8: New York, NY, and the last being Washington, District of Columbia.

Casein Paint (Germany, Romanesque Period 1000-1150 CE) was used mainly for fresco and mural painting. In regards to painting on canvas, the paint is a mixture of pigments and a casein binder of milk protein and is water miscible. The binding medium, however, is inflexible and becomes increasingly brittle with age.

If applied to textiles, or too thickly on rigid panels the paint will eventually flake or crack. Consult with a professional conservator who is experienced with Casein paints, if a painting becomes soiled. For additional information regarding the care and storage of Casein Paintings, refer to painting.

Collage a.k.a. Assemblage (Paris, 1911-12 CE): The forerunner to Mixed Media. A collage is a work of art created by using various materials and by interweaving disciplines and techniques. Building on Cubism, Picasso began to use items typically not thought of as artist materials and created the Collage titled Still life with Chair-caning.

In this work, Picasso painted the letters JOU (of the journal) and pasted oilcloth to a cubist painting framed with rope. In later paintings, he added everyday household items such as postage stamps, bits of paper and small pieces of aluminum foil.

Color Models: Computerized color models using HSL (Hue, Saturation, and Lightness) or HSB (Hue, Saturation, and Brightness) or RGB (Red, Green, and Blue).

Color Wheel System (1687 CE): Newton developed the first color circle. At present, paint manufacturers, artists, teachers and instructors across the globe use the Color Wheel System. It is a chromatic theory involving three primary pigment colors. These three hues are displayed on the Color Wheel, in three sections. Starting at the top of the Color Wheel, and moving clockwise 1: Yellow, 2: Blue, and 3: Red.

Three secondary pigment colors shown in between the three primary Hues are 1: green, 2: violet and 3: orange. There are also six intermediate colors, which fall between the primary and

secondary colors. They are 1: Yellow Green, 2: Blue Green, 3: Blue Violet, 4: Red Violet, 5: Red Orange, 6: Yellow Orange.

Adding black or white pigment to a hue will darken or lighten that hue. Incrementally mixing black and white pigments will produce shades of gray.

Personal Note: *Primary Light Colors*, Light, Electromagnetic Theory, and the White Light Spectrum have established that both Black and White are not colors

Combines (1955 CE) A genre developed by Rauschenberg. A combine is type of collage, which combines painting and sculpture.

Comic Strip Art (1961 CE): A concept, technique and style conceived by Lichtenstein (painter and graphic artist): A style similar to the comic strip section of the newspaper, where the images of the subject are Supersized.

Commercial Arts: Of or relating to an educational institution offering a curriculum in graphic design, digital design and illustration for both hard copy and cyber books, periodicals, and/or advertising.

Of or relating to a business offering services in graphic design, digital design and illustration to businesses that utilize advertising, or to publishers of books and periodicals.

Concept: **1**: An idea or a thought conceived in the mind, intellect. **2**: (*visual art*) a concept is an idea developed and based upon a belief, philosophy or attitude which affects the approach to painting by a single artist or group of artists.

One of the objectives of a new concept is for the audience to experience different ideas and styles of painting. The development of a concept involves how and/or why it affects the creation of a new style and/or technique.

Consequently, the neology of a concept, style or technique will have some relation to the work as a whole. Refer to Cubism, Divisionism, Soak Stain Painting and style.

Conceptual: 1: The formulation of a thought, 2: Consisting of or relating to an idea or concept created in the mind/intellect. 3:

(philosophy) An approach to analyzing a theory or concept and involves the study of relative arguments or statements in order to gain a better understanding, or appreciation of that particular subject.

Conceptualist: 1: Of or relating to a person who can visualize or formulate a complex thought. 2: A person who creates conceptual art.

Conceptual Art or Conceptualism (c. 1955 CE, Philosophy): Some credit this concept to Duchamp, some credit American Neo-Dada/Pop artists, while still others believe it evolved from artists like Kaprow. In any case, the intent behind this art form is to focus on, and convey a particular idea, rather than to concentrate on the physical work itself.

Concrete Art (1930 CE) is a term coined by van Doesburg, who continued to search for the pure art form. The intent of Concrete Art was to remove the human element from the design process. The content of a work (painting or sculpture) should be devoid of any human emotion, sentimentality, symbolism, sensuality, lyricism, 3-dimensional qualities, and must lack anything derived from nature. The content must contain only two elements, surface (2-dimensional shapes) and color. Van Doesburg, **Carlsund**, **Hélion** and **Tutundjian**, all believed Concrete Art to be a pure art form.

Construction: Of or relating to the act of building a structure. Of or relating to Sculpture, Assemblage or Installation (1913 CE): Taking the idea of the Collage one-step further, Picasso created the first Construction titled Bouteille et Guitare. The Construction took place in front of double doors to a coach house, which served as a frame for the 3-dimensional work.

Materials consisted of lumber, a wooden shipping crate (approximately 3' x 8' x 6'), a cowbell, wire, a fedora and a cone shaped object. Photographed in 1913, this work, however, no longer exists. Refer to Cubism, Collage, mixed media, Papier Collé and Ready Made.

Constructivism, Konstrucktivizm (Russia, 1913 CE): Initially known as Tatlinism. Conceived by Tatlin, Pevsner, Gabo and **Rodchenko**, Constructivism was a movement which concerned painting and architecture that promoted the use of the Arts for

practical and social purposes. Constructivists rejected the idea of independent art and Whistler's concept of Aestheticism.

Contemporary: Of or relating to something or someone of the same period.

Contemporary American Folk Art or Contemporary Americana (c. 1975 CE): Artworks influenced by American Folk Art, and Early American Memorabilia. Works ranging from doll making to sculpture to knitting-to quilt making.

Contemporary Art: This term can be confusing when not used in the proper context of the period. An artwork created in 1907 was called both contemporary and modern art. Refer to Contemporary.

Content Something that is contained within fixed boundaries, such as the text within a book. Content is often described as subject matter, which in turn may refer to the title or theme of the painting. However, a title or theme may not necessarily pertain to everything that is rendered. In this instance, content pertains to everything that is portrayed in a painting.

In essence, content is the heart and soul of any painting. It is one of the most difficult or challenging dimensions (of style) to bring to realization, as it relies entirely on the execution of the design and technique.Refer to Style, Design and Technique.

Copyright (1790 CE): A copyright is a means of protection provided by the laws of the United States for authorship of original works. The copyright last throughout the authors' life. However, in 1998, through the Sonny Bono Copyright Term Extension Act, the time-line of the copyright (for any applicant/s), was extended throughout the author's lifetime and, and seventy years after death. Said author/s of a copyrighted original work has the sole right to reap the fruits of his/her labors, and/or intellectual creativity.

Crushed Relief: Of or relating to relief engraving technique, of which the projection of a shape barely exceeds the thickness of a piece of 20-pound paper. Refer to relief and *three-dimensional quality*.

Cubism, Cubisme (c. 1907-1924 CE) sometimes referred to as Conceptual Reality: The patriarchs of Cubism are Braque and

Picasso. Inspired by Picasso's painting, "Les Demoiselles d' Avignon," Braque began formulating ideas and working on paintings later called Cubism. Shortly after meeting, Braque and Picasso started working together almost every day until 1909.

In the early stages of their collaboration, both Braque and Picasso believed the creation of art did not depend upon pre-existing doctrines, challenged academics, museum curators, patrons, and art critics, all of whom often dictated to artists and the public what they thought art should be.

As their friendship and creative alliance progressed, they came to believe their work to be realistic, as it re-presented an objective perception of factual reality. Both Braque and Picasso believed their paintings to have a tactile quality that the *mind's eye* could perceive.

Two artists who painted in the Cubist style, and lent some insight into Cubist concept was Gleizes and Metzinger. In essence, their intent was to clarify how multiple planes of one or more subjects could be rendered simultaneously, and in relationship to the complexities of life.

Since neither, Braque nor Picasso wrote any books or papers regarding their work this was the closest thing to a written description of Cubism by any artist working with Cubism.

In 1913, the Cubists entered the Synthetic Phase depicting conceptual reality with a softer attitude. To accomplish this, the Cubists applied brighter colors and used less complex shapes. Artists that joined the Cubist movement were Delaunay, Dentin, Duchamp, Duchamp-Villon, Gleizes, Gris, Kupka, Léger, Le Fauconnier, Lhote, Marcoussis, Metzinger, Picabia, and Villon.

Growing weary of falling under the shadow of both Picasso and Braque, three artists, Delaunay, Duchamp, and Léger broke away from the Cubist group to follow Apollinaire and his theory of Orphic Cubism and helped found Section d'Or.

The following represent a few disciplines, concepts, styles, and techniques influenced by Cubism: 1: architecture, 2: collage, 3: construction, 4: drawing, 5: literature, 6: music, 7: painting, 8: sculpture, 9: Conceptual Art, 10: Constructivism, 12: Dada.

CyberArt (developer unknown, c. 1992 CE) PC or Mac based images created by using graphics software programs. The completed artwork is sent into Cyber-Space and accessible to viewers on web pages Also see, Massurrealism.

Cyber-Space (a.k.a. The Web): A 2-dimensional graphics-based environment where human generated phenomena exist and is accessible through software programs developed for electronic media such as computers tablets and Smartphones.

D

Dada, born in Zurich, Switzerland (1916-1924 CE) was an anti-war/anti-art movement that propagated itself through its pacifist and expatriated parents, Ball (Expressionist writer) and Hennings (Artiste/Chanteuse).

The birth of Dada was a spontaneous eruption of ideas that took place in a little, out of the way bar called Meierei. In a backroom of the bar, Ball named Cabaret Voltaire, he and Hennings held the first meeting attended by **Tzara** and the **Janco** brothers, along with other unknown persons. At Balls request, Arp and Huelsenbeck soon joined the group.

Fueled by their contempt for the glorification of war, the destruction of human life, and disgusted by the pompous attitude of the aristocratic Art World, the group set out to bring the Fine Arts to its knees by nullifying the aesthetic values of the elite.

For the first six months, a variety of experimental performances took place ranging from bizarre to Sudanese dance, and literary readings inspired by Futurist, Symbolism and German Expressionistic literature. The presence of the Avant-garde was on display through the 2-dimensional artwork by Arp, **Oppenheimer, Slodki, Giacometti,** and Picasso.

Later in 1920, Huelsenbeck published the Dada Almanac. Dada was everything, yet nothing. Dada, simply, was Dada. Essentially, the intricacies of Dada became a labyrinth of ideas, involving literature, music, visual art, and performance art.

Nevertheless, perceived as becoming anarchists and the ever-increasing negativism toward society eventually, both factions (literary and visual art) brought about Dada's demise. After reaching its zenith in 1924, Dada faded into the shadows of the

backroom whence it came, and all official Dada centers in Europe and America closed.

Some of the artists, artistes and authors involved with Dada during its eight-year run were Ball, Hennings, the Janco brothers, Tzara, Arp, **Ernst**, **Höch**, **Baargeld**, Duchamp, Man Ray, Picabia, Grosz, Heartfield and his brother **Herzfelde** who cofounded Malik Verlag, a Dada publishing house, and Schwitters who adapted Cubist concepts to the Dada magazine titled Merz.

Décollage (c. 1960 CE): A technique developed by the Nouveau Réalistes, which is considered the opposite of creating a collage. Instead of building up a work, it is a method of dismantling segments of existing work, such as a poster. The mutilation process involves ripping, tearing, and/or cutting the poster.

Degenerate Art, Entartete Kunst (1937 CE): In 1933, the ailing President of the Weimar Republic, von Hindenburg was pressured into naming Hitler as Germany's new Chancellor. Two months later the Reichstag (German Imperial Parliament) voted in favor of the Enabling Act.

Through the Enabling Act, Hitler received complete control over public affairs and made him the legal Dictator over Germy. Believing German art to be morally corrupted, Hitler placed the onus on German Expressionists and those associated with groups such as Dada, the November Group, and the Bauhaus. In essence, Hitler declared any work of art that did not depict the high ideals of the Aryan (pure Germanic) race to be Degenerate Art.

He then gave the Nazi Party complete control over Public Relations, the News Media and the Arts. The Nazis immediately began to implement National censorship campaigns and established the Degenerate Art Commission.

In 1933, the Nazis banned the creation of German Expressionism and proceeded to go on a witch-hunt starting with the artist **Schmidt-Rottluf**. The Party then dismissed Beckmann from his teaching position at the public Stadelschule, then dismissed Dix from his teaching post at the Dresden Academy, then dismissed Klee from his teaching post at the Dusseldorf Academy.

By the end of the year, the Nazis dismissed Albers, Gropius, Moholy-Nagy and van der Rohe from their posts and forced the Bauhaus to shut down and close its doors.

By 1937, the reform of German art had gained momentum, and all works by the German Expressionists vanished from all the museums in Germany. In July of that year, the Nazis held their official Degenerate Art Exhibition.

The purpose of the Degenerate Art exhibition was to incite public rage towards modern/contemporary art and to publicly humiliate artists such as Albers, **Barlach**, Beckmann, Braque, Chagall, Corinth, Dix, Ernst, Feininger, **Freundlich**, Grosz, **Heckel**, Kandinsky, Kirchner, Klee, Matisse, Mondrian, Muche, Nolde, Picasso, Schmidt-Rottluf, and von Hofmann.

Also included in the exhibition were works by **Kokoschka** and **Kollwitz**. Neither artist had any affiliation with the Austrian or German Expressionist groups. Another member of Austria's Avant-garde was **Schiele**.

In 1906, Schiele received his acceptance to the Academy of Fine Art in Vienna, two years prior to Hitler's rejection. Considered a form of Expressionistic Erotica, Schiele's work was included in the exhibition. Ironically, the Anti-Nazi and Anti-Fascist posters by Heartfield and Grosz were not included in the exhibition.

The exhibition displayed over Six hundred and fifty works. The paintings hung in poor light, with one painting overhanging another, and had derogatory comments put next to them. Forbidden to attend the exhibition, the Degenerate Art Commission thought the art they considered repulsive would poison the minds of children.

In Berlin, on 20 March 1939, the Degenerate Art Commission gave orders to burn approximately five thousand drawings, paintings, and watercolors. Over 10,000 works escaped this catastrophe, as they were auctioned off or stolen.

In 1945, Captain **Posey** and Private **Kirstein**, of the United States Army, and other solders known as the Monument Men began to retrieve priceless artifacts looted and pilfered by the Nazi Party, which numbered approximately 150,000. Not all works of art have been returned to their rightful owners or next of kin.

Design (General reference) 1: A drawing/sketch/layout of a garment and its intended appearance. 2: A drawing/sketch/layout for a monument, or a floor plan for a building. 3: A sketch for a machined mechanism, such as a screw.

In reference to painting: A design is a pictorial syntax or the process that is a key element in bringing the content of a painting to realization. This process involves drawing or making a sketch of the composition, layout or arrangement of the content and the color scheme. The painting technique may also be considered part of the design process.

De Stijl, The Style, a.k.a. Neo-Plasticism (1914 CE): A Dutch movement and style influenced by Non-Objective art. The originators of De Stijl are Mondrian and van Doesburg (painter). Members of this Avant-garde group were advocates of Pure Abstractionism.

Their method involved reducing content down to the most fundamental components. They accomplished this by using horizontal lines, vertical lines, minimal shapes, and only the three primary colors. They also incorporated black and white in their compositions.

Deutsch Jugendstil, German Art Nouveau (1890-1913 CE): Essentially, German Art Nouveau had two phases. The 1^{st} phase had the soft floral and curvilinear look to its international counterpart. Two Jugendstil artists were **Behrens** and **Eckmann**.

The 2^{nd} phase took place shortly after the turn of the century. At this time, van de Velde and others decided to give the Arts and Crafts more of a hard edge appearance.

Dictator: Of or relating to a person who has absolute power over a country's government, military and press. This literally means Human Rights are suppressed, there are no elections for legislative bodies such as congress, governors or mayors, the nation becomes a Police State, and there is no Free Press.

Digital Computer Art (1962 CE) Using a digital computer Noll created a new art form/genre by transforming algorithms into artistic visual images. Three years later two German pioneers working with digital computer would join Noll, they were **Nake**, and **Nees**.

Discipline: Of or relating to the concentration and/or study within a specific field.

Divisionism (c. 1884 CE): In 1884, Seurat painter/color theorist began working with the concept, technique, and style of painting he called Divisionism. Influenced by the chromatic theory developed by the chemist Chevreul, Seurat developed his own concept and began to paint with harmonic and contrasting colors using minuscule brush strokes.

Viewed from a distance, these brush strokes appear to be small dots of color. Part of Seurat's concept was that he relied on the viewers optic nerves to blend this division of colors together.

Seurat also relied on the natural response of the optical nerves to create the image as a whole. Refer to French Impressionism, and Color Wheel System.

Duchamp, Marcel (1887-1968 CE): Two years after creating his first Ready Made, Duchamp moved to America in 1915, leaving the Cubists, Orphic Cubists, and the Section d'Or behind. However, Duchamp made frequent trips to Europe during World War I, and decided to join the Dada movement in 1917.

In 1921 Duchamp, Man Ray, and Picabia, a rabid anti-representationalist, led the movement that introduced Dada to the New York art community. After the death of Dada, Duchamp distanced himself from the movement, and devoted most of his time to playing chess. Refer to Cubism, Construction, Dada, Orphic Cubism, Ready Made and Section d'Or.

Duchampians (c. 1968 CE): A self-described moniker by people who believe/d Duchamp was the true voice of Dada. Many of his disciples also believe/d Dada never died, and made Duchamp their muse for "shock" art. Shortly after his death in 1968, Duchampians deemed the discipline of painting to be dead. However, Duchampians found/find Abstractions to be the only acceptable style of painting.

E

Egg Tempera or Tempera Paint (Medieval Period): A water miscible paint in which color pigments are dispersed in an emulsion of 1: egg yolk and water, 2: egg yolk, water, and glue, or 3: egg yolk, casein, water, and glue.

Until the development of Oil Paints in the 15th century, Egg Tempera was the primary media of the day.

Electromagnetic Theory (1861 CE): Scottish Physicist Maxwell creates the first color photograph, and formulates his Electromagnetic Theory involving the wavelengths of the White Light Spectrum. The Electromagnetic Theory shows that electric and magnetic fields move in waves at the speed of light. When these two fields are perpendicular to each other, their point of intersection creates the Electromagnetic Field/Wave.

There are seven fields within this spectrum. Each field is made up of measurable wavelengths and frequencies. One of the fields within the ES is visible light. The wavelength of each primary light color is listed under the term of *Light*.

Black and White do not have electromagnetic wavelengths. Therefore, they are not colors. Light or the lack of light will produce either a warm hue or a cool hue. To produce a pale hue, add light, to create a dark hue, subtract light.

Refer to Color Wheel System, Primary Light Colors, Light, and White Light Spectrum.

Enamel (c. 1580 BCE): A vitreous stone-like substance that resembles glass. This material has a wide chromatic range, and when crushed to a fine powder, it has a melting point of $500\,^{\circ}$ C or $932\,^{\circ}$ F. After the molten material hardens it takes on the characteristics of glass, however, it will only adhere to metal, glass and ceramics.

Some of the first enamel artifacts were found in Greece c. 1580 BCE. These pieces included Bronze daggers inlaid with gold and enamel ornamentation. Due to these findings, it is believed that Greek artisans discovered the new opaque or semi-transparent glass-like substance.

Enamel Paint (c. 1888 CE): Enamel paint contains no enamel. It is a commercial grade linseed oil based paint developed by Riep, a Dutch chemist. Due to its durability and glossy sheen, it was given the name of enamel paint. Ten years later Ripolin, a new paint company in France began manufacturing the oil base paint for commercial use.

Encaustic Paint (Egypt, Alexandrian Period, 336-323 BCE): A painting technique created by Greek artists living in Alexandria while under forced contract labor to Alexander III. Encaustic Paint is a blend of melted beeswax, color pigments, and resin.

The paint mixture is kept pliable on a heated palette, and dries shortly after the application to the canvas or surface of choice. After the initial application of paint, a handheld heated element passes over the dry paint until the colors are soft enough to meld together.

Even with present day technology, the use of this medium/technique demands experienced application, as the paintings are extremely vulnerable to damage from moisture accumulating between the beeswax paint and the canvas or surface of choice.

Consult with a professional conservator who is experienced with Encaustic paints, if a painting becomes soiled. For additional information regarding the care and storage of Encaustic Paintings, refer to painting.

Engineer: The title of engineer is reserved for an individual who works in one of the disciplines of Engineering.

Proof of human inventiveness dates back to the Early Stone Age, c. 2.6 million BCE This evidence consists of utilitarian tool kits having hammer-stones and sharp cutting stones. Early Homo ergaster (ancestor to Homo sapiens) engineers eventually evolved into a people who designed, invented, and/or built devices, methods, and/or machines.

Expressionism (Netherlands, c. 1880 CE) Expressionisme: Primaily a *Self-Taught* artist, van Gogh approached painting with unrestrained truthfulness in his renderings of the rural countryside in his native Netherlands.

Van Gogh favored the Impasto alla prima and/or the Impasto layering painting techniques to express the solemn lifestyle of country folk. Over the course of van Gogh's lifetime, his colour palette would change several times.

Known as the Father of Expressionism (both French and German), van Gogh was the embodiment of emotional spontaneity. After van Gogh's death, the word Expressionism

became the term to describe his particular manifestation of painting.

Although many of his contemporaries believed he was insane, it is possible van Gogh suffered from Dementia, Epilepsy or Bipolar Disorder.

Nevertheless, Van Gogh's approach to painting had a tremendous impact on artists of future movements such as French Expressionism and German Expressionism. Refer to impasto alla prima, and impasto layering.

F

F-111 Rosenquist (painter, graphic artist) starts work on the supersized painting titled F-111 (10' X 86'), making his anti-war statement on the Vietnam Conflict.

Fibonacci Sequence: The origins of this mathematical sequence date back to Indian mathematics between 900-700 BCE.

Later in 1202 CE, Fibonacci, an Italian mathematician wrote the book titled Liber Abaci concerning mathematics, in which he discusses what is presently known as the *Fibonacci Sequence*.

The sequence begins with 1, 1, 3, 5, 8, 13, 21, 34, 55, 89, 144, and so on. This sequence of numbers is also used in connection with the Fibonacci Rectangle. The curvilinear line inside the rectangle is called the Fibonacci Spiral.

Diagram not to scale

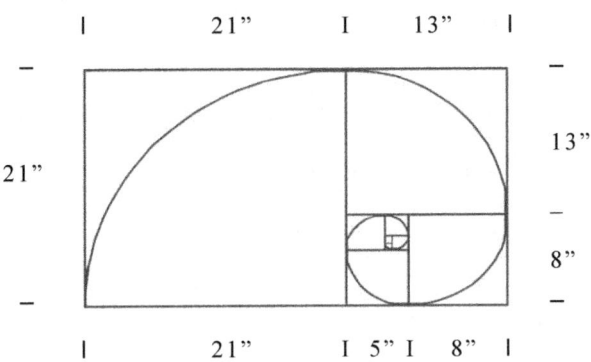

Note: Although similar in structure, the mathematical sequences relative to the Fibonacci Rectangle and the Golden Rectangle are dissimilar. Refer to Golden Ratio.

First Exhibition of the Editors of The Blue Rider (1911 CE) Traveling in Paris during the early 1900's Kandinsky met the artist Matisse. Influenced by the concept and techniques of the Fauvists, Kandinsky, however, began to take a different approach to painting. In 1910, he created a new concept he called Non-Objective.

In 1911, the Neue Kunstler Vereinigung Munchen (New Artists' Association of Munich, or NKVM) rejected Kandinsky's Non-Objective paintings for exhibition. Shortly after that, both he and Marc left the NKVM to begin work on the book titled Der Blaue Reiter Almanac (*The Blue Rider Almanac*), published in 1912.

In December 1911, Kandinsky and Marc arranged the First Exhibition of the Editors of The Blue Rider. This was a group exhibition of works by Arp (painter, sculptor, and poet), Bloch (painter and poet) Braque, Deráin, Kandinsky, Kirchner, Klee, Macke, Marc, Nolde, and Picasso.

Each artist presented different concepts and styles to the art community. Over the next three years, this exhibition traveled throughout Europe. Artists from this exhibition were included in the Armory Show held in New York in 1913.

Fluxus: In 1963, Maciunas wrote the Manifesto for Fluxus and founded the Neo-Dada, international multi-media movement. Maciunas believed that art was meant for, and to be created by everyday people.

With all its' ins and outs, twists and turns, Fluxus like Dada is a maze of musical chairs which managed to flow into society with the help of everyday people, before they became Ono, **G. Brecht**, Paik, **Beuys**, and **Knowles** to name a few.

Formalism (Renaissance Period c. 1430-1600 CE): Formalism refers to a strict adherence to traditional rules concerning the representation of form, and to the mandates concerning their methods of execution, such as accurate modeling, the use of natural color and the use of 3-dimensional perspective. These ideals also applied to the painting style of Realism and Trompe-

l'œil. The teaching methods Formalism continue to be taught in the 21St Century.

Framework: In the broad sense of the term, framework refers to the conceptual structure that supports an idea.

In regards to the physical framework of a painting, various materials are required for its physical construction 1: pregessoed or primed wooden panels, 2: cotton duck canvas, 3: linen, 4: gesso and or rabbit skin glue, 5: wooden stretcher strips to create a butt joint, or 6: mitered wooden/aluminum stretcher strips.

Four stretcher strips are joined to create either a square or a rectangular frame, over which canvas or linen is stretched and primed with the appropriate gesso.

French Expressionism, Expressionnisme Français (c. 1898 CE): A Parisian movement known as Fauvism. Dubbed Le Fauves, this group of French Expressionists led by Matisse (painter, draughtsman, lithographer, and sculptor), believed artistic expression to be a manifestation of physical and emotional action, which they rendered with a bold use of color.

Artists to join this movement did not exhibit together as a group until 1903. The Parisian Avant-garde and members of the Fauvist movement consisted of Braque (draughtsman, painter, printmaker, and sculptor), **de Vlaminck** (painter), Deráin (painter), **Dufy** (painter), **Friesz** (painter), **Marquet** (painter), and **van Dongen** (painter).

Even though **Charmy** (painter) was not part of the initial movement, she was the only woman of the time to be painting in the Fauvist style. Matisse, however, was the only artist to continue painting with this style throughout his lifetime. Refer to Expressionism.

French Impressionism, Impressionnisme Français (c. 1872 CE): The forerunners of the Impressionist movement were **Boudin** and **Jongkind**. Both artists painted outdoors, in natural sunlight. Of these two, Boudin taught Monet the fundamentals of outdoor painting, along with two of Monet's closest friends, **Bazille**, and Sisley.

While Monet is one of the most well-known painters of the Impressionists, Pissarro is considered the Patriarch of Impressionism. Unlike some of the other Impressionists, Pissarro was self-educated in the art of painting outdoors.

In order to paint outdoors Monet, Pissarro, Renoir, and Sisley began to travel the countryside in 1872 and became the core of the Impressionist movement. In addition to breaking away from traditional theories of painting, the Impressionists began to use the impasto alla prima and/or the impasto layering techniques.

There were approximately 30 artists to join the movement from 1872-1910. The inner circle however of five artists, separated into two distinct factions. One group consisted of Monet, Sisley, and Renoir; the other consisted of Pissarro and Cézanne. At the time, Pissarro was a confidant and personal instructor to Cézanne.

After Cézanne left the group in 1877, Impressionists such as **Cassatt** (painter) and Gauguin began to approach their painting from a subjective perspective, rather than theoretical. However, both artists continued to confide in and receive instruction from Pissarro.

Although **Bracquemond**, **Caillebotte**, **Degas**, **Corot**, and **Morisot** had also joined the group, they remained on its outer fringes. In c. 1874, Caillebotte assisted **Durand-Ruel** (patron of the arts, and gallery owner) with organizing the first group exhibition.

Caillebotte, however, did not show his work in this exhibition and Pissarro had to convince Cézanne to participate. Cézanne exhibited with the Impressionists only twice, the second and last time in c. 1877.

The Impressionists held a total of seven exhibitions, the first in c. 1874, 1876, 1879, 1880, 1881, 1882, and the last in 1886. Out of the core group of eleven artists, Pissarro was the only artist to participate in all seven exhibitions. Another painter to show in the last exhibition was Seurat.

Refer to Divisionism, impasto alla prima, impasto layering, **Manet**, Naturalism, and Pissarro.

Fresco (Italy, c. 1450 CE): A precursor to the alla prima and the Wet-in-Wet techniques. A fresco is a three-stage technique. Please note, the proper proportions of materials are essential to make fresco plaster, and water is the mixing agent for all stages.

The roughcast or first stage is a mixture of white lime, gravel, and coarse cement. The second stage/coat is a mixture of white lime, coarse sand, and fine sand. The third stage or the intonaco painting consists of white lime, coarse and fine sand or fine marble grit and fresco pigment colors.

One suitable surface for this type of fresco plaster is a wall constructed of clay fired brick.

Frontality Ancient Egypt, Predynastic Period (c. 3650-3150 BCE): In the early part of the 20th century (c. 1920 CE), archeologists assigned the term Frontality to these Egyptian works. In the latter part of this period, artists began to implement a new concept in relief carving and painting.

These new images simultaneously portrayed two distinct views of one person. For example, while rendering the head from a profile view, the torso of same subject depicts a frontal view. Refer to Picasso.

futhark (Europe, c. 1500 BCE): The futhark, commonly known as the Runes, is a series of phonetic hieroglyphs having both cultural and spiritual significance. Generally linked to ancient Celtic and Norse cultures, the ancient Aryan (Germanic and Indo-European) tribes of Eurasia developed this alphabet having only one letter case (no sentence case).

There have been several patterns of this alphabet over the last 3,500 years. However, only four dominant styles are still used, and there is only one common factor among all known designs.

Each configuration of the futhark begins with the same six runic staves ~ ᚠ ᚾ ᚦ ᚨ ᚱ ᚲ (f, u, th, a, r, k). 1: The Elder Form consisting of 24 hieroglyphs, with contemporary revisions and transliteration. 2: The Younger Form consisting of 16 hieroglyphs. 3: The Anglo-Saxon or Anglo-Frisian Form consisting of 33 hieroglyphs. 4: The Old Norse Form consisting of 18 hieroglyphs.

In 1919, the National Socialist German Workers' Party (NSDAP) was established, which became known as the Nazi Party. Hitler and members of the new Nazi Party began to adopt ancient Germanic symbols and hieroglyphs from the Old Norse Form for their insignias and emblems.

One of the ancient symbols the Nazi Party adapted was the Sun Wheel or the Wheel of Life. However, they reversed the direction of the four spokes and renamed the symbol, now known as the Swastika, or the Wheel of Death. However, the Nazis Party did not instate the Swastika as its official insignia until 1935.

The Nazis also incorporated the hieroglyph or runic stave ϟ (S) into their insignias. Juxtaposed, the ϟϟ is an ensign for the Elite Schutzstaffel, a.k.a. Storm Troopers.

After becoming Chancellor, Hitler and the Nazi Party quickly formed the Degenerate Art Commission, and banned the use of the futhark or ancient Germanic symbols in any artwork that did not adhere to Hitler's ideals of the pure Aryan race.

The restrictions imposed on the German people, however, did not apply to the fascist aristocracy, especially the four high commanders of the Third Reich (the Four Horsemen). They were Paul Joseph Goebbels (1897-1945 CE), Hermann Wilhelm Goring (1893-1946 CE), Heinrich Himmler (1900-1945 CE) and Hitler (a.k.a. Der Fuhrer).

Despite the ban on the futhark and Germanic symbols, artists such as Heartfield and Grosz put themselves in harm's way as they began to incorporate various symbols into Anti-Nazi paintings, prints, and posters. Refer to Degenerate Art and Germanic Religion.

Futurism, Futurismo (1909 CE): Futurism was an Italian Literary and Arts Movement conceived by Marinetti (dramatist, novelist, and poet.

In 1910, **Balla, Boccioni**, Carrà, **Rossolo**, and **Severini** wrote the Manifesto of the Futurist Painters. **J. Stella** joined the movement later. The Manifesto inspired Italian architecture, craft design, culinary arts, fashion design, furniture design, music, painting, poetry, sculpture, and the theater.

The commonality among the Futurists concerned the development of individualistic ideas relating to life and art, their fascination with machinery, their need for speed, and their love for urban life. Futurists did not adhere to nor follow any ideology but their own.

G

Gallery: A commercial establishment that exhibits various forms of artwork, such as paintings and sculpture, and known to be a gathering place for patrons of the arts and/or anyone who is interested in purchasing works of art. Most galleries open their doors to the public on the First Friday of the month.

Generation X (c. 1965-1983) A generation created by Baby Boomers and left unsupervised to raise itself as both parents generally worked outside the home. Because of this, Gen X often feels marginalized or like the forgotten generation. Despite this, they are resourceful, very tech savvy and social media conscious.

Refer to The Beat, The Beat Generation, Baby Boomer Generation, Millennial Generation and Silent Generation.

Genre: Of or relating to a music style, a literary style and/or to a painting style involving content, design and technique. Over the last two hundred years, only a handful of artists have created a new genre involving the Trilogy of Painting. Refer to technique and Trilogy of Painting.

German Expressionism (c. 1905-1918 CE) Deutsche Expressionismus: Rather than approach their art from an objective (or analytical) point of view, German Expressionists approached painting as an emotional response to factual reality.

The impetus behind German Expressionism was 1: To oppose acts of censorship by the Verein Berlin Kunstler (Berlin Artists Association), 2: To contest the attempts by The Church to annul Judaism and Germanic Religion, 3: To counter the enthusiasm for, and glorification of war.

The German Expressionist movement consisted of two separate factions, both of which influenced the development of European Arts (cinema, dance, drawing, literature, music, painting,

printmaking, sculpture, and theatre) from 1905 to 1918. The two movements were:

1: The Dresden Movement (c. 1905 CE) began with a group of artists who founded Die Brücke (The Bridge) in Dresden. Some of its members included Heckel, Kirchner, Klee, **Modersohn-Becker**, Nolde, Pechstein, and Schmidt-Rottluf.

2: The Munich Movement (c. 1909 CE) began with the last group of Expressionists who founded the Neue Künstler Vereinigung München (New Artists' Association of Munich, or NKVM). Some of the members included von Jawlensky, Kandinsky, Macke, Marc, Münter, and **von Werefkin**.

German Impressionism (c. 1880 CE) Deutsche Impressionismus: German artists to follow the lead of the French artists and began working with the effects of natural light were Corinth, von Hofmann, Liebermann, and Slevogt.

Germanic Religion (c. 1500 BCE) Early Germanic Religion was comprised of Animism, Polytheism, and Pantheism. Norse Gods and Goddesses ascended from two tribes.

The first is the tribe of Aesir, and its deities are Óðinn, his wife and Goddess Frigg, and their son and God Baldr. Also belonging to this tribe are the Gods Thor, Heimdallr, Týr, Loki, Bragi and the Goddess Iðunn, Their home is in Asgard, one of the Nine Worlds located in the world-tree known as Yggdrasil, which is the center of the cosmos.

The second is the tribe of Vanir, and its deities are the Goddess Nerthus, wife to the God Njörðr, who is the father of Freya, the sister to the God Freyr and to the Goddess Frigg, Óðinns wife. Their home is in Vanaheim, also one of the Nine Worlds located in the world-tree.

Despite Hollywood's depiction of the Norse Gods, for the people of ancient Northern Europe, their belief system was more of a spiritual experience. Among other things, they incorporated their ideologies into a way of life that was in harmony with mother earth.

Known as the God of War, Óðinn is also known as a prankster and to have a sense of humor. When riding his eight-legged horse, Sleipnir, Óðinn always wears a blue hooded cape.

Unfortunately, the four high commanders of the Third Reich a.k.a. the Four Horsemen (Goebbels, Goring, Himmler and Hitler) misunderstood and misrepresented Germanic religion/ and symbolism. Refer to futhark.

Gesso (Italy, c. 1400 CE): A primer first used in Fresco paintings. Gesso is a compound used in the preparation of any porous surface used for oil paintings. A traditional Italian gesso consisted of plaster of Paris, or gypsum and animal glue, usually rabbit skin glue.

Later in the 20th century, primers for oil painting consisted of pure titanium dioxide, zinc white or marble dust, and/or calcium carbonate and linseed oil. As a precaution, when preparing any porous surface for oil painting, it is recommended to coat the surface with rabbit skin glue first.

Another type of primer is acrylic gesso, which consists of titanium dioxide and polymer binders. While gesso is not required for acrylic paintings, painters who desire an un-textured surface will prime the canvas with gesso and sand it down to a smooth flat surface.

Giclée (1992 CE): The neologism given to a new printing process, by Jack Duganne, a pioneer and master printmaker. Giclée is a mechanically produced, high-resolution, fine art printing and reproduction process. Types of prints produced are digital prints, a series, or limited edition.

Some painters have since begun a process, which involves creating a print directly onto a blank canvas, then painting over sections of the print. Only archival pigment ink and acrylic paints are suitable materials for this process.

This practice is very similar to one used by commercial photographers in the 1950's and 1960's who hand painted black and white, or greyscale photos with a color photo ink.

G.I. Generation (c. 1901-1924 CE): The offspring of the Lost Generation. As of 2017, this generation of four million people is the corner stone of contemporary society. They schooled their children to be civic minded, and taught them family values and patriotic ideals, something their parents neglected to teach them.

Glazing: The first use of the glazing process or technique began with the invention of oil paints in the fifteenth century. Even though glazing was first used for paintings, it would soon be used for the art of ceramics. In relationship to painting, the glazing process is generally the last step to complete a painting. Glazing can be used as the sole medium to create a unique painting effect.

Oil base glaze is a mixture of an oil medium, such as stand oil or linseed oil, plus turpentine, mineral spirits or 190 proof Everclear alcohol and oil paint.

Acrylic based glaze is a mixture of an acrylic medium, such gloss or matte acrylic gel, and preferably, distilled water, plus acrylic paint.

The transparency and viscosity of the glaze depends upon the measure of paint blended into the mixture of mediums.

Glassine: (c. 1915): An ultra thin and smooth paper that has a milky white translucent appearance. Glassine is typically used for preservation purposes, as a separator page for storing fine art prints, pastels or watercolors.

Global Warming: Scientists started keeping track of global warming, early in the nineteenth century. The effects of global warming have had negative consequences to the earth's atmosphere and oceans due to the rise in average temperatures across the globe, which are caused by greenhouse gasses generated by an industrialized and fossil fuel driven culture.

Even if one does not accept that global warming does exist, why would anyone take a chance and risk the wellbeing of current and future generations, along with the planet? Rhetorical question.

Golden Ratio or Golden Section: The Golden Ratio is a number that is equal to 1.618 (approximately)/. The Golden Ratio has been applied in mathematics, art, science and architecture since c. 500 BCE.

To find the Golden Ratio of a Golden Rectangle (Diagram a) with dimensions of 13.6" x 22", divide the dividend (22) by the divisor (13.6) to reach the quotient of 1.618 (22 ÷ 13.6 = 1.618). To find the divisor of 8.4, subtract the subtrahend (13.6) from the

minuend (22). 22 - 13.6 = 8.4 ~ 13.6 ÷ 8.4 = 1.618, 8.4 ÷ 5.2 =1.618, and 5.2 ÷ 3.2 =1.618. Due to their length, some decimals have been rounded up or down The curvilinear line inside the Golden Rectangle is called the Golden Spiral.

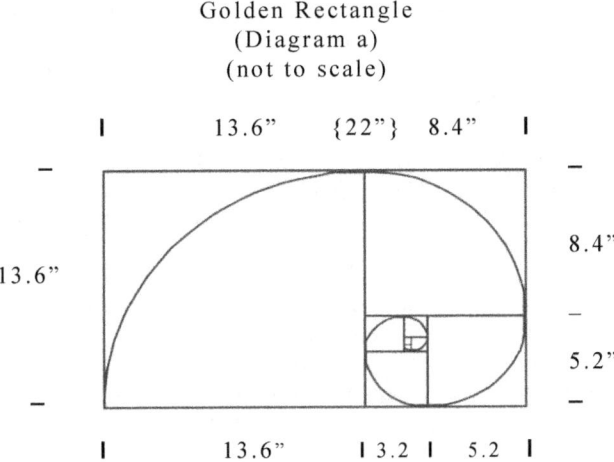

Golden Rectangle
(Diagram a)
(not to scale)

Note: Although similar in structure, the mathematical sequences relative to the Fibonacci Rectangle and the Golden Rectangle are dissimilar. Refer to Fibonacci Sequence.

Gouache (Medieval Period): Of or relating to a mixture of paint and mediums that contains the same ingredients as transparent watercolors, but with the addition of white chalk to make them opaque. At present, designer Gouache is a mixture of color pigment, gum arabic, and chalk that uses water as a dispersing agent.

Graffiti Art (Ancient Egypt, c. 3000 BCE): The first Graffiti artist or Graffitist is from the Perigordian Period (c. 32,000-28,000 BCE). However, the accredited lineage dates back to Ancient Greece in the form of Graffito.

Later in 1972, indigent teenage street artists from the Bronx created a painting technique, commonly known as graffiti, using spray paint in cans. Street artists called "Writers" work solo or with a group a.k.a. Crew or Tag Teams.

Employing a popular advertising stratagem, Writers initially chose a site that drew large numbers of people. Targeting the

public transportation system Taki 183 took Graffiti to a completely new level. Writers used subway trains as their canvas for elaborate and kaleidoscopic paintings. By 1975, Writers and Crews had emerged in Chicago and Los Angeles.

After 1975 students from national universities, colleges, art academies, and schools hit the streets to learn about this illegitimate art form. In the early 1980's, Writers dubbed their Tags as Hip-Hop or Graph.

In the mid-1990's Public Transportation Systems across the country began to hire Graphic Art firms to produce a type of appliqué (oftentimes resembling graffiti), which is affixed to buses and trains.

Note: Members of organized street gangs generate most of the graffiti found on the side of buildings, garage doors or exterior surfaces. Gangstas, Latino Mafia, and Gang Bangers generally use stark cryptic lettering and symbols in black, blue or brown to mark their territory. Call local anti-graffiti agencies to have it removed.

Grayscale: A range of shades or tints comprised of mixtures of black and white. Black and White photos are an example of the grayscale. Also, to create a shade of a color, add slight increments of black, and to create a tint of a color, add slight increments of white.

Grassroots Artist (c. 1800 CE): Of or relating to an artist who is/was primarily self-educated, or rejected theories involved with formal training, or had limited training in the Studio Arts. Grassroots Artists have been at the forefront of painting since the nineteenth century and are responsible for bringing about some of the most significant changes to their discipline in recent history. The following are but a few of the Avant-garde's grassroots artists who sought truth in art: Braque, Delaunay, Cézanne, Manet, Matisse, Monet, Munch, Picabia, Picasso, Pollock, Renoir, Toulouse-Lautrec, van Doesburg, and Van Gogh.

Guernica (Spanish Civil War, 1936-1939 CE): In 1936, General Francisco Franco (1892-1975 CE) allied with Hitler and Mussolini, led the Spanish Nationalists (consisting of the Fascist Falange Party, the Spanish Aristocracy, Roman Catholic Church,

and insurrectionist Russian military leaders) in a revolt to overthrow the Second Spanish Republic.

The Second Spanish Republic embodied the Spanish Loyalists (consisting of Liberals, Socialists, and Communists). The only government power to give aid to the Second Spanish Republic was the Soviet Union, who only sent supplies of dry goods.

On 4 April 1937, the German Luftwaffe bombed the unprotected town of Guernica y Luno, in the Basque province of Vizcaya, Northern Spain. During the 3 hours of bombing, German fighter, planes strafed unarmed civilians in open fields as they attempted to escape.

Up to this date, the content of Picasso's paintings was typically apolitical. Outraged by the mass murder of innocent and unprotected men, women and children of his native country, Picasso (Loyalist and Anti-Fascist) managed to keep his composure.

Well aware of the fact that repercussions from Franco or Hitler may follow, Picasso went to work with his weapons of choice and responded with his counterattack.

Incorporating Spanish and Germanic symbolism into his composition, Picasso created the painting titled Guernica within six weeks. Guernica's dimensions are 11' 6" x 25' 8", which approximates the billboard size propaganda used by Goebbels and the Nazi Party.

Note: In July 1937, works by Picasso were included in the Degenerate Art Exhibition. While there have been countless interpretations of the symbolism found in Guernica, the actual meaning remains an enigma, as Picasso never revealed its whispered secrets.

Nevertheless, society has this painting to serve as a reminder of what can happen when a person with severe narcissistic, psychopathic and/or psychotic disorders seizes or attempts to take control of a nation's government. Refer to Art Revolution and War.

H

Hieroglyphics (c. 4000 BCE): It is believed that Greek scholars created this term, which meant Spiritual Symbol. The first Hieroglyphs appeared as pictographic symbols. During the latter part of the Predynastic Period (c. 3650-3150 BCE), a script, writing system that represented different words involved the use of symbols and alphabetic elements.

High Arts: A term used during the late nineteenth and early twentieth centuries to describe the art work created in the Studio Arts and Architecture. Refer to Low Arts.

High Relief (deep relief): Of or relating to relief engraving. A High Relief engraving is the projection of a shape that equals one-half of the circumferences basic form. Refer to high relief, *low relief, middle relief,* and three-dimensional quality.

HyperRealist-Printmaking (c. 1963 CE) is a technique that became popular with visual and commercial artists. A term used to describe the silk-screen printing process at the Warhol Factory in New York.

There are several silk-screen-printing processes known as Mitography or Serigraphy. Some of the commercial processes include ceramic screen-printing, textile screen-printing, direct-screen and direct film-stencil.

In the direct film-stencil process, lithographers can use photographs, slides, film negatives, cinema film stills or their own designs to create original or limited edition prints. In order to co create a print, a film negative is re-photographed as an opaque or semi-opaque image on clear plastic film. This plastic film with the opaque image is placed over another impermeable plastic film.

Using heat intensified lamps; the opaque image on the plastic film is burned through the impermeable film. This produces a stencil. The stencil is placed over a silk-screen, which is placed over a flat surface (paper or canvas).

Using a graphics squeegee, printers' ink or Oil Paint is spread over and through the exposed area of the screen to produce the finished print. For additional information regarding the care and

storage of monotype prints, limited edition Mitograph or Serigraph prints and refer to paintings. Also, see Giclée.

I

Iconoclasm: A belief and practice involving the intentional destruction and/or elimination of one's own religious objects, artwork or symbols. During the Medieval Period, a group of bishops and priests belonging to The Church were opposed to the use of religious icons, claiming they led to idolatry. The bishops and priests wanted all such works destroyed.

Not only did the Iconoclasts destroy Christian Icons; they attempted to eliminate any trace of all religious and cultural artwork from Western to Northern Europe, to the Middle East. By the time Iconoclasm had reached its peak in the 7th and 8th centuries; a great many historical artifacts had already been destroyed, but not all.

Illuminations (c. 325-1325 CE): The term used to describe the artwork in religious books pertaining to Christianity. During this period, Christians believed all artwork, such as graphic symbols, detailed drawings, paintings, and sculpture were decorative art forms having only aesthetic and/or spiritual qualities.

Late in the 8th century, Christian artists led a new pictorial movement. Although the monks were in favor of spiritual expression, they continued to reject the intellectualism found in classical Greek and Roman sculptures and in Illusionism.

In 787 CE, the Second Ecumenical Council of Nicaea rejected Iconoclasm and declared it acceptable to admire but not worship religious images. With this established, Christian art would dominate the European art scene for the next 800 years.

Illusionism (c. 100 BCE) A new method of painting in which artists began to render the illusion of a 3-dimensional subject/object, but without relationship to perspective or the surrounding environment, or linear perspective. This was the first dramatic departure from the typical 2-dimensional style of painting, used since the Later Old Stone Age.

Even though Roman Republic artists received recognition for creating Illusionism, it is possible that transient Greek artists were the original creators of this new style.

Over the course of the last 2,500 years, Illusionism has gone through several changes regarding neology and procedures. Refer as Realism.

Imagism: In 1912, a literary movement involving poetry emerged in Britain. The Imagists preferred succinct, tight verse and precise imagery in their poetry, as opposed to long-winded writer) and included poets such as **Aldington** (poet and writer), **Doolittle** (poet and writer), and **Flint** (poet and writer).

Impasto (c. 1500-1600 CE): Of or relating to an oil painting technique that emerged in Europe during the late 16th and early 17th centuries. To create *textural* effects, the artist applied thick, wet pigment to the painting surface. French Impressionist painters, such as Monet often used the impasto technique in his paintings.

Later in the 20^{th} century, artists began to build up paint 1/8th of an inch thick. Depending upon environmental conditions, .an impasto oil painting of this thickness can take 3 to 6 months to dry thoroughly.

A drying agent may be used to quicken the drying time for both acrylic and oil based paints. However, restoration experts recommend minimal use of any drying agent.

When a drying agent is used in heavy impasto paintings (particularly oils), the binding medium/agent has a tendency to become unstable. This may cause the paint to crack and thereby set off an adverse chain reaction causing further problems. Also, see Alla Prima.

Installation: (c. 1922 CE) Influenced by Picassos Constructions Barnes creates installations in his home which are set to his own aesthetic views. These works involve a wide variety of materials including paintings, furniture, farm implements, home building supplies and pieces of decorative art.

Interactive: Of or relating to the law of reciprocal active response, or cause and effect. People, a computer, and a vending machine are all interactive mechanisms.

Interactive Art (c. 1992 CE): Of or relating to a movement involving sculpture and information technology, such as the use of computers to manipulate artwork or installations.

Intrinsic Value concerns the inherent, ethical or philosophical value that an object or thing possesses in itself, or for its own purpose.

Intuitive: Of or relating to an instinctual belief, thought, or the ability to know or understand something without prior knowledge of that thing. Intuition is often thought of as the sixth *sense*. Most people have some intuitive powers, such as the parent who knows their child is in danger but has no actual proof.

Intuitive Art (Medieval Period): During this period members of The Church, believed Divine Inspiration was the source of the intuitive power received by artists for their creations.

Later, in the 1980's and 1990's, Intuitive artists claimed they relied solely on their intuitive powers, and were not influenced, consciously or subconsciously, by mainstream culture or by Mass Media.

Nevertheless, many people including self-taught, grassroots and/or academically trained artists often use their instincts or intuition/sixth sense.

Refer to Grassroots Artist, Mainstream, Mass Media, Outsider Art, Self-Taught, Senses, and Visionary Art.

J-L

Jazz (c. 1895 CE): The invention of Jazz will always be an enigma, as there are many myths surrounding its birth. Some attribute the birth of Jazz to groups of street children known as Spasm Bands, who grew up in the Red Light District of New Orleans.

Others believe African American musicians were the originators. Still, some people believe both Creole and Caucasian musicians created the new sound.

However, one undeniable truth remains, the unique sound of Jazz would change the course of music on a global scale. The following are a few musical stylings that would emerge either directly or indirectly from Jazz.

1: Acid Rock, 2: Bebop, 3: Blues, 4: Boogie-Woogie, 5: Bop 6: Dixieland, 7: Doo-Wop, 8: Hard Rock, 9: Progressive Jazz, 10: Ragtime, 11: Rhythm-and-Blues, 12: Rock and Roll, 13: Soul, 14: Swing, 15: Smooth Jazz 16: Traditional Jazz and all new forms of Jazz.

Julian Calendar (c. 45 BCE): Introduced by Gaius Julius Caesar (100-44 BCE) in 45 BCE. Caesar based his calendar on having a solar year consisting of 12 months, 365 days, and a leap year of 366 days every fourth year.

In 1582, Pope Gregory XIII sponsored a corrected version of the Julian calendar. In the Gregorian calendar, leap year occurs only in years that are divisible by four.

L'Academie des Beaux-Arts (The Academy of the Beautiful Arts established in 1816). l'Academie de Peinture et de Sculpture (established in 1648 CE), and l'Academie d'Architecture (established in 1671 CE) merged becoming l'Academie des Beaux-Arts.

The newly formed l'Academie des Beaux-Arts thus became one of five Academies in union with l'Institute de France in Paris, (established in 1795 CE).

Refer to Le Salon des Refusés and Art Revolution.

l'Art Brut (1945 CE) Raw Art: Of or relating to Outsider Art by *Intuitive* or *Visionary Artists* institutionalized for being mentally insane. In 1945, Dubuffet began to collect the artwork by those he believed to be unschooled in the Arts. Refer to Outsider Art, Self-Taught and Visionary Art.

Les Nabis (c. 1890 CE): The primary idea behind this movement was to portray the Judaica community and their solemn lifestyle, as did van Gogh with Dutch peasants. Members of this movement included Bonnard (painter), Denis, and Vuillard (painter).

At the time it was believed that people of Jewish descent were not intelligent, lacked creativity, and had little if any artistic talent. Due to these beliefs and a rising anti-Semitic attitude in France, this movement received little attention. Refer to Pissarro.

Le Salon des Refusés (Paris, France 1863 CE): The beginning of the Art Revolution and the birth of the Alternative Art Space began with the opening of Le Salon des Refusés (Paris, France 1863 CE).

Once a year l'Academie des Beaux-Arts sponsored an Official Salon, of which artists were permitted to submit work for exhibition. Controlled by wealthy and privileged socialites, an indiscreet and subjective selection committee chose the artwork and always rejected works showing new styles and techniques.

Weary of this blatant elitism, Parisian artists whose work had been refused repeatedly by the Official Salon requested Napoleon III (1808-1873 CE) to sponsor, and to establish a new alternative exhibition space.

The first exhibition was held across the Seine River on the right bank at the Palais de l'Industrie, now the home to the Grand Palais des Champs-Élysées. All artists who had been refused by the Salon were welcome to exhibit.

Among the Avant-garde participating in the first exhibition were Boudin, Cézanne, **Fantin-Latour**, Jongkind, Manet, Monet, Pissarro, Renoir, and Whistler.

The establishment of Le Salon paved the way for future artists to develop new concepts, styles and techniques in painting, and to stand up to any who attempt to oppress, censor or regulate the creation, communiqué and/or exhibition of Art.

LGB: (c 1990 CE): The initials LGB replaced the term Gay Community from the 1970's. However, LGB activists felt the initials LGB (from the 1980's) did not fully represent their society, and expanded the scope of their community. The initials LGBT stand for lesbian, gay, bisexual and transgender.

Prior to the Hippie and Disco era, homophobes insecure with their own sexuality would (and continue to) use derogatory terms to bully, harass, demean, or embarrass individuals and groups in the LGBT community.

Light, Dimensions of: In space, two occurrences create The Electromagnetic Field. The first is a moving electric field which creates a magnetic field. When these two field are perpendicular

to each other, their point of intersection creates the Electromagnetic Field/Wave.

Visible light is just one of seven fields within the Electromagnetic Spectrum The wavelength of each color within the White Light Spectrum has a measurement within a range from 380 to 700 nanometers (nanometer = one-billionth of a meter).

In addition, the intensity level of a hue varies from one color to the next. The following list provides the wavelength intervals of the seven primary hues in the White Light Spectrum:

Red	-	700 ~ 635 nm
Orange	-	635 ~ 590 nm
Yellow	-	590 ~ 560 nm
Green	-	560 ~ 490 nm
Blue	-	490 ~ 450 nm
Indigo	-	450 ~ 430 nm
Violet	-	430 ~ 380 nm

Approximately 44 % of natural visible light emanates from the higher range of warm hues while 56 % of natural visible light generates from the lower range of cool hues. Considering Black or White does not have an Electromagnetic Wavelength, neither is a color/hue. However, one represents the light of day; the other represents the dark of night, or the yin and yang of space.

In addition to sunlight, there are several sources of natural light in our universe, such as reflected light off the moon and from starlight. Contrariwise, from sundown to sunrise the Blue Planet has been illuminated with materials and methods developed by Homo sapiens.

Neanderthal tribes and painters began to light up their lives with fire pits containing combustible materials such as wood, dried moss and/or grasses. Then came bowls filled with flaming animal fat, moss, and twigs, after that tallow/wax lamps, than came candlepower, and after that kerosene/oil lamps, than came natural gas light fixtures, which brings Homo sapiens to the invention of the incandescent light bulb.

Although several inventors created models for the incandescent bulb, both Edison, an American inventor, and Swan, a British physicist created prototype bulbs that are still in use.

Consequently, each light source both natural and industrial, will affect the appearance of pigment colors differently, especially when two or more light sources are used concurrently.

While having a studio with natural North light (full spectrum white light) is preferable for most studio painters, it is not always possible to obtain such conditions in an urban environment.

In addition to natural light, manufactured illumination is a second source of light which is measured in Kelvins (K), ranging from 2,700 to 6,000 K.
The three analogous dimensions of engineered light are: [a] Artificial, [b] Simulated, [c] Replicated.

[1a] Artificial: A warm yellow light (2,700 K), emanating from incandescent bulbs, halogen lamps and/or light emitting diode (LED) bulbs.

[1b] Simulated: A cool blue light (5,000 K), emanating from fluorescent, compact fluorescent lamps and/or light emitting diode (LED) bulbs.

[1c] Replicated: A color corrected/full spectrum white light (5,500-6,000 K), emanating from specialized fluorescent, metal-halide lamps and/or light emitting diode (LED) bulbs having a high Color Rendering Index (CRI).

Linear Perspective (c. 75 CE): The roots of linear perspective can be traced back to 75 CE when artists in Pompeii, Italy began using a method of painting similar to Trompe-l'œil. However, these methods would be lost, leaving the 2-dimensional perspective to dominate drawings and paintings until the Italian architect, Brunelleschi rediscovered the use of linear perspective in 1415.

Linear perspective is a system used in drawing and painting, in which three dimensional objects appear to reduce in size as they converge upon a horizon line, thus giving the illusion of distance and space. Also, refer to Illusionism.

Literary Arts: The study or creation of written works in genres involving poetry, novel, novella, short story, science, drama, play writing, comedy, philosophy, and essays.

Low Arts: A term used during the late nineteenth and early twentieth centuries to describe fine furniture design, fine crafts, and graphic arts. Refer to High Arts.

Low Relief (bas-relief): Of or relating to a relief engraving technique. A method in which a shape, mass or line is created so that it rises slightly above the surface plane. Refer to high relief, low relief, middle relief, and three-dimensional quality.

Luchism a.k.a. Rayonism (1909 CE): Of or relating to a style of painting developed by Larionov and his wife Goncharova, and in which the subject matter creates the illusion that the content is emitting light. Influenced by Cubism and allied with Futurism.

M

Magna Paint (N.Y., N.Y. 1946-49 CE): Developed by S. Golden while working at Bocour Artist Colors. Magna Paint is a mixture of ground color pigment, ground acrylic resins and liquid solvent binders, such as turpentine (distilled oil resins from pine trees). Even though Magna Paint has an acrylic base, it is a solvent miscible vehicle, unlike acrylic polymer paint, which is a water miscible vehicle. Refer to Acrylic Polymer Paint and Medium.

Mainstream: 1: Of or relating to current, popular and dominant trends affecting society, 2: Of or relating to the leading members of the *visual fine arts community*, the *Performing Arts* (including Pop, Country and Hip Hop music) and *Mass Media*.

Manet, Édouard (1832-1883 CE): Exhibiting at Le Salon des Refusés in 1863, Manet created an uproar in the Parisian art community with his painting titled Le déjeuner sur l'herbe (luncheon on the grass).

The dissension stemmed from Manet's breaking away from the academic teachings of Formalism and his use of a new technique involving light impasto and bold brush strokes. Two artists who were particularly enthused by Manet's painting were Cézanne and Pissarro.

Curators at the Musée d'Orsay in Paris claimed the controversy was due to his use of nudes sitting with clothed persons. This theory, however, does not hold water, considering that Corot a distinguished and acclaimed Parisian artist created the painting

titled Diana and Actaeon, which contains nudes and partially clad persons (1836).

Contrary to popular belief, Manet began to study the effects of natural light in relationship to color in 1874. Even though he was invited, Manet never exhibited with the Impressionists. His inner circle of friends included Whistler and Fantin-Latour.

A retired officer of the French military (Franco-Prussian War, 1870-1871 CE), Manet chose to exhibit only in Salons sponsored by the French government. Refer to Aestheticism, Formalism, impasto, and Pissarro.

Mass Media: Of or relating to the methods of communication: 1: advertising, 2: cinema, 3: multi-media broadcasts (radio, television, and internet), 4: print and internet publications (blogs, periodicals, newspapers, books and magazines).

Mass Production: Manufacturing plants and factories began the mass production of interchangeable parts in the 19^{th} century during the Industrial Revolution. However, this was not always a cost efficient method, as skilled labor was still required for production and assembly.

During the early part of the twentieth century, the assembly line process was streamlined, becoming more cost effective. Modernized, the factory was able to produce hundreds of thousands of units as opposed to earlier production in the tens of thousands.

Note: Keep in mind the objet d'art that comes from a big box factory is a mass produced product and the cost of labor does not justify the exorbitant prices charged by some Designers and Home Stylists. From a globally economic perspective, it makes more sense to support local artists and purchase original works of art, as it helps keep more people employed throughout the industry.

Massurrealism (Developer unknown, c. 1992 CE): A graphics software program, which allowed the user to scan images from Mass Media to personal computer data files. The software program made it possible to manipulate the scanned image and to create a new illustration. Prints were made from jpeg files. Refer to CyberArt Collage, Mass Media, and Photomontage.

McCarthyism (1950-1954 CE): Also known as The Red Scare. The unjustifiable accusations, by Senator (R) Joseph McCarthy (1908-1957 CE), that communists had infiltrated the State Department, which prompted a nationwide anti-communist inquisition, and which caused many Hollywood writers and screen writers to loose their livelyhood. In 1954, after attacking the United States Army, the Senate formally condemned McCarthry for conduct Contrary to Senate Traditions. Also see page 193

Media: 1: Of or relating to the disciplines within the Studio Arts, 2: Of or relating to several types of paint such as oil paints, acrylics, casein, egg tempera and watercolors. 3: Of or relating to the types or means of communication such as newspapers, magazines, radio, television, social media and blogs. Refer to Mass Media, medium, discipline, and painting.

Medieval Period (c. 325-1325 CE): Depending on the school of thought this period is also known as the Dark Ages, the Middle ages, or the Age of Anxiety. It concerns the period of Western European culture just after the collapse of the Roman Empire. Unfortunately little is known about this period, as the Iconoclasts set out to destroy all evidence of previous cultures and their theologies leading up to the 9^{th} century. Refer to Iconoclasts.

Medium: 1: Of or relating to a method or way of doing something. 2: Of or relating to a single discipline in the Studio Arts. 3: Of or relating to the material used to create a painting or statue, such as oil paint or marble. 4: Of or relating to a vehicle such as linseed oil, walnut oil, Damar varnish, alkyd oil, Flow Gel, Copal painting medium, Turpenoid gel, acrylic glazing gel, or impasto mediums and Gels. Refer to painting for a list of paints and mediums. Also, see mass media, media, and discipline.

Metaphysical Art (1917): de Chirico, the Father of Metaphysical Art, and Carrà created this genre and forerunner of Surrealism. The concept of this genre was derived from Metaphysics, a branch of Philosophy concerning Temporal Parts and the Supernatural (fourth dimension).

In relation to painting, the content or subject matter is approached from the fourth-dimensional perspective and oftentimes rendered as being surreal, or possessing a dreamlike quality.

Middle Relief (demi-relief): Of or relating to the relief engraving technique, in which the projection of a shape equals one-quarter of the circumference of its basic form. Refer to high relief, low relief, middle relief, and three-dimensional quality.

Millennial Generation (c. 1984-2004 CE): This is a complex social network group consisting of approximately 76 million people. Generally, they are educated with a keen awareness of social media and online activism. However, many Millennials erroneously believe loyalty to country and trust in government is the same.

Refer to The Beat, Beat Generation, Baby Boomer Generation, Generation X and Silent Generation.

Mind's Eye: 1: Often referred to as the imagination, 2: The doorway to the fourth dimension (space-time continuum or creative infinity), 3: The minds' ability to conceive images (mental visualization), 4: The minds' ability to recall a sensation related to a physical sense. Also, refer to intuitive.

Minimalism (c. 1959 CE): Of or relating to a concept and/or style of painting, sculpture, and music: A Minimalist work has nothing to do with the scale or size of an object; rather it deals with reducing the elements of a design or composition to a minimum value. A few members of the Avant-garde and Pop Art movement were Stella, F. (painter), **Truitt** (sculptor) and **Flavin** (sculptor and installationist), **LeWitt** (sculptor), and **Ryman** (painter).

Mixed Media (c. 1960's CE): A technique or style derived from Collage, Papier Collé, and Constructions. A Drawing, Painting, Sculpture or work incorporating a variety of disciplines and/or materials.

A few examples of materials that might be used in a Mixed Media work are Acrylic Paint, aluminum foil, dry powder pigments, Gel Medium, plastics, and a piece of a cereal box or candy wrapper. For additional information regarding care and storage of mixed media works, refer to painting, Collage, Papier Collé and Constructions.

Mixed Media Relief (origin, Egypt, Early Dynastic Period 2600 BCE), termed in the 1960's. A type of sculpture with three-dimensional qualities and incorporates a variety or mixture of materials. A relief or mixed media relief constructed by hand

using overlay and/or inlay techniques. Refer to mixed media, relief, and three-dimensional qualities.

Mobile Electronic Art (c. 1976 CE): Essentially, a process using computers and mechanical paintbrushes mounted to a tiny four-wheel vehicle (approximately 1' 6" x 2' 6") to create large-scale paintings.

Moda: The manner, in which something is fashioned, completed or made.

Moda Contemporary Art (1976 to 2000 CE): Refer to Art Period.

Modern: Of or relating to something new or someone with new ideas, in the present day or very recent past. Refer to Art Period.

Modernism (c. 1870-1899 CE): Modernism was a philosophical movement involving the Arts and Sciences. Members within each discipline sought new methods of expression and communication that would represent present day attitudes and trends.

Since the turn of the 20th century, one of the great debates involves the question, when did Modern Art begin and end. Another debate concerns the question, when did Post-Modern Art begin and end? Refer to Art Period.

Modern Art (c. 1870 CE): Of or relating to a work of art that is created and relevant to current events or issues. Many members of the visual fine arts community consider Cézanne as the Father of Modern Art, and the period known as Modern Art began with the creation of Cézanne's Naturalism.

Monochromatic: Of or relating to the use of only one hue/color and a mixture of shades using black or tints using white.

Mosaic (Babylonia, 1750 BCE): The art of producing a design by inlaying small clay-cone pieces (colored and fired ceramics) into wet loam. This was common practice for laying a new floor. Over the next 3700 years, additional techniques involved the use of wall and mounted mosaics, and materials such as marble, glass, tile, stained glass, semi-precious stones, and wood.

Multi-Media (c. 1992 CE): Two or more mediums, such as painting, dance performance, music and readings that are

involved with a single event or movement. Refer to Mass Media and media.

Munsell Color System: In 1907, Munsell, a painter, teacher and color theorist published A Color Notation. Like Chevreul and Seurat, Munsell was interested in the perception of color relationships and their differences. Munsell also believed that a color embodied three dimensions which consisted of a Hue (color), Value (A quality that helps distinguish light colors from dark colors), and Chroma (a measure of color purity).

Munsell also attempted to formulate an accurate color model. To accomplish this Munsell devised a numerical color system. This system is still a model used by paint manufacturers.

Mural (Grotte de Lascaux, France c. 20,000 BCE). The murals de Lascaux are some of the earliest known cave wall paintings created by Neanderthals artists. These murals are massive in scale, with figures measuring twenty feet across.

As Homo sapiens evolved, so did the art of mural painting. Known for their attention to detail Ancient Egyptians created Hieroglyphic murals. Much later, artists such as Michelangelo painted "The Creation" on the ceiling of the Sistine Chapel at the Vatican in Rome, Italy.

At present Mural Art is found on buildings in every major city across the globe.

Museums (Egypt, c. 300 BCE): Civilization's first museums were established by and for Egyptian royal families who began to acquire, preserve, and exhibit works of art.

Early in the 17th century, European museums began to open their doors to the wealthy and middle classes. Two centuries later, museums began to allow entrance to the lower economic public. Contemporary museums often have affiliations with art academies.

Museums and the Please Do Not Touch policy:

The human desire to touch is not governed by status, wealth, or education. The desire to touch is inherent in all people. It seems very doubtful that royal, wealthy, or middle-class society would not have, at one time or another, a desire to touch a work of art.

Concerned with the preservation of fine art and ancient artifacts, nineteenth century museum directors began to hire watchmen to enforce a new Please Do Not Touch policy. Relying on authoritarian rule, the new guards would quote the company line, Art Is Created To Be Seen, Not To Be Touched. Uneducated in the Arts themselves the guards often chastised the public and very rarely gave any plausible explanation as to why works of art, paintings, in particular, were not to be touched. This practice has not changed in many institutions.

Prior to the 19th-century alkyd, casein, encaustic, and oil paints were the primary media for European and American painters. To render the elements of form artists natural animal hair brushes to create thin, overlapping brush strokes. Paintings prior to and of this era do not possess characteristics that would be tactilely discernible. Therefore, it would serve no real purpose to touch them.

Nevertheless, the public was never informed that the oil/grime from unclean human hands would cause damage to several different mediums, oil paintings in particular. With this in mind, it is understandable why museum directors would not want thousands of people to touch paintings, hundreds of years old.

The age of a painting is another reason for the Please Do Not Touch rule. For example, an oil painting that is four or five centuries old, yet appears to be in good condition may actually have entered an advanced retrogressive state. Even though the surface of the painting may seem to be undamaged, the *framework* may be deteriorating. This degenerative process can occur for any number of reasons.

One must consider that five hundred years ago the alchemy used to develop painting media was not as advanced as the technology of the 20^{th} century. Along with this, bear in mind, the technology used to monitor and maintain a museum's environmental conditions did not exist prior to mid-20th century.

Many museums are now equipped with state of the art systems which monitor and alert conservators to sudden or erratic changes in the environment within a particular room, which in turn helps to prevent the degenerative process from accelerating, which causes irreparable damage.

The most common painting surfaces for media such as Egg Tempera, Gouache, Pastels, Sumi, and Watercolor Paints are handmade and manufactured papers. Frames with clear glass, non-glare glass, or Plexiglas are common materials used to protect fragile paintings from damage caused by variable environmental conditions. Refer to Tactile Art, Tactile Dome, textural, three-dimensional quality, and Senses.

N

Naturalism (France, c. 1877 CE): like Pissarro, Cézanne, the father of Modern Art, received little recognition during his lifetime. Not only did Cézanne's work challenge the mind's eye and the intellect; it transcended prevailing academic theories regarding the discipline of painting.

Cézanne took an intellectual and naturalistic approach to painting and applied unconventional tridimensional concepts to his work. Cézanne also used the impasto alla prima and/or the impasto layering painting techniques.

In turn, these concepts would influence future artists such as Matisse and Picasso. The two artists who greatly influenced Cézanne's own work were his closest friends and confidants. One friend was **Zola** (journalist and writer on Naturalist theories) the other was Pissarro, an Impressionist painter. Another artist who had impressed Cézanne was Manet.

Considered an outsider by most of the Impressionists, Cézanne exhibited with the group only twice (in 1874 and 1877). Refer to Cubism, French Expressionism, French Impressionism, impasto alla prima, impasto layering, Manet, Picasso, Pissarro.

New Age Spiritualism: (c. 1975 CE) A non-violent culture that embraces the teachings and practices of philosophies ranging from Baha'ism to Zen Buddhism. Even though this eclectic global culture had been around for centuries, it began to experience resurgence in the mid 1970's.

New York School (c. 1954 CE): An expression coined by Motherwell to describe the painters and Abstract artwork emerging in New York City (Greenwich Village in particular) after World War II to 1959. Refer to Abstract Expressionism.

Non-Objective Art (c 1910 CE) There is no question that Marxist politics, Existential philosophy, and economic environments played a role in shaping the German visual fine arts community, and ultimately influenced the development of Non-Objective Art.

While in Germany in 1911, Kandinsky published, his treatise titled *Concerning The Spiritual In Art*. Kandinsky was opposed to the philosophical stance on consciousness and matter (metaphysics), was averse to creative conceptualism, critical of wealthy society's posture toward materialism (consumerism), and thought inanimate objects had no intrinsic value and rejected representationalism believing it to be impure.

The hypothesis by Malevich materialized in his manifesto regarding Suprematism published in 1913. Malevich was intensely opposed to all forms of utilitarian art and all imitations of nature such as representationalism and realism. Part of his theory was to separate the utilitarian element of art by eliminating the intrinsic value, believing the appreciation of the artwork would perdure on its own.

Personal note: In their quest to find and/or create the perfect art form, many abstract artists have since attempted to eliminate the human element from painting, thereby creating its own paradox.

Nouveau Réalisme (1960 CE): A European counterpart to American Neo-Dada/Pop Art. **Restany** (philosopher and art critic)) created the neologism for the concept that would define how artists would approach art and reality. A few of the artists involved with this movement were **Y. Klein** (painter and creator of International Klein Blue-IKB), **Tinguely** (sculptor), and **Spoerri** (constructionist and writer).

November Events or the Velvet Revolution (1989 CE): The revolution started on November 17, 1989, which marked the 50th anniversary of the demonstration held by Czech students to protest the Nazi occupation of Czechoslovakia.

On this particular anniversary, however, students in the capital city of Prague were protesting the oppressive Czechoslovakian political system and demanding democratic reforms. Joining the rebellion were artists, art students and teachers who protested oppression in the visual fine arts community.

November Group, Novembergruppe (c. 1918 CE): In November of 1917, during the Weimar Revolution, the German working class and German servicemen revolted against the government's refusal to end World War I.

In 1919, the German National Assembly met in the city of Weimar and established the Weimar Republic. The liberal government lasted until 1933.

Influenced by the Weimar Revolution and German Expressionism, Pechstein and C. Klein founded the November Group. This collection of unassuming artists began to approach the Arts from an intellectual perspective.

The intent of these artists was to create a sense of camaraderie with the German public and to acquaint the people of the Weimar Republic with progressive concepts in the Arts.

The November Group's intelligentsia included artists such as **A. Berg** (composer), **B. Brecht** (writer), Feininger, **Felixmüller** (painter and writer) Gropius, Moholy-Nagy, **Müller** (painter), and van der Rohe. Refer to Bauhaus, Cubism, Dada, German Expressionism and Degenerate Art.

O

Oil Paint (c. 1430-1600 CE): A painting vehicle developed in Europe between the Early and Late Renaissance Periods. In the early stages of development, young apprentice artists were generally assigned the lengthy and hazardous duty of blending sometimes toxic color pigments and binders for the master painters and teachers.

Artists who did not have an apprentice working under them had no choice but to blend their own paints. Oil Paint became a pre-blended manufactured product available in tubes around 1885.

Early oil paints consisted of dry powder pigment with an oil based binding vehicle such as linseed or purified walnut oil, which were blended into a soft butter like consistency. To thin out thick paints the painter or apprentice used vehicles or solvents such as Linseed oil or turpentine.

A few examples of porous surfaces suitable for oil painting when properly prepared with rabbit skin glue and gesso are; linen, canvas, textiles, and wood.

Op Art, Optical Art or Abstract Illusionism (c. 1938 CE): Even though Vasarely (painter) developed the concept in 1938, Op Art as a movement did not arrive on the New York and London art scenes until the early 1960's.

One idea behind the concept was to create the illusion that a stationary object appeared to be moving. In the 1960's, the movement affected painting, sculpture, and printmaking. Two prominent Op artists were **Poons** and **Riley**.

Opposition Party: Of or relating to a political party, or an organized group that is opposed to a person, group, party, or a government that is in power.

Original: Of or relating to the beginning of a specified thing. 1: Authentic 2: of or relating to something from which a copy, a photocopy, reproduction or recording is made.

Orphic Cubism (Paris): In 1912, Apollinaire formulated his theory for Orphisme and began to convince some of the Cubists to follow his new doctrine. In 1913, Apollinaire presented the concept of Orphic Cubism, which he meant as a statement to counter Cubism. Orphic Cubism, however, was still Cubism; just more spontaneous then it was analytical.

Artists who broke away from Braque and Picasso to follow Apollinaire were Delaunay, Duchamp, Léger, and Kupka. Picabia, a member of the Section d'Or also joined the Orphic group. Despite rumors, personal conflicts, and artistic rivalries, Apollinaire and Picasso remained friends until Apollinaire's premature death in 1918. Refer to Cubism.

Outsider Art (c. 1980 CE): Derived from l' Art Brut. An aphorism adopted by art collectors, dealers and gallery owners. Outsider Art has since become a generic term used to describe works by Self-Taught, Intuitive, and Visionary Artists. Outsider Art involves l' Art Brut, Crafts all disciplines in the Studio Arts,

Refer to Intuitive Art, Self-Taught, Visionary Art, I 'Art Brut, Mainstream, and Mass Media.

Outsider Art Movement (c. 1980 CE): A movement outside the mainstream art world started by outsider artists, mainstream collectors, dealers, and galleries to promote Outsider Art. Intuitive, Self-Taught, and Visionary Artists are thought to be Outsiders.

P-Q

Paint by Numbers (1950 CE): M.S. Klein an engineer and owner of Palmer Paint Company and commercial artist Robbins invented the first painting by numbers kit.

Based on the Yellow, Blue, and Red color model, these kits made it possible for almost anyone to create an oil painting. Even though the art community snubbed their nose at this concept, paint by numbers eventually became a popular teaching aid along with Crayola coloring by numbers.

Paintbrush (origins, c. 40,000-10,000 BCE): The first paintbrushes may have been constructed from twigs and grasses. The contemporary painter on the other hand has four primary categories of paint from which to choose, oil, watercolor, Sumi, and acrylic paint. Each medium has its own set of brushes. While most of these brushes are compatible with other mediums, most painters are very particular and use one set of brushes for each type of paint.

Contemporary (c. 2000-2017) paintbrushes are available in a variety of natural woods or synthetic resin handles. At the base of the handle, a brass or steel ferrule holds either natural animal bristles or hair or synthetic bristles or hair.

The bristles and hair of these brushes ranging from soft to a hard differ in length, size, and shape and paint capacity. Consequently, the choice of a well-made brush helps determine the effect of a brush stroke.

Painting, Discipline of (c. 40,000-10,000 BCE): As a discipline, painting has gone through several changes over the last forty-two thousand years. Some of these changes include the development of new concepts, styles and painting techniques.

The one constant that has remained throughout this disciplines evolution is the premise that an original painting has intrinsic value, and that one individual creates the work by hand.

While some members of the visual fine arts community have attempted to change this fundamental precept, others have built upon it and developed several different categories and genres pertaining to painting.

It is often said that a picture is worth a thousand words. Nevertheless, the communiqué of all pictographic languages need some additional insight into the veiled or profound meaning behind the image itself.

Aside from this and regardless of the genre, the discipline of painting has a technical process, which at times can be quite complex. Knowing what materials and techniques to use, and the appropriate alchemy, is a skilled art in itself.

In light of this, it might help the layperson to understand and appreciate the process of creating a painting, from the initial conception to the final *overpainting*. However, the process in which a painting is completed may vary from artist to artist. The following is just one example of the technical procedures.

Working with a chosen *style* the painter decides upon the content/subject matter, than goes through the design process and lays out the composition. The artist will select from a variety of paintable surfaces, than choose the type of paint and medium. It is essential that the surface material be compatible with the paint and medium.

The following is a partial list of painting surfaces: 1: canvasboard, 2: paper canvas, 3: plastic or Plexiglass™ sheets, 4: rice paper, 5: watercolor paper (cold/hot/rough press) 6: watercolor cotton canvas, 7: wood or composite wood panels, 8: glass sheets, 9: synthetic fabric canvas, 10: linen, or 11: cotton duck canvas.

If the artist chooses to paint with oils, and is leaning towards using linen or canvas he/she must decide upon whether to use a pre-stretched linen/canvas, or elect to personally stretch the linen/canvas over the *framework* of four butt-end or mitered stretcher bars made of wood, or wood/metal.

If the artist elects to stretch the linen or canvas, he/she must choose between raw linen/canvas, or use linen/canvas pre-primed for oil paints, or for acrylic paints.

The weight of the canvas is also important. Cotton Duck canvas weights range from 6 to 14 ounces. Using a lightweight cotton canvas for large or heavy impasto paintings, the canvas will eventually begin to sag from the weight of the paint.

If the artist is going to use raw linen/canvas, the stretched material must be prepared, using oil based primers/gesso and/or rabbit skin glue.

If the artist is going to complete an acrylic painting, no gesso is required. However, the artist may want a smooth glass like surface to paint on and will use acrylic gesso to prime the canvas, then sand the gesso down to achieve a smooth flat surface.

After completing the process above, the artist returns to the initial composition (content and design), and decides whether to use, or not to use an under-drawing or *under-painting*. Once the artist goes through these initial steps, he/she will choose which professional artist paints and/or inks to complete the painting.

The following is a list of tools and techniques used to apply paint to a canvas or suitable surface.

1: *alla prima*, 2: *airbrush*, 3: blotting, 4: *brushes*, 5: *glazing*, 6: dripping, 7: *impasto*, 8: layering, 9: mottle, 10: *painting knives*, 11: splatter, 12: *soak stain*, 13: sponging, 14: Wet-in-Wet.

Paints are available as powder pigments, in solid sticks or liquid states. Premixed pigment colors can be purchased in jars or in tube containers and come in a choice of liquid states, ranging from watery to soft butter to a thick paste.

The following is a list of paints manufactured for the contemporary studio dwelling artist/painter.

1: acrylic polymer paint, 2: alkyd paint, 3: airbrush paint, 4: casein paint, 5: encaustic paint, 6: enamel paint, 7: designer gouache, 8: oil paint, 9: oil paint sticks, 10: pastels, 11: Solvent free oil paint, 12: Sumi ink, 13: tempera paint, 14: watercolor paint, 15: water mixable oil paint, 16: spray can paint.

The following is a partial list of acrylic mediums and varnishes:

1: matte gel medium, 2: pumice stone medium, 3: iridescent tinting medium, 4: opaque gel medium, 5: modeling paste extender, 6: molding paste medium, 7: gloss gel medium, 8: gloss medium, 9: gel retarder medium, 10: Illuminating medium, 11: UV resistant acrylic varnish, 12: clear acrylic coating and varnish, 13. Acrylic matte varnish, 14: kamar varnish, 15: matte finish varnish.

The following is a partial list of oil, alkyd and solvent free mediums: and varnishes:

1: alkyd glaze and drying medium, 2: alkyd resin gel, 3: cold wax medium, 4: dammar varnish, 5:flaxseed oil & gel (solvent free), 6: gloss varnish, 7: gum turpentine, 8: Japan dryer, 9: linseed oil (solvent free), 10: mineral spirits, 11: oil impasto medium, 12: poppy oil (solvent free), 13: Retouch varnish, 14: safflower oil & gel (solvent free), 15: stand oil, 16: transparent glaze, 17: walnut oil.

In addition to this, a painting must never hang on a wall that is exposed to direct sunlight or behind a window facing the sun. Doing so can cause extensive damage to the painting.

The following types of paintings should never be stored in warm, damp conditions such as lavatories or cellars, nor in extremely arid environments:

1: acrylic, 2: alkyd, 3: casein, 4: collage, 5: egg tempera, 6: encaustic, 7: gouache or designer gouche, 8: mixed media, 9: oil, 10: pastel drawings or paintings, 11: Sumi, 12: watercolor. Please refer to original, concept, style and echnique.

Painting Knife: In addition to the paintbrush, another method of applying paint involves the use of the painting knife. It is possible to achieve some level of detail with a painting knife that typically is thought to be attainable only with a brush. Nevertheless, just like the paintbrush, the choice of painting knife, and the type of stroke of the blade are crucial to achieving a desired effect.

While various forms of the painting knife date back to the Predynastic Period (c. 3650-3150 BCE), this tool became popular in the seventeenth century with painters such as Rembrandt.

There are at least thirty-two different designs for the painting knife, each with a unique blade, shape, and size. Contemporary painting knives are available in a variety of natural woods or synthetic resin handles.

Depending upon the style of knife, a blade will have a thick shaft and double bend or crank, or a shaft with no crank. The shaft embedded in the base of the handle is held in place with a brass or steel ferrule. Both types of shaft lead to a thin blade made of flexible stainless steel.

Supplementing the painting knife is the palette knife, which serves a utilitarian purpose. The primary function of the palette knife is to mix paint and/or spread a substantial amount of paint on a surface. The palette knife looks very similar to the spatula used by confectioners to spread frosting.

The palette knife is available in two designs and manufactured with a choice of natural wood or synthetic resin handles. One design has a cranked shaft with a stiff, flat, wide blade, and the other has a blade with no crank and has a stiff, flat, wide blade. Each style comes in three different lengths and widths.

Papier Collé (c. 1912 CE): Conceived by Braque. His first Papier Collé titled Compotier et Verre involved pasting pieces of wallpaper to a drawing on paper. Refer to Collage and mixed media.

Pastels (Western Europe, Perigordian Period 32,000-28,000 BCE): Used primarily for drawing, this material is suitable for painting. Even though artists have used Pastels for thousands of years, this media did not receive notoriety until the 18th century.

Manufactured Pastels (hard and soft) consists of various compositions of Gum Tragacanth solutions and water miscible color pigments such as Champagne Chalk. For additional information regarding the care and storage of pastel drawings and paintings, refer to painting.

Performance Art (c. 1916 CE): A Multi-Media or interdisciplinary performance, which may or may not involve the audience in a spontaneous or scripted routine. Early influences are found in Dada and Guerilla Theater.

Performing Arts: Of or relating to any of the disciplines involving dance, music or theater (opera, drama, spoken word, comedy including stand-up comedy).

Photomontage (1915 CE): A variation of the Collage: A German movement and technique conceived by Heartfield (photographer and publisher) and, Grosz (painter, lithographer, and writer).

A photomontage is a composite picture made by assembling pieces of photographs and/or pieces of graphic material from newspapers or posters. From this composite photomontage, a seamless photographic print can be developed.

Other artists to work with this technique were Höch (draughtswoman, photomontagist, and painter), Moholy-Nagy, and Schwitters. In 1980, Hockney created a new type of Photomontage when he began working with Joiners, a composite of Polaroid photos. Refer to Cubism, Collage, Dada, and Papier Collé.

Photo-Realism or Grid Painting (c. 1963 CE): Grid Painting is a technique and system of painting developed by Close. The process involves placing a scaled grid onto a large canvas then superimposing a photograph over the grid. Close often allowed the grid to show through in the finished work.

Using a projector, an image from a photograph, slide, film negative or cinema film still is superimposed directly onto a canvas or some other painting surface. The projected image, now traceable, is a baseline to create an underpainting and completed later. At such time, the artist can then emulate the realism found in the photograph, or depict any style of choice.

Picasso, Pablo (25 October 1881-8 April 1973 CE): Ceramist, draughtsman, lithographer, painter, set designer, and sculptor. Encouraged by his father **Blasco** (painter, instructor and museum curator); Picasso began to draw and paint at a very early age. By the age of fourteen, he had become a master draughtsman and long surpassed his fathers' expectations as a painter.

Picasso enrolled at the Llotja School of Fine Art in Barcelona, and then at the Royal Academy in Madrid. However, Picasso was not satisfied with the concept of Realism, and the outdated methods of Formalism taught at both schools.

In 1900, Picasso moved to Paris and was impressed with the paintings by Gauguin. By the age of twenty-five he had mastered the styles of numerous Parisian artists, had gone through his Blue Period (c. 1901-1904 CE), and the Rose Period (c. 1904-1906 CE).

According to authors close to Picasso, he had been impressed with works by Cézanne (Naturalism), the concept of Divisionism, and the conceptualism found in African primitive art. There is also some speculation that works involving *Frontality* influenced his work.

In 1907, Picasso completed the painting titled Les Demoiselles d' Avignon. From this point forward, Picasso's work would take a new direction. That same year Apollinaire introduced Braque to Picasso.

Picasso and Braque continued with their collaboration until the war broke out in 1914. A pacifist at heart Picasso did not enlist in the army. However, Braque had enlisted and understood Picasso's position. Consequently, some of Picasso's colleagues were not as empathetic and began to chastise him. Twenty years later, Picasso would use painting as a weapon to fight the fascists in his own way.

After World War I ended, Braque and Picasso remained good friends and over the course of both artists' lifetimes, their work continued to evolve. Refer to Braque, Cubism, and Guernica

Pissarro, Camille (1830-1903 CE): The Patriarch of the Impressionism. Although Pissarro had no formal training in the Studio Arts, he had taught himself the fundamentals of painting outdoors. In 1855, he moved to Paris, where he attended Ecole des Beaux-Arts.

However, displeased with the instruction there, he sought the advice of experienced artists. In 1860, Pissarro met an established painter by the name of Corot, who befriended and gave counsel to the younger artist.

Pissarro proceeded with his own studies in art theory, continued to adapt new painting techniques and to study the effects of light, climate, and seasons in relationship to color. Friends and colleagues of Pissarro recognized that he was the backbone of the Impressionist group.

Pissarro's influence was extensive as it affected works by Caillebotte, Cassatt, Cézanne, Gauguin, Monet, Sisley, Renoir, and two other contemporaries, Seurat and van Gogh. Pissarro later acknowledged that the lighting in the Salon should have been a concern of the Impressionists.

Pointillism (c. 1891 CE): A Post-Divisionist movement and style of painting started by **Signac**. Before Seurat's death, he and Signac became friends, after which time Signac began painting in the Divisionist style. After Seurat's death, Signac and two prominent artists **Cross** (painter) and **Luce** (painter) started to use the Pointillist technique.

These artists were more concerned with the type or style of the brush stroke, rather than how the eye perceived the division of color. The movement was short-lived due to alleged limitations and the meticulous nature of the technique/style.

Pop Art (Great Britain, c. late 1940's CE): The forerunners of the Pop Art movement belonged to the Independent Group, a group of British painters, which consisted of **Alloway, Banham, Hamilton**, Smithson, Smithson-Gill, and Paolozzi.

Shortly after WW II, the British Avant-garde composed of Blake and Paolozzi began working with the concept of Pop around the same period. Both of whom had been impressed by values found in Dada and Photomontage, and. inspired by a variety of concepts ranging from Cubism to Papier Collé.

Pop Art, a Post-Dada movement first emerged in London, England in 1952. Often referred to as Neo-Dada, the concept of Pop pertains to the influence Mass Media had on the public, and how the form of a particular work expresses an artist's attitude toward Mass Media's manipulation of popular culture.

In 1955, Pop Art had reached the New York School, but without the angst. The new Avant-garde consisted of artists like Johns, Rauschenberg, Segal and Marisol who were creating works that appealed to both the eye and the mind. By 1957, the movement had spread to the West Coast with artists such as Bengston, **Ruscha, Altoon, Dine**, and **McCracken**.

In the early 1960's, both Lichtenstein and Warhol had mastered the art of media manipulation and took Neo-Pop in a different

direction. Rosenquist, Oldenburg and **Wesselman**, and Haring would join the Neo- Pop culture. Refer to Retinal Art.

Post-Modern Art (c. 1901-1950 CE): Refer to Art Period.

Post-Painterly Abstractions (c. 1960 CE) is a term that would become an umbrella for several genres. Post-Painterly Abstractions refers to individual concepts and/or styles known as Hard Edge Painting, Color Field Painting, Minimalism, Op Art, and Lyrical Abstraction. Eventually, the genres under Post-Painterly Abstractions would fall under the umbrella of Abstract Expressionism.

A few of Americas Avant-garde painters were **Kelly** (Hard Edge Painting, Color Field Painting, Minimalism), **Newman** (Color Field Painting), **Noland** (Color Field Painting), Stella, F. (Minimalism), **Marden** (Minimalism), **Lanfield** (Lyrical Abstraction) and Poons (Op Art, Minimalism) and Riley (Op Art).

Prehistoric: Many archeologists believe human history began with the written word. However, humankind's first documented history began with the visual communiqué of paintings in Western Europe during the Upper Paleolithic Period (c. 40,000-10,000 BCE).

Primary Light Colors: Of or relating to the White Light Spectrum. There are three sets of primary colors.

1: The three primary colors used by artists are Yellow, Blue, and Red.

2: The three primary colors in modern electronics are Blue, Green, and Red, which are converted to a color difference model.

3: Print houses, print shops, graphic artists, home/office printers and ink manufacturers use the CMYK color model (Cyan, Magenta and Yellow, Black = K).

Refer to Color Wheel System, Primary Light Colors, Light, Electromagnetic Theory, and White Light Spectrum.

Propaganda 1: Of or relating to the deliberate use and/or manipulation of unverified information. 2: The use of unverified information or rumor to help, or do harm to another person or

group. 3: To use unverified and/or unclarified information to further ones own cause, and/or deliberately do harm to the opposition.

Public: Of or relating to the general population.

Pure alla prima: Of or relating to a painting technique in which there is no under-drawing or under-painting. Also, the desired final effects are achieved in the initial and only application of paint. Refer to alla prima, under-drawing, and under-painting.

R

Rapid Prototyping (c. 1995 CE) a.k.a. RP: Post-Neo-Pop Sculpture. A high-tech process using computer-aided design programs to create sculptures. Working with design programs, the designer sends a completed design file to an RP manufacturer. The manufacturer feeds the information into a computerized machine that generates the actual sculpture by firing laser beams into a resin-based material.

Raison D'être (French): Reason or justification for existence.

Ready Made (c. 1913 CE): Of or relating to sculpture and conceived by Duchamp. The idea behind the Ready Made is to purchase items not perceived as typical artist materials, and then to arrange, rearrange or re-assemble the merchandise as an art form.

In 1913, Duchamp created his first Ready Made titled "Bicycle Wheel". Although this work was lost, he stated that materials included the rim of a bicycle wheel, the front fork of a bicycle and a wooden stool. Duchamp later created the Ready Made titled "Fontaine" (Fountain). The materials consisted of a single toilet bowl (bol de toilette). Refer to Collage, Construction, Cubism, and Duchamp.

Realism (c. 1430 CE): 1: A style of painting, which requires the subject matter to be rendered truthfully, exactly as it appears in reality in 3 dimensional form, natural color and accurate modeling. Reality being a paradox, often presents philosophical discussions.

Relief (Magdalenian Period, c. 15,000-10,000 BCE): A relief is a type of engraving having various three-dimensional qualities. To

create a relief the artist may choose to use a hammers and chisels, carving tools, engraving tools or power tools. Materials generally consist of stone, metal, glass, Plexiglas, or wood.

There are five types of relief engraving. 1: *high relief,* 2: *low relief,* 3: *middle relief,* 4: *crushed relief,* 5: *relief-in-reverse,* 6: In addition to these methods is the cast relief technique, which involves using molds and materials such as molten metal (generally bronze), glass, liquid plasters, or plastics.

Relief-in-Reverse (hollow relief, incised relief, sunken relief or concave relief): Of or relating to relief engraving techniques. To crete effects in reverse the engraver uses specialized tools to carve out a shape below the surface of a metal plate.

The purpose of this technique is to create the illusion that the shape rises above the surface plane, as in a high relief. Refer to high relief, low relief, middle relief, and three-dimensional quality.

Religion: Religion is an assemblage of cultural, spiritual, and belief systems. At present there are at least one hundred known religious and spiritual systems across the globe. One religion is not superior to another religion. Refer to New Age Spiritualism and War.

Religious Right or Christian Right (c. 1970 CE): Of or relating to right-wing ultra-conservative Christian groups, which includes politicians, that use their religious beliefs as a means to influence government policy, on both state and federal levels.

Hiding behind the First Amendment, they attempt to force their beliefs on other Americans, or hide behind the First Amendment to promote hate and to justify sanctions they place against groups that do not adhere to, or believe in their particular religious and/or moral codes.

Representational ((Upper Paleolithic Period, c. 40,000-10,000 BCE): Humanities first representationalists and conceptualists were the cave dwelling artists as they rendered 2-dimensional scenes of animals and human beings on cave walls.

In this context, representational means to render or depict something of a physical nature in a manner that represents the subject, but not exactly as it appears in reality.

Depending on the school of thought, the term representational may also mean to render or depict something of a corporeal nature truthfully, as something appears in the real world.

In a broader sense of the term, all styles of painting including abstract and concrete art are representational. This is evident when one considers that each style represents something, whether it is corporeal or simply an idea without physical form.

Retinal Art (c. 1950 CE, conceived and popularized by Marcel Duchamp): Of or relating to works of art created to please the eye rather than to engage the mind

Ruralism: An ideology developed by a group of seven artists who moved from urban to rural life, which they rendered in their paintings using various styles. The intent of this group of artists was to leave the hustle and bustle of London, in order to break away from socio/political issues. The artists were Blake, Haworth, A. Arnold, G. Arnold, A. Ovenden, G. Ovenden, and Inshaw.

S

Salon: Early in the 19th century, the artwork was seldom the focal point of the European Salon. The typical Salon was generally overcrowded with furniture, and the rooms rarely had adequate light (natural or artificial) to see the crowded artwork on the walls.

This, however, changed when Whistler began to approach the idea of the Salon with a fresh attitude. Influenced by aesthetic values found in Japanese interiors, Whistler turned the Salon into an orderly space in which the artwork became the focal point and shown with adequate natural light when possible.

Late in the 20th century, the decor of the commercial gallery became a streamlined open space, generally having sufficient light, solar and/or artificial, to view the artwork. The new and improved galleries have sparse seating arrangements (if any), but still serve as a meeting place for art patrons on First Friday and on opening night of a new exhibition.

San Francisco Mime Troupe, SFMT (1959 CE): Founded by R. G. Davis. Winning a court case against censorship, Davis, and the troupe would go on to produce politically minded, satirical plays

against racism and the Viet Nam War. Two years later **P. Berg** (writer/activist) coined the phrase and dubbed the SFMT, Guerilla Theater.

Secco (Ancient Egypt, Old Kingdom Period c. 2680-2260 BCE): Secco painting is a technique that involves coating interior walls of pyramids or personal dwellings with a thin coat of wet lime plaster. After the plaster had dried, artists used a type of watercolor or casein to paint decorative designs on the freshly coated walls. Refer to watercolor and casein.

Section d'Or (c. 1912 CE) Golden Section: A group of Parisian artists working with Cubism. Members included Delaunay, Duchamp, Duchamp-Villon, Gleizes, Gris, Herbin, Léger, Le Fauconnier, Lhote, Marcoussis, Metzinger, Picabia, Villon, and Kupka.

Self-Taught (c. 40,000-10,000 BCE): The cave-dwelling artist was the first of many self-taught artists to evolve over the years.

Even though Monet and Pissarro received limited formal instruction, they once were thought to be self-taught artists. This belief stemmed from the fact that their creativity did not originate from their academic instruction.

Nevertheless, the term Self-Taught was redefined after the Outsider Art Movement began in the 1980's. The new definition refers to an individual who has received no formal education, instruction or training in the Studio Arts. It is however, acceptable for mainstream art, books or Mass Media to have had an influence on the Self-Taught artist and their work.

Refer to Grassroots Artist, Intuitive Art, Visionary Art, Mainstream and Mass Media.

Sense: 1: Of or relating to the meaning or interpretation of something, such as a mental impression, a feeling, or function. 2: Of or relating to any of the five physical senses; hearing, sight, smell, taste, and touch. Each sense serves as an autonomous organic communication mechanism.

This synchronous biotic network receives and transmits information/impulses via the central nervous system to the brain. The mind then processes and interprets these impulses as thoughts.

The five organic communication mechanisms, however, do not always function in the same manner for each individual. In regards to the sixth sense, refer to intuitive. Also, refer to museums, Tactile Art, Tactile Dome, and Visual Art.

Silent Generation (c. 1925-1945 CE): The meat and potatoes generation that came of age during the Great Depression, W. W. II, and lived with the shadow of McCarthyism. For the most part, the Silent Generation did not want to make waves.

Refer to The Beat, The Beat Generation, Baby Boomer Generation, and Millennial Generation.

Soak Stain: (1964 CE) is a painting technique developed by Frankenthaler. Essentially, this process involves diluting paint with thinners and mediums to water like consistency. The diluted paint is poured onto a canvas, and allowed to soak into a canvas.

The next step is to pick up a section of the canvas and allow the liquid paint to swirl and run to another section of the canvas. This method is repeated until the desired effect is achieved. Typically, a composition consists of multiple colors, along with charcoal contour lines drawings.

Société des Vingt, Society of Twenty (c. 1891 CE): This group of Belgium painters focused on the mysticism, illusion, and symbolism of one's inner or spiritual life, rather than concentrate on corporeal life. Two of the most renowned forerunners of the Symbolist movement were Munch and Ensor.

In 1892, the Verein Berlin Kiinstler (Berlin Artists Association) censored and closed Munch's exhibition in Berlin. This action by the Berlin Artists Association served as a catalyst for the Berlin Art Revolution. Refer to German Expressionism.

Space: Also known as outer space, cosmos or universe, which may be part of an infinite number of multi-verses.

The National Aeronautics and Space Administration (NASA) established that space begins at an altitude 75 miles above earth's sea level.

Depending on the school of thought there are a least six independent dimensions pertaining to space.

1: Space: A dimension in which all phenomena takes place.

2: Space: The surrounding environment, or an area with fixed or variable spatial dimensions.

3: Space: The distance (a straight line measure) between point (A) and point (B). In the event an additional point (C) is placed anywhere between (A) and (B), the line/distance becomes a variable (warp line~wave or twist) of the fixed distance of (A) and (B).

4: Space: An intangible and infinite dimension where all material objects exist.

5: Space: Often thought of as a vacuum or void.

6: Space: An unfocused feeling, a preoccupied state, or a state of euphoric enlightenment.

Space-Time: (1908 CE) The fourth dimension consists of time as one dimension, and space, in which three distinct spatial dimensions exist. Joined together all four dimensions form a single continuum.

Spatialism, Spazialismo (1947 CE): An Italian movement founded by Lucio Fontana, and Joppolo. Fontana's primary goal was to transcend the boundaries of the canvas. His abstract *installation* synthesized space, sound, color, movement, and time, which involved the use of neon and canvas with slits through which the audience could peer.

Studio Arts or Studio Fine Arts: The Studio Arts refer to the disciplines of drawing, painting, sculpture, printmaking and photography. Each of these disciplines has a specialized field that is related to a genre such as Cubism, or category, such as Collage, Mixed Media, Combines, Photomontage or Giclée.

Style, Dimension of: Depending on the school of thought, there are at least three interpretations of this term, which concerns the discipline of painting.

1: Style: The pictorial language associated with an artist or group of artists.

2: Style: The intrinsic value of a work/painting.

3: Style: The manner in which three separate dimensions [a] are fused together to create a succession of works that possess some element of consistency.

[3a] Three Dimensions of style: Content [I], Design [II], Technique [III].

[I] Content: Something that is contained within fixed boundaries, such as the text within a book. Content is often described as subject matter, which in turn may refer to the title or theme of the painting.

However, a title or theme may not necessarily pertain to everything that is rendered. In this instance, content pertains to everything that is portrayed in a painting.

In essence, content is the heart and soul of any painting. It is one of the most difficult or challenging dimensions (of style) to bring to realization, as it relies entirely on the execution of the design and technique.

[II] Design (a.k.a composition)) 1: A drawing/sketch/layout of a garment and its intended appearance. 2: A floor plan for a building. 3: A sketch for a machined mechanism, such as a screw.

In reference to painting: A design is a pictorial syntax or the process that is a key element in bringing the content of a painting to realization. This process involves drawing or making a sketch of the composition, layout or arrangement of the content and the color scheme. The painting technique may also be considered part of the design process.

[III] Technique: Of or pertaining to the act of painting. A technique is a method involving the application of paint to a canvas or other suitable surface. There are several techniques that include the skillful and unique use of brushes, paintings knives, dripping, staining, spraying, layering, glazing or various impasto and/or alla prima processes.

Technique and Style are often mistaken to have the same meaning. While technique is one dimension of style, the two terms have dissimilar purposes.

Sumi a.k.a. Chinese ink (Ancient China, Han Dynasty c. 206 BCE-220 CE): A water miscible vehicle, consisting of a carbon-based mixture made with burnt pine or lampblack and a glue binding agent.

Sumi typically comes in the form of a short hard stick, approximately 2-5/8" x 5/16". Two traditional types of Sumi are bluish black and brown. In addition to these, contemporary Sumi is available in primary and secondary pigment colors, and white and black. Refer to Color Wheel System.

Sumi-e: Chinese ink picture. Sumi refers to Chinese ink; e refers to picture. Also, see painting for additional information regarding care and storage of Sumi-e.

Suprematism (1913 CE) was conceived by Malevich (painter), and published in 1913. Malevich's hypothesis materialized in his manifesto on Suprematism. Malevich was intensely opposed to all forms of utilitarian art and all imitations of nature such as representationalism and realism.

Part of this theory was to separate the utilitarian element by eliminating the intrinsic value, believing the appreciation of the work of art would perdure on its own. **Lissitzky**, another prominent artist in the Russian art community, also embraced Suprematism.

Surrealism: (c. 1925 CE): A style of painting founded by Benton (art critic, poet, and theorist). Liberating the subconscious mind from conventional thought, the Surrealists used unorthodox themes to create their art. Official members of the Surrealist movement consisted of **Dali** (painter), Ernst (painter), **Magritte** (painter), Miró (painter), and **Tanguy** (painter).

Synchromism: (c. 1913 CE) A painting style in which the rendered form consists of sinuous lines, and with the intent to create emotion with color. Conceived by Macdonald-Wright (painter) and Russell (painter), this style of painting became an American movement.

T

Tachisme: Tachism, Abstraction Lyrique, Autre Art, Art Informel (c. 1947 CE), A concept and style of painting in which the content is deliberately mottled. The technique involves dripping

paint, using blobs of paint or squeezing paint directly from a tube to complete the work. Members of the French Avant-garde and proponents of this concept were **Fautrier**, **Mathieu**, and **Wols**.

Tactile Art, a.k.a. Art for the Blind (c. 1966 CE): Of or relating to works such as sculptures, replicas of original artwork and craft items that possess tactile qualities. Originally, these works were created to be experienced as visual art.

In the early part of the 20th century, the World of Art made an exception to the "Please Do Not Touch" rule. This exception applied to Helen Keller, author and international lecturer (1880-1968 CE) who was blind and deaf from birth.

While Keller was permitted to experience the form of sculptures through the tactile sense, the "Please Do Not Touch" rule continued to be policy for the public, including people who are blind or visually impaired.

In 1966, the North Carolina Museum of Art established a program, which allowed people who are blind to experience Tactile Art. Subsequently, various institutions began to establish Touch Tour programs for people with visual impairments. A few institutions that offer touch tours are:

1: The Museum of Modern Art (NY), 2: The Museum of Contemporary Ideas (NY), 3: The Philadelphia Museum of Art, 4: The Joseph H. Hirshhorn Museum and Sculpture Garden in Washington, D.C.

Note: There is a difference between Tactile Art and art created to have Multi-Sensory qualities. Nevertheless, many people from the public sector and members of the visual fine arts community erroneously believe that people who are blind are unable to comprehend and/or appreciate artwork from the Studio Arts.

Tactile Dome (1971 CE): A movement and installation involving Art and Science. Conceived by **Dr. Coppola** (academic, author, film executive, advocate for the arts and the Dome designer) The Dome was co-developed by Carl Day (architect and gallery director).

In 1971, the Exploratorium at the Palace of Fine Arts (San Francisco, CA) opened the Tactile Dome. The Palace of Fine

Arts was one of, if not the first museum to open this type of exhibit to the public.

The concept behind this installation is to make the public aware of how complex and underused the sense of touch is. To help bring this to realization, the only way an individual can experience the installation (a darkened maze inside a large geodesic dome) is by using the tactile sense alone. Also, refer to museum and Tactile Art.

Technique: Of or pertaining to painting. A technique is a method that involves the application of paint to a canvas or other suitable surface. There are several techniques that include the skillful and at times unique use of brushes, paintings knives, dripping, staining, spraying, layering, glazing or various impasto and/or alla prima processes.

Technique and Style. While technique is one dimension of style, the two terms have dissimilar purposes. Even though, a Technique and Style can possess the same neologism, they have two separate meanings.

Paintings that are completed by two or more individuals and the use of mechanical devices or computer technology fall under specialized categories of painting such as Interactive mechanical and/or computer painting techniques.

Term 1: The usage of the word *term* may refer to, 1: a word, 2: a phrase, 3: locution, 4: idiom, or 5: neologism. The word *term* may also refer to a length of time.

Textural: Of or relating to the structural makeup, appearance, and/or feel of an object or material.

Three-Dimensional Quality: A three-dimensional object has height, width, depth, and a $360°$ view. A two-dimensional object has height and width, and angle views up to $180°$. However, a three-dimensional object placed on a flat surface creates a two-dimensional illusion.

Time (c. 1500-700 BCE) Origins: Gnomon and Sun Dial: Time is a concept involving units of measurement that mark the progression of seconds, minutes, hours, days, months and years. Time can also mean to mark a specific point of occurrence.

In addition to this, a Light Year is measurement of distance, which determines how far a beam of *light* travels within one human year. One (1) Light Year equals approximately 6 trillion miles.

Title: A title is a form of descriptive reference, and may refer to the name of a book, painting or sculpture. A title may also refer to person's gender, such as mister or miss. While titles do not define who a person is, they do serve to help describe an individual's vocation.

Some individuals however, believe that having a title that signifies power or some importance means that everyone should automatically show them respect. This is a fallacy. Regardless of a person's title, respect is something one earns it is not an entitlement.

In the Studio Arts, Artist is the title reserved for an individual who creates works of visual art. However, in recent years members of the Performing Arts began to adopt this title.

While there is no written rule against it, some consider it disrespectful/pretentious for an artisan, artist or artiste to give oneself an esteemed title, such as the Father of...

A few Studio artists that have received honorific titles are Cézanne, known as The Father of Modern Art, de Chirico known as The Father of 4^{th} Dimensional Art, Frankenthaler known as The Matriarch of Soak Stain Painting, and Pissarro known as The Patriarch of French Impressionism.

In the Performing Arts, Artiste is the title reserved for an individual who performs or entertains. A few select artistes have received honorific titles, such James Brown, known as The Godfather of Soul, and Elvis Presley known as The King of Rock-n-Roll.

Another honorific title bestowed upon someone is that of Lady or Sir, such as Sir Elton John. It is also appropriate for an artiste like Calvin Cordozar Broadus Jr. a respected musician, to give himself the moniker of Snoop Dog.

Toulouse-Lautrec (c. 1888 CE): Lautrec was not associated with any particular Parisian movement. However, his creative new style of illustrative painting rendered a unique perspective into

Parisian nightlife. As one of the Parisian Avant-garde, his work would greatly influence the upcoming movement of Art Nouveau.

Trilogy of Painting: This trilogy involves the creation of a new concept, a new style and a new painting technique, all of which have a single interrelated neologism. Over the last one thousand, nine hundred, and fifty years, only a few painters have worked with or brought the Trilogy of Painting to realization. They are Seurat (Divisionism), Mathieu (Tachisme), and Frankenthaler (Soak Stain Painting).

Trompe-l'œil (c. 75 CE): A French term meaning to deceive the eye. This particular style of painting dates back to Pompeii, Italy c. 75 CE. Archeological finds show the remains of frescos, In which the illusion of doors and windows were created on interior walls.

It is very possible that Christian monks intentionally overlooked the Trompe-l'œil style during the Medieval Period as they only approved of the Illuminations and Visionary Art. Nevertheless, the Trompe-l'œil style regained popularity during the Baroque period.

One of the most famous artists to use the Trompe-l'œil technique and style was Harnett.

U-Z

Under-Drawing: Generally, a new painting will start with an under-drawing unless the Pure All Prima technique is used. To begin the painter will generally start with a pencil or charcoal sketch/drawing of the content that either will lack detail or will have much detail.

Under-painting/Over-painting: If not using the Pure All Prima technique, the artist may choose to start a new painting with an underpainting. This may or may not consist of an under-drawing. In either case, the artist will use grayscale, monochromatic or several colors of paint to create a vague rendering of the content.

After the completion of the initial under-painting, the artist adds more detail and layers of paint until the final layer or over-painting is applied.

United States Capitol: Construction for the Capitol Building began in 1793. Seven years later the U.S. Congress met for the first time in the North Wing. To accommodate the nation's growth, and its new Representatives and Senators, Congress authorized the expansion of the North and South wings of the building.

United States Congress: The United States Congress is a bicameral legislative body consisting of 535 members. The two branches of this governing body consist of the U.S. Senate with 100 members and the U.S. House of Representatives with 435 members.

The House also has six non-voting members who represent Washington, D.C., Puerto Rico, American Samoa, Guam, the Northern Mariana Islands and the U.S. Virgin Islands. Members of the House serve a two-year term, whereas members of the Senate serve a six-year term. Voters in each of the fifty States elect members of Congress into office.

Members of Congress earn an annual income of $176,000 plus benefits. 47% of Senators are millionaires, while the average annual income for a middle class family is $46,000, and the average annual income for a low income family is $16,000.

Utilitarian: Of or relating to something or to an object possessing a practical, functional or useful purpose.

Visionary Art (Medieval period, c. 375-1002 CE): During the Medieval period, monks under The Church believed that the visionary artists received Divine Inspiration for all their designs.

Later, in the twentieth century (c. 1980's) advocates for visionary art alleged that these artists relied solely on their visionary powers. These artists also claimed they were not consciously or subconsciously influenced by mainstream culture or by Mass Media. Refer to Outsider Art, Intuitive Art, Mainstream and Mass Media.

Visual Art (a. k. a. visual fine art): Of or relating to works of art created within the Studio Arts. Also, refer to Arts and Sciences.

Visual Communication (c. 1970's CE): 1: Of or relating to the utilitarian studies in Graphic Design and Mass Media which

involve Advertising, Comic Book/Comic Strip art, Film, Television and Multi-Media Computer Programs.

Visual Fine Arts Community: Of or relating to a local, national or global community concerning the Studio Arts and Fine Crafts. 1: academia (educational institutions, teachers, professors, researchers and students). 2: alternative art spaces. 3: architects. 4: artisans 5: artists (draughtsmen, painters, photographers, printmakers and sculptors). 6: art galleries/salons 7: art museums 8: art organizations 9: art conservators. 10: art consultants. 11: art critics. 12: art curators (museum and independent. 13: art historians. 14: art patrons. 15: art periodicals. 16: members of the Film/Performing Arts.

War: (c. 1500 BCE): As a people, Homo sapiens have been waging war against each other for the last 3,500 years. The top three reasons humans justify lethal warfare are as follow:

1: Holy War: This is the most absurd and heinous type of warfare. Holy War may be instigated by followers of one religious dogma, who do not agree with the doctrines of another sect, or covets the other's land. In a Holy War, the regard for human life is sacrificed, and no human being is indispensable including women, the elderly, children, and clergy.

2: Economic War: A war to protect corporate interests, which involves governments, military and/or rebel troops. An Economic War generally starts so that one power may seize, or maintain control of a government and/or its land, and/or the economic growth of a particular country. Soldiers are dispensable units, and civilians are considered casualties of war.

3: Military War: Despite social and technological advancements made over the last forty two thousand years, Some Homo sapiens cannot get past the idea of resorting to deadly warfare to resolve socio/economic/political disagreements. Nevertheless, soldiers are dispensable units, and civilians are casualties of war.

4: War of Words: A type of war in which an individual, author, writer or journalist will use words as their weapons of choice. In such a war, a combatant's ego may be hurt or bruised, but, for the most part nobody dies.

5: War on Art: An attempt to suppress, nullify or censor the intellectual and/or visceral properties and/or processes, which are involved with the creation of an art form.

6: Art of War: 1: Art Revolution 2: Dada, 3: Guernica, 4: F-111.

Watercolor (c. 40,000-10,000 BCE) 1: A mixture of crushed colored earth and water, or crushed berries.

2: (Egypt, Predynastic Period, c. 3650-3150 BCE): an organic color pigment mixed with water and an unknown substance/glue as a binding agent.

3: (Medieval Europe c. 375-1000 CE): Watercolor paint becomes a water miscible vehicle, consisting of animal glue and color pigment.

4: (Great Britain, c. late 18th century): Watercolors become a manufactured product, and around the same time artists begin to use the Wet-in-Wet painting technique.

One of the most common formulas for manufactured watercolors in the twenty first century consists of a water miscible binding medium, gum arabic and color pigment. In addition to this Acrylic Polymer Paint, a water miscible vehicle may substitute for Watercolor Paint.

Wet-in-Wet (c. 1000-1150 CE): A painting technique first used in frescos. The term Wet-in-Wet serves to differentiate a watercolor painting from media such as oil or acrylic painting.

The two most common watercolor painting methods are the Wet on Dry, and the Wet-in-Wet techniques. The latter method involves brushing color pigment saturated with water onto a wet painting surface.

Depending upon the affect a painter desires, a few surfaces suitable for watercolor painting are watercolor papers (hot or cold press), handmade paper, and rice papers. Refer to Fresco and alla prima.

White Light Spectrum: Of or relating to visible light and a range of seven colors which are 1: red, 2: orange, 3: yellow, 4: green, 5: blue, 6: indigo, 7: violet. Refer to Color Wheel System, Primary Light Colors, Light, and Electromagnetic Theory.

Artists and Personages

A

Abbott, Elenore Plaisted; 98
America, 1875-1935 CE

Albers, Josef; 43
Germany, 1888-1976 CE

Aldington, Richard; 132
England, 1892-1962 CE

al-Ghazālī; 26
b. Abū Ḥāmid Muḥammad ibn Muḥammad al-Ghazālī
Persia, c. 1058-1111 CE

al-Haytham, Ibn; 26
b. Abū ʿAlī al-Ḥasan ibn al-Ḥasan ibn al-Haytham,
Iraq, 965-1040 CE

Alk, Howard; 73
b. Earth (?), 1930-1982

Allen, Paul Gardner; 49
America 1953 CE

Alloway, Lawrence; 156
England, 1926-1990 CE

Altoon, John; 156
America, 1925-1969 CE

Amaral, Tarsila do; 64
Brazil, 1886-1973 CE,

Andrade, Oswald de; 64
José Oswald de Souza Andrade
Brazil, 1890-1954 CE

Andrade, Mário; 62
Mário Raul de Morais Andrade
Brazil, 1893-1945 CE

Apollinaire, Guillaume; 67
b. Guglielmo Alberto Vladimiro Apollinaire de Kostrowitzky
Italy, 1880-1918 CE

Aristotle; 18
Greece, 384-322 BCE

Arnold, Ann; 76
England, 1936-2014 CE

Arnold, Graham; 76
England, 1932

Arp, (Jean) Hans; 40
Germany, 1886-1966 CE

Artis, William Ellisworth; 94
America, 1914-1877 CE

Avery, Milton; 43
America 1885-1965 CE

B

Baargeld, Johannes Theodore; 111
b. Alfred Emanuel Ferdinand Grünwald
Germany, 1892-1927 CE

Bacon, Francis; 91
Ireland, 1909-1992 CE

Baháʼuʼlláh; 36
b. Mírzá Ḥusayn-ʿAlí Núrí
Persia, 1817-1892 CE

Baird, John Logie; 42
Scotland, 1888-1946 CE

Ball, Hugo; 68
Germany, 1886-1937 CE

Balla, Giacomo; 122
Italy, 1871-1958 CE

Banham, Reyner; 156
England, 1928-1988 CE

Barlach, Ernst; 112
Germany 1870-1938 CE

Barr, Jr, Alfred Hamilton; 70
America, 1902-1981 CE

Barnes, Albert Coombs; 69
America, 1872-1951 CE

Batteaux, Charles; 100
France, 1713-1780 CE.

Bayer, Herbert; 100
Austria, 1900-1985 CE

Bazille, Frédéric Jean; 119
France, 1841-1870 CE

Beckmann, Max; 68
Germany, 1884-1950 CE

Bee, Samantha; 82
Canada, 1969 CE

Behrens, Peter; 113
Germany, 1886-1940 CE

Bellini, Jacopo; 27
Italy, 1400-1470 CE

Bengston, Billy Al; 73
America, 1934 CE

Berg, Alban; 147
Alban Maria Johannes Berg
Austria, 1885-1935 CE

Berg, Peter; 160
America, 1938-2011 CE

Berresford, Virginia; 67
America, 1902-1995 CE

Bernard, Émile; 62
France, 1868-1941 CE

Berry, Chuck; 46
Charles Edward Anderson Berry
America, 1926-2017 CE

Beuys, Joseph; 118
Germany, 1921-1986 CE

Biden, Joe; 56
Joseph Robinette Biden Jr.
America, 1942 CE

Blake, Peter; 72
England, 1932 CE

Blasco, José Ruiz; 154
Spain, 1838-1923 CE

Bloch, Albert; 40
America 1882-1961 CE

Boccaccio, Giovanni; 27
France, 1313-1375 CE

Boccioni, Umberto; 122
Italy, 1882-1916 CE

Bocour, Leonard; 46
America, 1910-1933 CE

Bolotowsky, Ilya; 70
Russia, 1907-1981 CE

Bonnard, Pierre; 63
France, 1867-1947 CE

Botticelli, Sandro; 27
b. Alessandro di Mariano di
Vanni Filipepi
Italy, 1444-1510 CE

Boudin, Eugéne; 119
Netherlands, 1824-1898 CE

Bracquemond, Marie; 120
b. Marie Anne Caroline Quivoron
France, 1840-1916 CE

Braque, Georges; 40, 104
France, 1882-1963 CE

Brecht, Bertolt; 147
Germany, 1898-1956 CE

Brecht, George; 118
b. George Ellis MacDiarmid
America, 1926-2008 CE

Breurer, Marcel Lajos; 102
Hungary, 1902-1981 CE

Brown, James; 46
America, 1933-2006 CE

Browne, Byron George; 95
America, 1907-1961 CE

Browne-Bengelsdorf; 95
b. Rosalind Bengelsdorf
America, 1916-1979 CE

Brownscombe, Jennie; 41
Jennie Augusta Brownscombe
America, 1850-1936 CE

Brunelleschi, Filippo; 27
Italy, 1377-1446 CE

Burke, Selma Hortense; 94
America, 1900-1995 CE

Burroughs, William Seward; 103
America, 1914-1997 CE

Bush, George; 53
George Herbert Walker
America, 1924 CE

Bush, George Walker; 56
America, 1946 CE

Butler, Theodore Earl; 62
America, 1861-1936 CE

C

Caillebotte, Gustave; 120
France, 1848-1894 CE

Calder, Alexander; 69
America 1918-1976 CE

Caravaggio, 29
Michelangelo Merisi Caravaggio
Italy, 1571-1610 CE

Carlsund, Otto Gustaf; 107
Sweden, 1897-1948 CE

Carrà, Carlo; 67
Italy, 1881-1966 CE

Carriera, Tosalba; 29
Italy, 1675-1757 CE

Cassady, Neil; 101
America, 1926-1968 CE

Cassatt, Mary Stevenson; 120
America, 1844-1926 CE

Castellon, Federico; 47
Spain, 1914-1971

Catlett, Elizabeth; 94
America, 1919-2012 CE

Cavallon, Georgio; 95
France, 1904-1989 CE

Cézanne, Paul; 41
France, 1839-1906 CE

Chagall, Marc Zakharovich; 63
Russia 1887-1985 CE

Charmy Émilie; 119
France, 1878-1974 CE

Cherniak, Lisa; 79
Canada, 19??

Chevreul, Michel-Eugène; 34
France, 1786-1889 CE

Chicago, Judy; 76
America, 1939 CE

Chidish, Billy; 54
b. Steven John Harper
England, 1959 CE

Christo; 73
b. Christo Valdimirov Javacheff
Bulgaria, 1935 CE

Clinton, Bill; 53
William Jefferson Clinton
America, 1946 CE

Clinton, Hillary; 56
b. Hillary Diane Rodham
America, 1947 CE

Close, Chuck; 75
Charles Thomas Close
America, 1940 CE

Colbert, Stephen; 82
America, 1964 CE

Coppola, Dr. August Floyd; 166
America, 1934-2009 CE

Corinth, Lovis; 62
East Prussia, 1858-1925 CE

Corot, Camille; 120
Jean-Baptiste-Camille Corot
France, 1796-1875 CE

Corsi, Jacopo; 29
Italy, 1561-1602 CE

Corso, Gregory Nunzio; 103
America, 1930-2001 CE

Courbet, Jean Désiré Gustave; 35
France, 1819 -1877

Cross, Henri-Edmund; 156
Henri-Edmond-Joseph Delacroix
France, 1856-1910 CE

D

da Vinci; 27
Leonardo di ser Pier da Vinci
Italy, 1492-1519 CE

Danby, Ken; 46
Canada, 1940-2007 CE

Darwin, Charles Robert; 35
England, 1809-1882 CE

Davis, Ronald (Ronnie) G; 73
America, 1944 CE

Dali, Salvador; 165
b. Salvador Domingo Felipe
 Jacinto Dali Domènech
Spain, 1904-1989 CE

Davy, Sir Humphrey; 34
England, 1778-1829 CE

de Chirico, Giorgio; 41
Greece, 1888-1978 CE

de Kooning, Willem; 91
Netherlands, 1904-1997 CE

de Kooning-Fried, Elaine; 91
America, 1918-1989 CE

de Vlaminck, Maurice; 119
France, 1876-1958 CE

Debord, Guy Ernest; 73
France, 1931-1994 CE

Degas; 120
Hilaire Germain Edgar Degas
France, 1834- 1917 CE

DeGeneres, Ellen; 82
America, 1958

Delaunay; 67
Robert-Victor Félix,
France, 1885-1941 CE

Demuth, Charles; 69
America 1883- 1935 CE

Denis, Maurice; 63
France, 1870-1943 CE

Deráin, André; 66
France, 1880-1953 CE

Diller, Burgoyne; 70
America, 1906-1965 CE

Dine, Jim; 156
America 1935 CE

Dix, Otto; 68
Germany, 1891-1969 CE

Doolittle, Hilda; 132
America, 1886-1961 CE

Douglas, Aaron; 69
America, 1899-1979 CE

Dreier, Katherine Sophie; 69
America, 1877-1952 CE

Du Bois, William; 94
America, 1868-1963 CE

Dubuffet, Jean; 43
France, 1901-1985 CE

Duchamp, Marcel; 41, 114
France, 1887-1968 CE

Duchamp-Villon, Raymond; 66
b. Raymond Duchamp
France, 1876-1918 CE

Dufy, Raoul; 119
France, 1877-1953 CE

Durand-Ruel, Paul; 120
France, 1831-1922 CE

Dürer, Albrecht; 28
Germany, 1471-1528 CE

Dylan, Bob; 47
b. Robert Allen Zimmerman
America 1941 CE

E

Eckmann, Otto; 113
Germany, 1865-1902 CE.

Edison, Thomas Alva; 36
America, 1847-1931 CE

Eins, Stefan; 78
Czechoslovakia, 1953 CE

Einstein, Albert; 40
Germany, 1879-1955 CE

Ensor, James Sidney; 63
Belgium, 1860-1949 CE

Ernst, Max; 111
Germany, 1891-1976 CE

Evers, Medgar Wiley; 47
America, 1925 – 1963 CE

F

Factor Sr., Max; 69
b. Maksymilian Facktorowicz
Poland, 1872-1938 CE

Fantin-Latour; 135
Henri Jean Théodore
France 1836-1904 CE

Fautrier, Jean; 166
France, 1898-1964 CE

Feininger; 102
Lyonel Charles Adrian Feininger
America, 1871-1956 CE

Felixmüller, Conrad; 147
Germany, 1897-1977 CE

Fibonacci; 26
b. Leonardo Pisano
Pisa (Italy), 1170-1250 CE

Fiddes, Christopher; 82
England, 19??

Fiorentino, Rosso; 28
b. Giovanni Battista di Jacopo
Italy, 1494-1540 CE

Flavin, Dan; 141
America, 1933-1966 CE

Flint, Frank Stuart; 132
England, 1885-1960 CE

Fontana, Lavinia; 28
Italy, 1552-1614 CE

Fontana, Lucio; 70
Argentina, 1899-1968 CE

Frankenthaler, Helen; 47
America, 1928 CE

Freud; Sigismund Schlomo; 40
Austria, 1856-1939 CE

Freundlich, Otto; 112
Germany, 1878-1943 CE

Friesz, Othon; 119
France, 1879-1949 CE

G

Gabo, Naum; 68
b. Naum Neemia Pevsner
Russia, 1890-1977 CE

Gabrieli, Giovanni, 29
Italy, 1557-1612 CE

Gallé, Émile; 63
France, 1846-1904 CE

Garfield, James Abram; 37
America, 1831-1881 CE

Gates, Bill; 49
William Henry Gates III, KBE
America, 1955 CE

Gaudier-Brzeska, Henri; 68
France, 1891-1915 CE

Gauguin, Paul; 41
b. Eugène Henri Paul Gauguin
France, 1848-1903 CE

Ghirlandaio, Domenico; 27
Italy, 1449-1494 CE

Giacometti, Alberto; 110
Switzerland, 1901-1966 CE

Ginsberg, Allen; 72
America, 1926-1997 CE

Gleizes, Albert Léon; 67
France, 1881-1953 CE

Golden, Sam; 43
America, 1915-1997 CE

Goncharova, Nataliya; 66
Russia, 1881-1962 CE

Gore, Albert (Al) Arnold; 53
America, 1948 CE

Gorky, Arshile; 91
b. Vosdanik Manook Adoian
Armenia, 1904-1948 CE

Gottlieb, Adolph; 91
America, 1903-1974 CE

Gris, Juan; 67
b. José Victoriáno Gonzalez Pérez
Spain, 1887-1927 CE

Gropius, Walter Aldoph; 41
Germany, 1883-1969 CE

Grosz, George; 68
Germany, 1893-1959 CE

Guimard, Hector-Germain; 98
France, 1867-1942 CE

Guston, Philip; 91
Canada, 1913-1980 CE

Gutenberg, Johann; 27
Germany, 1397-1468 CE

H

Hamilton, Richard William; 156
England, 1922-2011 CE

Hanson, John; 30
America, 1721-1783 CE

Haring, Keith; 53
America, 1958-1990 CE

Harnett, William Michael; 36
Ireland, 1848-1892 CE

Haworth, Jann; 76
America, 1942 CE

Harrison, George; 74
England, 1943-2001 CE

Heartfield, John; 68
b. Hellmuth Franz Joseph
 Herzfelde
Germany, 1891-1968 CE

Heckel, Erich; 112
Germany, 1883-1970 CE

Hefner, Hugh Marston; 46
America, 1926-2017 CE)

Hélion, Jean; 107
France, 1904-1987 CE

Hennings, Emmy; 68
Germany, 1885-1948 CE

Herbin, Augustte; 70
France, 1882-1960 CE

Herodotus; Caria, c. 484-c. 420 BCE	18	**J**	
Herzfelde, Wieland; Switzerland, 1896-1988 CE	111	**Jagger**, Mick; Sir Michael Philip Jagger England, 1943 CE	74
Höch, Hannah; Germany, 1889-1978 CE	111	**Janco**, Georges; Romania, 1896-1985 CE	110
Hockney, David; England, 1937 CE	78	**Janco**, Marcel; Romania, 1895-1984 CE	110
Hoffman, Abbie; Abbot Howard Hoffman America, 1936-1989 CE	75	**Jeanne-Claude**; Jeanne-Claude Denat de Guillebon Morocco, 1935-2009 CE	73
Hoffman, Anita; b. Anita Kushner America, 1942-1998 CE	75	**Jobs**, Steven Paul; America, 1955-2011 CE	49
Holmes, John Clellon; America, 1926-1988 CE	103	**Johns**, Jasper; America, 1930 CE	46
Holtom, Gerald Herbert; England, 1914-1985 CE	73	**Jones**, Brian; b. Lewis Brian Hopkins Jones England, 1941-1969 CE	74
Hopper, Edward; America, 1882-1967 CE	41	**Jongkind**, Johan Barthold; Netherlands, 1819-1891 CE	119
Huelsenbeck, Richard; Germany, 1892-1967 CE	41	**Joppolo**, Beniamin; Italy, 1906-1963 CE	70
Huncke, Herbert Edwin; America, 1915-1996 CE	103	**Jorn**, Asger; Asger Oluf Jorgensen Jutland, 1914-1973 CE	73
I		**K**	
Inshaw, David; England, 1943 CE	74	**Kain**, Gylan; America, 19?? CE	76
Isou, Isidore; Romania, 1925-2007 CE	70	**Kandinsky**, Wassily; Russia, 1866-1944 CE	40
Itten, Johannes; Switzerland, 1888-1967 CE	102		

Kaprow, Allan; 73
America, 1927- 2006 CE

Keane, Margaret; 70
b. Peggy Doris Hawkins
America, 1927 CE

Kelly, Ellsworth; 157
America, 1923-2015 CE

Kennedy, John Fitzgerald; 47
America, 1917-1963 CE.

Kennedy, Robert Francis; 48
America, 1925-1968 CE

Kerouac, Jack; 72
b Jean-Louis Lebris de Kérouac
America, 1922-1969 CE

Kienholz, Edward; 74
America, 1927-1994 CE

King Jr; 47
Dr. Martin Luther King Jr.
America, 1929-1968 CE

Kirchner, Ernst Ludwig; 42
Germany, 1880-1938 CE

Kirstein, Lincoln Edward; 112
America, 1907-1996 CE

Klee, Paul; 40
Switzerland, 1879-1940 CE

Klein, César; 68
Germany, 1876-1954 CE

Klein, Max S; 72
America, 19?? CE

Klein, Yves; 146
France, 1928-1962 CE

Klimt, Gustav; 63
Austria, 1862-1918 CE

Kline, Franz; 91
America, 1910-1961 CE

Kluver, Billy; 75
Monaco, 1927-2004 CE

Knowles, Alison; 118
America, 1933 CE

Kokoschka, Oskar; 112
Austria, 1886-1980 CE

Kollwitz, Käthe; 112
Prussia, 1867-1945 CE

Krasner, Lee; 91
America, 1908-1984 CE

Krassner, Paul; 75
America, 1932 CE

Kupka, Frantisek; 67
Bohemia, 1871-1957 CE

Kurshan, Nancy Sarah; 75
America, 1944 CE

L

Lack, Richard Frederick; 49
America, 1928-2009 CE

Lady Butler; 41
b. Elizabeth S. Thompson
Switzerland, 1846-1933 CE

Lanfield, Ronnie; 157
America, 1947 CE

Larionov; 66
Mikhail Fyodorovich Larionov
Russia, 1881-1964 CE

Lassaw, Ibram; 70
Egypt, 1913-2003 CE

Leary, Timothy Francis; 48
America, 1920-1996 CE

Le Corbusier; 68
b. Charles-Édouard Jeanneret
Switzerland. 1887-1965

Le Fauconnier; 67
b. Henri Victor Gabriel
France, 1881-1946 CE

Léger, Fernand; 67
France, 1881-1955 CE

Lennon, John Winston; 49, ccx
England, 1940-1980 CE

Lewis, Jerry Lee; 46
America, 1935 CE

Lewis, Percy Wyndham; 68
Bay of Fundy, 1886-1957 CE

LeWitt, (Sol) Solomon; 141
America, 1928-2007 CE

Lhote, André; 67
France, 1885-1962 CE

Lichtenstein, Roy; 74
America, 1923-1997 CE

Liebermann, Max; 62
Germany, 1847-1935 CE

Lin, Maya Ying; 52
America, 1959 CE

Lincoln, Abraham; 36
America 1809-1865 CE

Lissitzky, El; 165
Russia, 1890-1941 CE

Long, Huey Pierce; 43
America, 1893-1935 CE

Louis, Morris; 95
b. Morris Louis Bernstein
America, 1912-1962 CE

Luce, Maximilian; 156
France, 1858-1941 CE

Luciano, Filipe 76
America, 1947 CE

M

Macdonald-Wright, Stanton; 66
America, 1890-1973 CE

Maciunas, George; 73
b. Jurgis Maciunas
Lithuania, 1931-1978 CE

Macke, August; 40
Germany, 1887-1914 CE

Magritte; 165
René Francois Ghislain Magritte
Belgium, 1898-1967 CE

Maher, "Bill" William 79
America, 1956 CE

Mahesh, Maharishi Yogi; 46
b. Mahesh Prasad Varma
India, 1918-2008 CE

Majorelle, Louis; 98
France, 1859-1962 CE

Malcolm X; 47
b. Malcolm Little
America, 1925-1965 CE

Malevich; 40
Kasimir Severinovich Malevich
Ukraine, 1878-1935 CE

Malfatti, Anita Catarina; 64
Brazil, 1889-1964 CE

Man Ray; 69
b. Emanuel Radenski
America, 1890-1976 CE

Manet, Édourd; 120, 138
France, 1831-1883 CE

Mantegna, Andrea; 27
Italy, 1431-1506 CE

Marc, Franz; 40
Germany, 1880-1916 CE

Marcks-Stiftung, Gerhard 102
Germany, 1889-1981 CE

Marcoussis, Louis; 67
Poland, 1883-1941 CE

Marden, Brice; 157
America, 1938 CE

Marinetti, 66
Filippo Tommasso Emilio
Italy, 1876-1944 CE

Marisol; Escobar; 75
France, 1930-2016 CE

Marquet, Albert; 119
France, 1875-1947 CE

Masson, André; 69
France, 1896-1987 CE

Mathieu, Georges; 166
France, 1921-2012 CE

Matisse, Henri; 41
Henri Émile Benoit Matisse
France, 1869-1954 CE

Max, Peter; 48
Germany, 1937 CE

Maxwell, James Clerk; 35
Scotland, 1831-1879 CE

Mendelson, Joe; 79
b. Birrel Josef Mendelson
Canada, 1944 CE

McCann, Les; 94
America, 1935 CE

McCartney, Paul; 74
Sir James Paul McCartney
England, 1942 CE

McKinley, William; 37
America, 1843-1901 CE

McCracken, John Harvey; 156
America, 1934-2011 CE

McLuhan, Herbert Marshall; 48
Canada, (1911-1980 CE

McNeil, George; 95
America, 1908-1995 CE

Metzinger, Jean; 67
France, 1883-1956 CE

Meyer, Hannes; 102
Germany, 1889-1954 CE

Michaels, Lorne; 76
Canada, 1944 CE

Michelangelo; 27
b. Michelangelo di Lodovico
Buonarroti Simoni;
Italy, 1475-1564 CE

Milk, Harvey Bernard; 52
America, 1930-1978 CE

Minkowski, Hermann; 40
Germany, 1864-1909 CE

Miró, Joan Ferrá; 70
Spain, 1893-1983 CE

Modersohn-Becker, Paula; 124
Germany, 1876-1907 CE

Moholy-Nagy, László; 95
Hungary, 1895-1946 CE

Mondrian, Piet; 41
Pieter Cornrlis Mondrian
Netherlands, 1872-1944 CE

Monet, Oscar-Claude; 60
France, 1840-1926 CE

More, Sir Thomas; 27
England, 1478-1535 CE

Moreau; Gustave; 36
France 1826-1898 CE

Morisot, Berthe; 120
France, 1841-1895 CE

Morris, George; 95
George Lovett Kingsland Morris
America, 1905-1975 CE

Moscone, George Richard; 52
America, 1929-1978 CE

Motherwell, Robert Burns; 91
America, 1915-1991 CE

Muche, Georg; 102
Germany, 1895-1987 CE

Munch, Edvard; 63
Norway, 1863-1944 CE

Munsell, Albert Henry; 40
America, 1858-1918 CE

Müller, Otto; 147
Germany, 1874-1930 CE

Münter, Gabriele; 66
Germany, 1877-1962 CE

N

Nake, Frieder; 113
Germany, 1938 CE

Nees, Georg; 113
Germany, 1926 CE

Neiman, LeRoy; 72
b. Leroy Leslie Runquist
America, 1921-2012 CE

Nelson, David Jordan; 76
America, 1939 CE

Newman, Barnett; 157
America, 1905-1971 CE

Newton, Sir Isaac; 29
England, 1642-1727 CE

Niépce, Joseph Nicéphore; 34
France, 1765-1833 CE

Nietzsche, Friedrich; 36
Friedrich Wilhelm Nietzsche
Germany, 1844-1900 CE

Nixon, Richard Milhous; 49
America, 1913-1994 CE

Noland, Kenneth; 157
America, 1924-2010 CE

Nolde, Emil; 40
b. Emil Hansen
Germany, 1867-1956 CE

Noll, A. Michael; 74
America, 1939 CE

Nuriddin, Jalaluddin Mansur 76
America, 1944-2018 CE

O

Obama, Barack; 56
b. Barack Hussein Obama II
America, 1961 CE

O'Keeffe, Georgia Totto; 69
America, 1887-1986

Oldenburg, Claes Thure; 74
Sweden, 1929 CE

Ono, Yoko; 75
Japan, 1933 CE

Oppenheimer, Max; 110
Austria, 1885-1954 CE

Opper, John; 70
America, 1908-1994 CE

Orlovsky, Peter Anton; 103
America, 1933-2010 CE

Ovenden, Annie; 76
England 1945 CE

Ovenden, Graham; 76
England, 1943 CE.

Oyewole, Abiodun; 76
b.. Charles Davis
America, 1948 CE

Ozenfant, Amédée; 68
France, 1886-1966 CE

P-Q

Paik, Nam June; 73
Korea, 1932-2006 CE

Paolozzi, Eduardo; 46
Scotland, 1924-2005 CE

Pechstein, Hermann Max; 68
Germany, 1881-1955 CE

Pereira, Irene Rice; 91
America, 1902-1971 CE

Peri, Jacopo; 29
Italy, 1561-1633 CE

Pierelli, Attilio; 78
Italy, 1924 CE

Perugino, Pietro; 27
b. Pietro Vannucci
Italy, 1446–1523 CE

Petrarca, Francesco; 27
Italy, 1304 -1374 CE

Pevsner, Antoine; 68
Russia, 1886-1962 CE

Picabia, Francis; 67
b. Francis Marie Martinez Picabia
France, 1879-1959 CE

Picasso, Pablo; 40, 154
b. Pablo Diego José Francisco
 de Paula Juan Nepomuceno
 Maria de los Remedios
 Cipriano Santisima Trinidad
 Ruiz y Picasso
Spain, 1881-1973 CE

Picchia, Paulo Menotti Del; 64
Brazil, 1892-1988 CE

Pissarro, Camille; 62, 155
Camille Jacob Pissarro
Danish West Indies,
1830-1903 CE

Plato; 18
Greece, c. 427-347 BCE

Pollock, Jackson; 43
America, 1913-1956 CE

Pontormo; 28
b. Jacopo Carucci
Italy, 1494-1557 CE

Poons (Larry) Lawrence; 148
Japan, 1941 CE

Porter, James Amos; 94
America, 1905-1970 CE

Posey, Robert Kelly; 112
America, 1904- 1977 CE

Pound, Ezra Weston; 67
America, 1885-1972 CE

Poussin, Nicolas: 28
Normandy, 1594-1665 CE

Presley, Elvis Aaron; 46
America, 1935-1977 CE

R

Raphael; 27
b. Raphael Sanzio
Italy, 1483-1520 CE

Rauschenberg, Robert; 46
b. Milton Ernest Rauschenberg
America, 1925-2008 CE

Reagan, Ronald; 53
Ronald Wilson Reagan
America, 1981-1989 CE

Rembrandt; 29
Rembrandt Harmenszoon van Rijn
Netherlands, 1606-1669 CE

Renoir, Pierre Auguste; 62
France, 1841-1919 CE

Restany, Pierre; 146
France, 1930-2003 CE

Richards, Keith; 74
England, 1943 CE

Riep, Carl Julius Ferdinand; 37
Netherlands, 1835-???? CE

Riley, Bridget; 148
England, 1931 CE

Robbins, Dan; 72
America 19?? - CE

Rockwell, Norman Perceval; 41
America, 1894-1978 CE

Rodchenko; 105
Alexander Mikhailovich
Rodchenko
Russia, 1891-1956 CE

Röhm, Otto Karl Julius; 42
Germany, 1876-1939 CE

Roosevelt, Franklin Delano; 42
America, 1882-1945 CE

Rosenberg, Harold; 93
America, 1906-1978 CE

Rosenquist, James; 47
America, 1933 CE

Rossolo, Luigi; 122
Italy, 1885-1947 CE

Rothko, Mark; 91
Markus Yakovlevich Rothkowitz
Russia, 1903-1970 CE

Rousseau, Henri; 63
France, 1844-1910 CE

Rubens, Sir Peter Paul; 29
Germany, 1577-1640 CE

Rubin, Jerry Clyde; 75
America 1938-1994 CE

Ruscha, Ed; 156
America, 1937 CE

Russell, Morgan; 66
America, 1886-1953 CE

Ryman, Robert; 141
America, 1930 CE

S

Sahlins, "Bernie" Bernard; 73
America, 1922-2013 CE

Sargent, John Singer; 41
Italy, 1856-1925 CE

Schiele, Egon Leo Adolf; 112
Austria, 1890-1918 CE

Schlemmer, Oskar; 102
Germany, 1883-1943 CE

Schmidt-Rottluf, Karl; 111
Germany, 1884-1976 CE

Schulze, Johann Heinrich; 30
Germany, 1667-1744 CE)

Schwitters, Kurt; 68
Germany, 1887-1948 CE

Segal, George; 74
America, 1924-2000 CE

Seurat, Georges-Pierre; 37
France, 1859-1891 CE

Severini, Gino; 122
Italy, 1883-1966 CE

Shaw, Charles Green; 70
America, 1872-1974 CE

Sheeler, Charles; 41
America, 1883-1965 CE

Signac, Paul; 156
France; 1863-1935 CE

Sills, Paul; 73
b. Paul Silverberg
America, 1927-2008 CE

Sisley, Alfred; 62
England, 1839-1899 CE

Skiles, Jacqueline; 76
America, 1937 CE

Slevogt, Max; 62
Germany, 1868-1932 CE

Slodki, Marcel; 110
Poland, 1892-1943 CE

Smithson, Peter Denham; 72
Great Britain, 1923-2003 CE

Smithson-Gill, Alison; 72
b. Alison Margaret Gill
Great Britain, 1928-1993 CE

Spoerri, Daniel; 146
Romania, 1930 CE

Stanley, Francis Edgar; 36
America, 1849-1918 CE

Stanley Freelan Oscar; 36
America, 1849-1940 CE

Starr, Ringo; 74
b. Richard Starkey Jr.
England, 1940 CE

Stella, Frank; 46
America, 1936 CE

Stella, Joseph; 122
Italy, 1877-1946 CE

Stewart, Ian Andrew Robert; 74
England, 1938-1985 CE

Swan, Sir Joseph Wilson; 36
England, 1828-1914 CE

T-U

Talbot, William Henry Fox; 34
England, 1800-1877 CE

Tanguy, Yves; 165
France, 1900-1955 CE

Tatlin; 67
Vladimir Yevgrafovich Tatlin
Russia, 1885-1953 CE

Thomson, Charles; 54
England, 1952 CE

Tinguely, Jean; 146
Switzerland, 1925-1991 CE

Toulouse-Lautrec; 63, 168
b. Henri Marie Raymonde de
Toulouse-Lautrec-Monfa
France, 1864-1901 CE

Truitt, Anne; 141
America, 1921-2004 CE

Tutundjian, Léon Arthur; 107
Armenia, 1905-1968 CE

Twachtman, John; 62
America, 1853-1902 CE

Twombly, Cy; 91
b. Edward Parker Twombly Jr.
America, 1928-1970 CE

Tworkov, Jack; 91
Poland, 1900-1982 CE

Tzara, Tristan; 110
b. Samuel Rosenstock
Romania, 1896-1963 CE

V

Valázquez, 29
Diego Rodríguez de Silva y
Spain, 1599-1660 CE

van de Velde; 63
Henry Clemens van de Velde
Belgium, 1863-1957 CE

van der Rohe, Ludwig Miës; 102
Germany, 1886-1969 CE

van Doesburg, Theo; 41
b. Christian Emil Marie Küpper
Netherlands, 1883-1931 CE

van Dongen, Kees; 119
Netherlands, 1877-1968 CE

van **Dyck**, Sir Anthony; 29
Netherlands, 1599-1641 CE

van **Gogh**, Vincent Willem; 41
Netherlands, 1853-1890 CE

van **Hemessen**, Caterina, 28
Netherlands, 1528-1587

van **Honthorst**, Gerad; 29
Netherlands, 1590-1656 CE

Vantongerloo, Georges; 67
Belgium, 1886-1965 CE

Vasarely, Victor; 70
Hungary, 1906-1997 CE

Vermeer, Johannes; 29
Netherlands, 1632-1675 CE

Villon, Jacques; 67
b. Gaston Emile Duchamp,
France, 1875-1963 CE

von **Goethe**; 34
Johann Wolfgang von Goethe
Germany, 1749-1832 CE

von **Hindenburg**, John; 42
b. Paul Ludwig Hans Anton
 von Beneckendorff und
 von Hindenburg
Germany, 1847-1934 CE

von **Hofmann**, Ludwig; 62
Germany, 1861-1945 CE

von **Jawlensky**, Alexej; 66
Russia, 1864-1941 CE

von **Werefkin**, Marianne; 124
b. Marianna Wladimirowna
 Werewkina
Russia, 1860-1938 CE

Vuillard, Édourd; 63
France, 1868-1940 CE

W

Watts, Charlie; 74
b. Charles Robert Watts
England, 1941 CE

Waldhauer, Fred; 75
Frederick Donald Waldhauer
America, 1927-1993 CE

Warhol, Andy; 74
America, 1928-1987 CE

Washington, George; 30
America, 1732-1799 CE

Wedgwood, Thomas; 34
England, 1771-1805 CE

Weir, Julian Alden; 62
America, 1852-1919 CE

Wesselman, Tom; 156
America, 1931-2004 CE

Whistler, James; 36
b. James Abbott McNeil Whistler
America, 1834-1903 CE

Whitman, Robert; 75
America, 1935 CE

Winfrey, Opray; 78
America, 1954 CE

Wols; 166
b. Alfred Otto Wolfgang Schulze
Germany, 1913-1951 CE

Wozniak, Stephen Gary; 49
America, 1950 CE

Wright, Frank Lloyd; 63
America, 1869-1959 CE

Wyman, Bill; 74
b. William George Perks Wyman
England, 1936 CE

X, Y, Z

Zagar, Isaiah; 76
America, 1939 CE

Zagar, Julia; 76
America, (?) 1939 CE

Zola, Emile; 145
b. Emile Edouard Charles
 Antoine Zola
France, 1840-1902 CE

Art with an Attitude

Section IV
Government and the Free Press

United States Federal Government
Federal Government Infrastructure
Executive Orders
White House Office
Alternative Information Outlets
The Free Press

United States Federal Government
Fact Check Sources

The 56 Delegates who signed the United States Constitution:
http://www.ushistory.org/Declaration/signers/index.html

The United States Constitution, the first Ten Amendments, and subsequent Amendments, 11 through 27:
http://constitutioncenter.org/media/files/constitution.pdf

To ensure a separation of power, the United States Federal Government is divided into three branches. They are the legislative, the Executive and the Judicial Branches.
http://www.house.gov/content/learn/branches_of_government/

United States Congress
https://en.wikipedia.org/wiki/United_States_Congress

United States Library of Congress
https://loc.gov/
http://www.copyright.gov/

The 24 Billionaires, Millionaires and Washington Insiders Trump chose to fill White House Cabinet Positions:
https://www.whitehouse.gov/administration/cabinet

Congress, a millionaires club:
http://time.com/373/congress-is-now-mostly-a-millionaires-club/

United States Congress pay and benefits:
http://usgovinfo.about.com/od/uscongress/a/congresspay.htm

Federal Government Infrastructure

The following departments are earmarked to have severe budgets cuts. The huge surplus from these cuts is earmarked for the military budget, and to help finance Trump's Wall along the American/Mexican border.

 United States Environmental Protection Agency
 United States Department of State
 United States Department of Agriculture
 United States Department of Labor
 United States Department of Health and Human Services
 United States Department of Commerce
 United States Department of Education
 United States Department of Housing and Urban Development
 United States Department of Transportation
 United States Department of the Interior
 United States Department of Energy
 The Small Business Administration
 United States Department of the Treasury
 United States Department of Justice
 The National Aeronautics and Space Administration/NASA

Departments earmarked for complete elimination

 National Endowment for the Arts-NEA
 National Endowment for the Humanities-NEH

The loss of these programs will affect societies all over the world.

The loss of jobs due to budget cuts will affect thousands of families and children across the country.

Executive Orders and Presidential Memoranda
Fact Check Sources

(HTTP References)

White House Presidential Actions:
https://www.whitehouse.gov/briefing-room/presidential-actions

The inconsistencies between Trump's actions and his words are astounding.

For example, under the heading of Economy and Jobs, on May 31, 2018, Trump declared June 2018 to be Nation Homeowner Month.

Despite this, Trump's new tax plan (which benefits large corporations and the top 2%) put a cap on the amount of interest a homeowner can declare on their Federal Tax Return. Prior to this, there was no cap. This impacts middle class America the most.

Budget Blueprint for 2018.
https://www.whitehouse.gov/sites/whitehouse.gov/files/omb/budget/fy2018/2018_blueprint.pdf

The federal government's annual budget deficit is set to exceed $1 trillion by 2020.

White House Office
Office of the Chief of Staff

White House Chief of Staff and Assistant to the President:
John Francis Kelly

> Deputy Chief of Staff for Operations and Assistant to the President: Joe Hagin
>
> Deputy Chief of Staff for Legislative, Intergovernmental Affairs, and Implementation and Assistant to the President: Rick Dearborn

Counselor and Assistant to the President:
Kellyanne Conway

Senior Advisor and Assistant to the President:
Jared Kushner, Trump's son-in-law

White House Press Secretary (WHPS):
Sarah Elizabeth Huckabee Sanders (as of July 2017).

Senior Advisor for Policy and Assistant to the President
Stephen Miller

White House non-salaried staff

Council and Senior Advisor to her father, Ivanka Trump

Alternative Information Outlets
News sources of White House Office and non-staff members.

Twitter

The New York Observer:
Owned by Jared Kushner

Breitbart News Network:
Alex Marlow, Editor-in-Chief.

The National Enquirer (TNE):
David Pecker, CEO and Chairman of America Media and publisher of TNE.

Infowars and The Alex Jones Show:
A Far-Right radio show hosted by Alex Jones.

Fox News Channel:
Owned by the Fox Entertainment Group, a subsidiary of 21st Century Fox.

The Free Press
Fact Check Sources

The origins of the newspaper date back to ancient Rome during the first century BCE. Daily public records were known as the Acta Diurna. During this period the Rhetorician, Hermagoras of Temnos formulated the five W's of sound journalism. The five W's pertain to Who, What, Where, When and Why.

In the eighteenth century, newspapers became an integral source of information during the founding of the United States. Freedom of the Press began with the United States Constitution, and the First Amendment ratified in 1791.

The following are just a few of the thousands of legitimate news media outlets in the United States known as The Free Press. Some of these institutions have been in existence since the nineteenth century.

HTTP, Print and Televised

ABC News - est. 1948 CE
BBC - est. 1922 CE
CBS News - est. 1928 CE
CNN - est. 1980 CE
CS-T - est. 1844 CE
LAT - est. 1881 CE
MSNBC - est. 1996 CE
NBC News - est. 1926 CE
NPR - est. 1970 CE
NYDN - est. 1919 CE
NYT - est. 1851 CE
Politico - est. 2007 CE
Reuters - est. 1851 CE
The Hill - est. 1994 CE
TPI - est. 1829 CE
TWP - est. 1877 CE

Trump, a man of 72 years, frequently lashes out at The Free Press, referring to the news media as the enemy of the people, the *opposition party* and/or Fake News.

On Friday, February 24, 2017, Sean Spicer/WHPS banned the following members of The Free Press from White House news briefings: CNN, Los Angeles Times, New York Times, Politico, The Hill, and BuzzFeed, an entertainment news publication.

On Thursday, 28 June 2018, five journalists were murdered during the premeditated shooting at the Capital Gazette newsroom in Annapolis, Maryland.

Despite this, one week later to the day, Thursday July 5^{th}, Trump continued to malign The Free Press, insulted President George H. W. Bush and Senator John McCain, harassed Representative Maxine Waters and Senator Elizabeth Warren, and mocked the #MeToo movement.

Helsinki Summit (Finland) July 16, 2018: Televised on the world stage, Trump chose to take sides with Putin and the Russian government over the United States Intelligence community, in regards to the Russia Investigation.

Many individuals within the Trump Base have chosen to turn a blind eye to the egregious realities of The Trump Show, and to ignore Trump's particular brand of bullyism and adolescent behavior. That is to say, until it affects them personally, or someone they know.

Art with an Attitude

Section V
External References

Bibliography
Kindle Books
Manifestos
HTTP Reference Material
About The Author

Bibliography
Print Sources

Ades, Davis. **Photomontage**. Thames and Hudson, London. 1976.

Bergson, Henri. **Creative Evolution**. Henry Holt and Company, New York, NY 1911. Copyright obtained by Publishing in Motion 2011

Blake, Wendon. **Complete Guide To Acrylic Painting**. Watson-Guptill Publications, New York, NY, 1978.

Bloch, Albert. **The American Blue Rider**. Edited by Adams, Henry and Conrads, Margarete and Hoberg, Annegret. Prestel-Verlag, Munich and New York, 1997.

Chevreul, M.E. **Principles of Harmony and Contrast of Colours, and Their Applications To The Arts**. Translated. Second Edition, Longman, Brown, Green, and Longmans, London, 1855 Paperback Reprint (date unknown)

Chilvers, Ian and Osborne, Harold. **The Oxford Dictionary of Art**. Edited by Chilvers, Ian and Osborne, Harold. Oxford University Press, Oxford, NY, 1988.

Chipp, Herschel B. **Theories of Modern Art**. University of California Press, Berkeley, CA, 1968.

Christensen, Erwin O. **The History of Western Art**. The New American Library, New York and London, 1959.

Darwin, Charles. **On the Origins of Species by Means of Natural Selection**. John Murray Publisher, London, Eng. 1859. Dover Thrift Editions Reproduction of the original text 2006

Dehn, Adolf. **Water Color, Gouache, and Casein Painting: A Handbook of Techniques**. The Studio Publications, Inc., New York, and London, 1955.

de la Croix, Horst and Tansey, Richard G. **Art Through The Ages**. Harcourt, Brace & World, Inc., New York, NY, 1970.

de Santillana, Giorgio. **Leonardo da Vinci**. Reynal and Company, New York, NY, 1977.

Di san Lazzaro, G. **Klee**. Translated. F. A. Praeger, Inc., New York, NY. 1954

Gardner, Helen. **Art Through the Ages**. Harcourt, Brace & World, Inc., New York, NY, 1959.

Gleizes, Albert and Metzinger, Jean. Translated. **Cubism**. T. Fisher Unwin, London, England, originally printed c. 1913, University of Michigan Library, Printed In USA 2013.

Golding, John. **Cubism**. A History and an Analysis 1907-1914. Harper & Row, Publishers, New York, NY. 1968.

Goldwater, Robert and Treves, Marco. **Artists on Art**. Edited by Goldwater, Robert and Treves, Marco. Pantheon Books, New York, NY, 1972.

Gowing, Sir Lawrence. **A Biographical Dictionary of Artists**. Facts On File, Inc., New York, NY, 1995.

Grumbacher, Max. **Grumbacher Color Compass**. Third Edition, M. Grumbacher., New York, NY 1977

Haden-Guest, Anthony. **True Colors: the real life of the art world**. The Atlantic Monthly Press, New York, NY, 1996.

Hardie, Daniel. **Exploring Early Jazz: The Origins and Evolution of the New Orleans Style**. iUniverse 2002

Henri, Robert. **The Art Spirit**. J.B. Lippincott Co., New York, NY, 1958.

Herbert, Robert L. **Modern Artists on Art**. Edited by Herbert, Robert L. Prentice Hall, Inc., England

Huelsenbeck, Richard. **DADA ALMANAC**. Central Committee of the German Dada Movement, Berlin, 1920. Translated by Green, Malcom. Atlas Press, London, 1992.

Ivans, Jr. William, M. **Art & Geometry**. Dover Publications, New York, NY. 1964

Kandinsky, Wassily and Marc, Franz. **Der Blaue Reiter Almanac**. Translated. Edited by Kandinsky and Marc. The Viking Press, New York, NY, 1912, 1974.

Kandinsky, Wassily. **Concerning The Spiritual In Art**. Translated. Dover Publications, Inc., New York, NY, 1977.

Kandinsky, Wassily. **Point And Line To Plane**. Translated. Dover Publications, Inc., New York, NY, 1979.

Keck, Caroline K. A **Handbook on the Care of Paintings**. Watson-Guptill Publications, New, NY, 1967.

Klee, Paul. **The Diaries of Paul Klee 1898-1918**. Translated. Edited by Klee, Felix. University of California Press, Berkeley, CA, 1968.

Mailer, Norman. **Picasso, Portrait of Picasso as a Young Man**. An Interpretive Biography. Warner Books, Inc. New York, NY 1996.

Mayer, Ralph. **A Dictionary of Art Terms and Techniques**. Apollo Edition, Thomas y. Crowell Co., New York, NY, 1975.

More, Thomas. **Utopia**. Translated by Miller, Clarence H. Yale University Press. New Haven, CT and London. Reprint 2001

Munsell, A. H. **A Color Notation**. 2^{nd} Edition (revised). Geo. H. Ellis Co., Boston, MA. 1907.

Neumann, Erich. **Art and the Creative Unconscious**. Translated. Princeton University Press, Princeton, NJ, 1974.

Neumann, Eckhard. **Bauhaus and Bauhaus People**. Edited by Neumann, Eckhard. Translated by Richter, Eva and Lorman, Alba. Van Nostrand Reinhold, New York, NY, 1993.

Newton, Isaac. **The Principia ~ Mathematical Principles of Natural Philosophy**. Snowball Publishing, 2010

Newton, Isaac. **Opticks, or, A treatise of the reflections, refractions, inflections, and colours of light**. Originally published: London: Printed for W. Innys, 1730. Re-published: Prometheus Books, Amherst, NY, 2003.

Nietzsche, Friedrich Wilhelm. **The Birth of Tragedy: Out of the Spirit of Music**. Edited by Tanner, Michael. Translated by Whiteside, Shaun. 1^{st} print 1872, Penguin Putman, Inc. New York, N.Y. 1994.

Nietzsche, Friedrich Wilhelm. **The Antichrist** Translated by Mencken, H. L. Merchant Books, 1924. Reprint 2012.

Ortega y Gasset, Jose. **The Dehumanization of Art**. Princeton University Press, Princeton, NJ, 1972 (© 1948).

Osborne, Harold. **The Oxford Companion To Art**. Edited by Osborne, Harold. Oxford University Press, London, 1970.

Picasso, Pablo. **Picasso On Art**. Edited by Dore Ashton, Da Capo Press, New York, NY, 1972. Reprinted by Viking Penguin Inc.

Pissarro, Camille. **Camille Pissarro: letters to his son Lucien**. Edited by Rewald, John. Da Capo Press, New York, NY, 1995.

Raynal, Maurice. **History of Modern Painting**. Translated by Gilbert, Stuart. A Skira, Geneva, Switzerland, 1949.

Shahn, Ben. **The Shape of Content**. Harvard University Press, Cambridge, MA. and London. 1978.

Stout, George L. **The Care of Pictures**. Dover Publications, New York, NY, 1975.

Thorsson, Edred. **Runelore**: A Handbook of Esoteric Runology. Samuel Weiser, Inc., York Beach, ME, 1992.

Thorsson, Edred. **At the Well of Wyrd**: A Handbook of Runic Divination. Samuel Weiser, Inc., York Beach, ME, 1996.

Tzu, Sun Wu. **The Art of War**. Translated by Cleary, Thomas. Shambhala Publications. Boston, MA 1988

Von Goethe, Johann Wolfgang: **Theory of Colours**. Dover Publications, Inc., New York 2006

Wallar, John D. **Glossary of Art, Architecture and Design**. Cline Bingley, Ltd., London, England, 1977.

Wehlte, Kurt. **The Materials and Techniques of Painting**. Translated. Van Nostrand Reinhold Co., New York, NY, 1975.

Wilder, Daniel. **The Manifesto Concerning Das**. Create Space, SC, 2014

Kindle Books

Nietzsche, Friedrich Wilhelm. **Human, All Too Human A Book for Free Spirits**. Translated by Harvey, Alexander Miller

McCoy, Dan. **The Love of Destiny: the Sacred and the Profane in Germanic Polytheism**.

Davidson, H. **Gods and Myths of Northern Europe**.

Manifestos
and similar text on the subject of painting

Balla, Boccioni, Carrà, Rossolo, and Severini. **The Manifesto of the Futurist Painters.** c. 1910 CE.

Benton. **Surrealism.** c. 1925 CE.

Chidish and Thomson. **The Stuckist Manifesto.** 1999 CE

Fontana. **The Manifesto Blanco,** 1946 CE.

Fontana and Joppolo. **Spatialism.** c. 1947 CE.

Gleizes and Metzinger. **Cubism.** 1913 CE.

Huelsenbeck. **Dada Almanac,** 1920 CE.

Kandinsky and Marc. **Der Blaue Reiter Almanac.** 1912 CE.

Malevich. **Suprematism.** c. 1913 CE.

Mondrian and van Doesburg. **De Stijl.** c. 1914 CE.

Rothko and Gottlieb. **Manifesto on Art.** 1943 CE, New York Times.

Van Doesburg, Carlsund, Hélion and Tutundjian. **Concrete Art.** c. 1930 CE.

HTTP Reference Material
(Hyper Text Transfer Protocol)
Fact check sources

Athens Museum:
http;//ancient-greece.org/index.html

Authoritarian Rule
http://www.biography.com/people/vladimir-putin-9448807

Bocour Artist Colors:
http://www.goldenpaints.com/history

College of Arts and Science University of Buffalo:
http://www.math.buffalo.edu

Encyclopædia Britannica:
http://www.britcannica.com
https://www.britannica.com/biography/Joseph-McCarthy

Eye's Gallery, the:
https://www.eyesgallery.com

FDR, The New Deal:
http://www.ushistory.org/us/49g.asp
http://www.laboreducator.org/newdeal2.htm

History of the Newspaper:
http://www.nyu.edu/classes/stephens/Collier's page.htm

Imagine John Lennon Day:
http://www.johnlennonday.com/

Liquitex®
http://www.liquitex.com/AboutUs/

McCarthyism:
 http://www.history.com/topics/cold-war/joseph-mccarthy
 https://en.wikipedia.org/wiki/McCarthyism

Merriam-Webster Dictionary:
 http://www.merriam-webster.com/

Museum of Modern Art:
 http://www.moma.org/

National Geographic:
 http://www.nationalgeographic.com/

Norse Mythology:
 http://norse-mythology.org/

Ripolin Paint Manufacturer:
 http://www.ripolin.tm.fr/

Roman Numerals Table:
 http://romannumerals.babuo.com/roman-numerals-1-1000

Smithsonian National Museum of Natural History:
 http://humanorigins.si.edu/

Stanford Encyclopedia of Philosophy:
 http://plato.stanford.edu/contents.html

Utrecht Linens, Inc.:
 http://www.utrechtart.com/About-Us---Home-g10t0.utrecht

Wikipedia, the free encyclopedia:
 https://en.wikipedia.org/wiki/Main_Page

About The Author

Daniel Wilder is a painter, a theorist concerning the discipline of painting and author.

Having an interest in the history of art, since childhood, Wilder was disappointed that he never came across any reference material, which focused on the evolution of painting.

In 1996, Wilder began research for his treatise titled Art with an Attitude, and over the next nineteen years, he chronicled the origins of painting, its materials, techniques and terms along with current events that may have influenced artists.

Having moved to the Mid-Atlantic Region in 2003, Wilder continued to paint and follow current events. In 2010, he began writing drafts for his Manifesto. In 2014, Wilder published The Manifesto Concerning Das. In this declaration, Wilder provides the Articles of Intent and gives a detailed description for each of the sixteen dimensions concerning Das, an acronym for Dimension and space.

One year later, Wilder completed his exploration into the history of painting and published his findings. In mid-2018, Wilder revised his treatise to reflect the current political climate and its relationship to society, the discipline of painting, and to artists/painters.

danielwilder@outlook.com

www.danielwilder.com

www.amazon.com

www.ingramcontent.com/pod-product-compliance
Lightning Source LLC
Chambersburg PA
CBHW071420170526
45165CB00001B/342